FIRE ISLANDS

Recipes from Indonesia

ELEANOR FORD

For Sebastian

and a life of love and adventure

FIRE ISLANDS

Recipes from Indonesia

ELEANOR FORD

APOLLO
PUBLISHERS

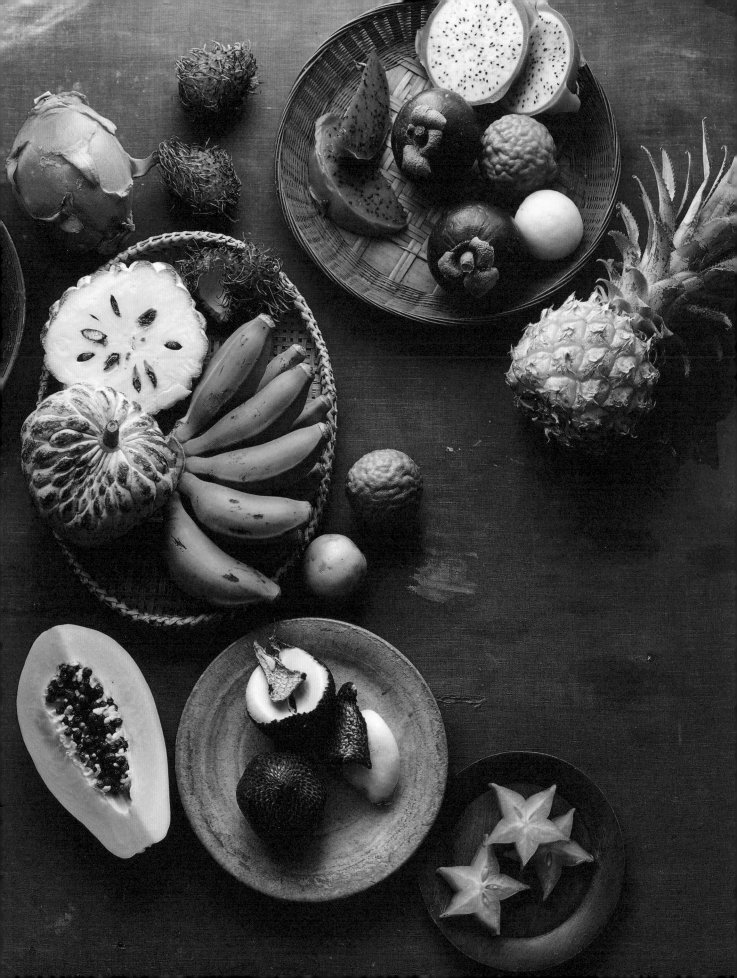

Contents

The scent of frangipani blossoms hanging in humid air. Shimmering sounds of a gamelan orchestra making rhythmic, mesmeric music. Dragging sticks of smoky chicken sate through salty-sweet peanut sauce. These are some of the sharpest memories of my childhood.

My architect father designed hotels in Bali and Java, taking us back year after year. Their locations seemed otherworldly to me then: in Sultans' palaces and coffee plantations shrouded in morning mist, deep in the lush vegetation of bamboo forests and in the volcanic highlands overlooking the ninth century temple of Borobudur. I quickly became intoxicated by the magic of the Indonesian archipelago.

Life was filled with exploration and our days fell to a new rhythm. Painted boats with crab claw sails slid onto the beach after dawn fishing trips. The call of morning market traders meant time for snacks of chilli-flecked omelettes, pancakes the colour of pale jade filled with treacly palm sugar, and young coconut water to drink from the shell. At afternoon dance schools, girls in gold-threaded costumes with flowers in their hair practised flicking hands and flashing eyes. I joined classes but could never master their graceful moves, like palm leaves swaying in a breeze. At dusk my parents would light aromatic clove cigarettes to ward off mosquitos and soon the pulsating nighttime call of crickets would start.

One particularly grey winter in London, my husband, Sebastian, and I decided to move back to Indonesia with our young children, Otto and Sylvia, so they too could experience the colours, sounds and tastes that so captivated me as a child.

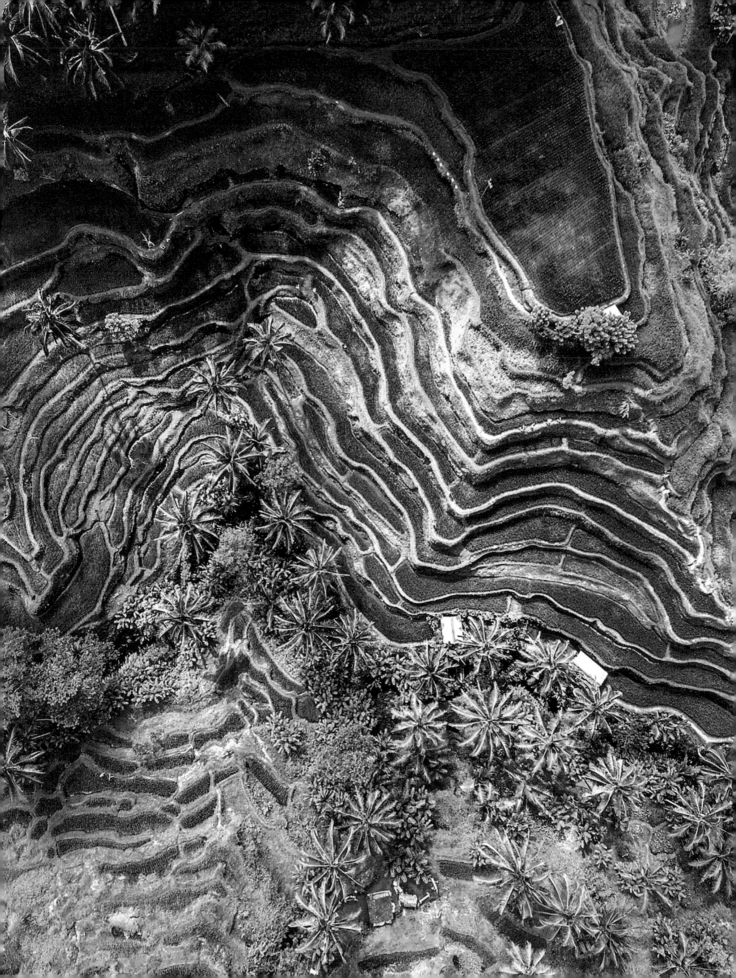

INDONESIA: *the* ISLANDS, *the* SPIRIT, *the* FLAVOURS

Seventeen thousand islands make up the world's largest archipelago. Or perhaps eighteen thousand. Even official figures vary as sandy cays are exposed and submerged by the tides of the Indian and Pacific oceans. It runs along the girdle of the Earth, covering the distance of Britain to Iraq. To the northwest is conservative Islamic Aceh and to the southeast are the penis-gourd wearing tribes of Papua. Between is dizzying geographical and cultural diversity all belonging to a single country: Indonesia.

Lying on the Pacific Ring of Fire, many islands are pockmarked with volcanoes that rumble and erupt frequently. The combination of fertile volcanic soil, warmth and heavy rainfall means food grows on most islands with abundance. Hills are striped with verdant rice terraces. Mountainous regions produce some of the world's finest coffee beans. Lush, steamy rainforests are teaming with tropical fruits, coconuts, spices and cocoa beans. Then, of course, there are the silver sanded beaches, coral atolls and perfect surf breaks, which lure travellers from the world over.

Whilst they may come for the tropical idyll, it is often the beguiling cultures and traditions that captivate visitors. Every one of the seven hundred or so languages denotes a different culture. Leave the sophisticated, largely Muslim island of Java, home to sixty percent of Indonesians, and you'll find the blood-sacrificing Sumbanese, the longhouse-dwelling Dayaks of Kalimantan, the matrilineal Minangkabau, the seafaring Bugis and

the Hindu Balinese. People have different gods, different foods, different races – and they are adapting ancient traditions to modern times in very different ways. Tribal villagers asked me for selfies with their smartphones; I saw camera drones swarm the air at the spear-throwing pasola festival in Sumba and at a royal cremation ceremony in Bali; Jakarta tweets more than any city on Earth.

Even in this sprawling collection of people, a national Indonesian identity has emerged. This started through the fight for independence from Dutch colonial rule (achieved in 1945) and was cemented by education programmes and promotion of the national language, Bahasa Indonesia. Threads of commonality are evident. Hospitality is one: guests are greeted warmly and looked after well. The importance of both family and community is another and elders are accorded great respect. Religion plays a key role in daily life throughout the archipelago and indeed is a principle of the state. Though predominantly Islamic, in many places this has interwoven with local animism and traditions of offerings and sacrifice. Another unifier for this vast land of contrasts is the universal love of fiery, fragrant chilli sauces called sambal.

'Unity in Diversity' is the national motto and the emblem symbolising this is a banyan tree. These huge, splendid trees hang with aerial roots that grow down into the soil creating additional trunks. It represents

one country formed from many far-flung cultural roots. Banyans are treated with both respect and caution as they are thought to harbour spirits. They also provide a shady respite from the heat so beneath the banyan tree is often a village gathering place to socialise and enjoy snacks of soft rice puddings served in waxy green banana leaves, or peanuts crisped in batter flecked with lime leaves and black pepper.

For more than two thousand years the outside world has been drawn to Indonesia. The main western islands lie in the middle of the sea trading routes between Arabia, China and India. Around the equator, the winds change direction mid-year, providing a sea conveyor belt that brought early traders through Indonesian waters. In the fickle winded doldrums, they would stay and discover local treasures to export. The most sought after of these were spices.

The Banda Islands in the east of the archipelago were once the only place in the world where nutmeg and cloves grew, meaning the so-called Spice Islands became powerful magnets in their own rights. The trade that had been peaceful for millennia changed when Europeans got a taste for spice. The new arrivals weren't content to trade with sultans as their predecessors had and spices became so valuable they started a spiral of monopolies, conflict, colonisation and, finally, a war of independence.

Throughout this all, Indonesians have been accepting of new people, new ideas, new religions, new crops and new foods that the age of trade, discovery and exploration brought. The culture and cuisine have been shaped by influences from India, China, Malaysia, Europe and the Middle East. People learnt a Chinese appreciation for ingredients retaining their unique properties as well as the technique of stir-frying. They kept the Arab and Indian skills for using spices and flavours. They adopted a love of sweet steamed cakes from Portuguese and Dutch traders. It was the Spanish who introduced both peanuts and chillies, two ingredients that Indonesian food as we know it would be unimaginable without. Everything is combined with a local flair for style and presentation, making this one of the world's most colourful cuisines.

For a land that was once the beating heart of the spice trade, it is curious that Indonesian food is characterised by its freshness. Rather than relying on dried spices, fresh ingredients are pounded to spice pastes known as *bumbu* to unlock exotic, vibrant

flavours. Ginger, galangal, red chillies, coconut, tamarind, treacly palm sugar, shrimp paste, lemongrass, smoky fermented soy sauce, turmeric root, peanuts, garlic – these are the Indonesian culinary backbone. There is heat, complexity, richness and savoury piquancy.

To experience the full hit of these flavours, the traditional morning markets are a joy to explore. Deep inside a labyrinth of stalls, somewhere shaded from the dazzling sun, you'll find bamboo baskets overflowing with tiny perfumed limes, piles of baby yellow bananas, silver-skinned fish, glossy betel leaves and camphorous gingers still damp from the soil. Lemongrass is cut long and tied in generous bundles, hessian sacks bulge with curled chillies, tubs are filled with the freshest, porcelain-white beansprouts and shiny purple and cream aubergines. The yeasty aroma of fermentation hangs in the air around the tempeh – blocks of soya bean protein that are one of Indonesia's greatest inventions.

Ladies in lace kabaya tops and faded batik sarongs sell fat bunches of Chinese greens and frilly fern tips. These are delicious blanched and tossed with spiced coconut. There might be an old wooden wardrobe spilling with different varieties of noodles. There will likely be a knife seller, each blade carved by hand, and other kitchen paraphernalia – coconut shell spoons, graters made from punched tin, volcanic stone mortars called *ulek*, floral enamel plates, woven plastic baskets for covering food and bamboo cones for steaming rice. Your senses are assaulted by bustling pathways, pungent scents, iridescent colours, gangly roots, baskets of live poultry and the chatter of enthusiastic bargaining.

It is at the market where days begin as people gather each morning to get the daily news and provisions. Everything is bought just in the quantity needed for that day, no more. Coffee is sold in sachets for one, individual spices are wrapped in twists of paper, vegetables are sold by the handful, meat and fish is prepared to order.

Rice forms the centre of every meal in most of Indonesia – it is said that if you haven't eaten rice then you haven't eaten. At its simplest, it will be bolstered with dried fish or a vegetable in thin broth, lime juice, a slick of hot and tangy sambal, and crisp-fried shallots or a cracker of some sort (as crunch is key).

Celebratory meals contain a tantalising array of different foods for everyone to help themselves to. There will be the wetter dishes: vegetable and fish stews with

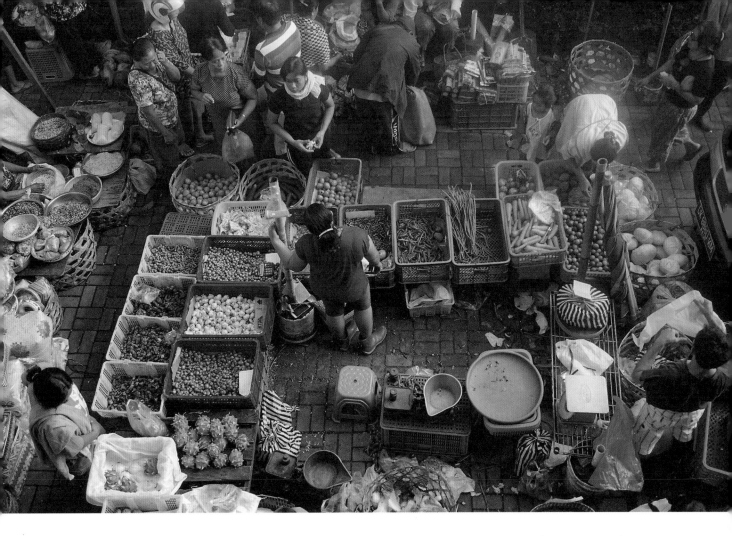

sauces to sop into the rice, creamy coconut milk curries, and fragrant meat broths brightened with lime juice. There will also be drier counterparts, more substantial in flavour and protein. Perhaps rich coconut-infused meat, unctuous braises, barbecued sate, steamed parcels of fish or stir-fried noodles threaded with vegetables. If you are lucky there will be tempting accompaniments too: a scatter of red-skin peanuts, spiced coconut sprinkles, sticky fried tempeh and pickled vegetables. Don't forget the chilli sambal: the spicy crescendo to every meal.

At big shared feasts, foods are chosen for their contrasting flavours and textures, and if guests are present there will be more than can possibly be eaten as a mark of hospitality. The Sundanese of West Java have a particularly spectacular way of feasting, sitting together on the floor around giant palm leaves spread with edible delights. Food is scooped up deftly between the fingers of the right hand – I've heard it said the steely coolness of the fork in your mouth disrupts the toasty

warmth of spices. It also helps slow mealtime down to almost an act of meditation.

Quietness when eating is something I've noticed across Indonesia. Even when eating together, conversation often pauses so you can focus on the food. On days without ceremony, members of a family will help themselves at a point they feel hungry rather than at set mealtimes. Food is cooked freshly each morning then left out at room temperature, under woven baskets. It is quite usual for people to eat alone sitting in a quiet corner, so they can appreciate every mouthful without the distraction of conversation.

Enak is the word for delicious in Bahasa Indonesia. It goes beyond simply taste to the pleasure felt by all the senses. The scent of lime blossom can be enak, or the firm stroke of a massage, or the ripple of gamelan music. Food is enak for its aroma, colours, texture and flavour and each of these is given full attention both in cooking and in eating.

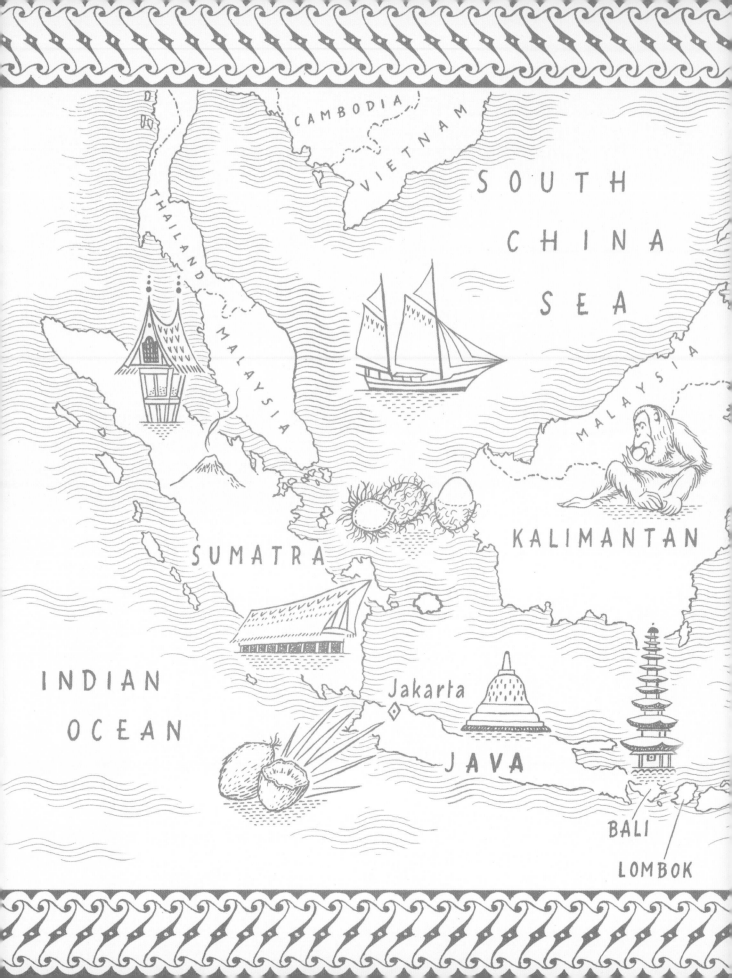

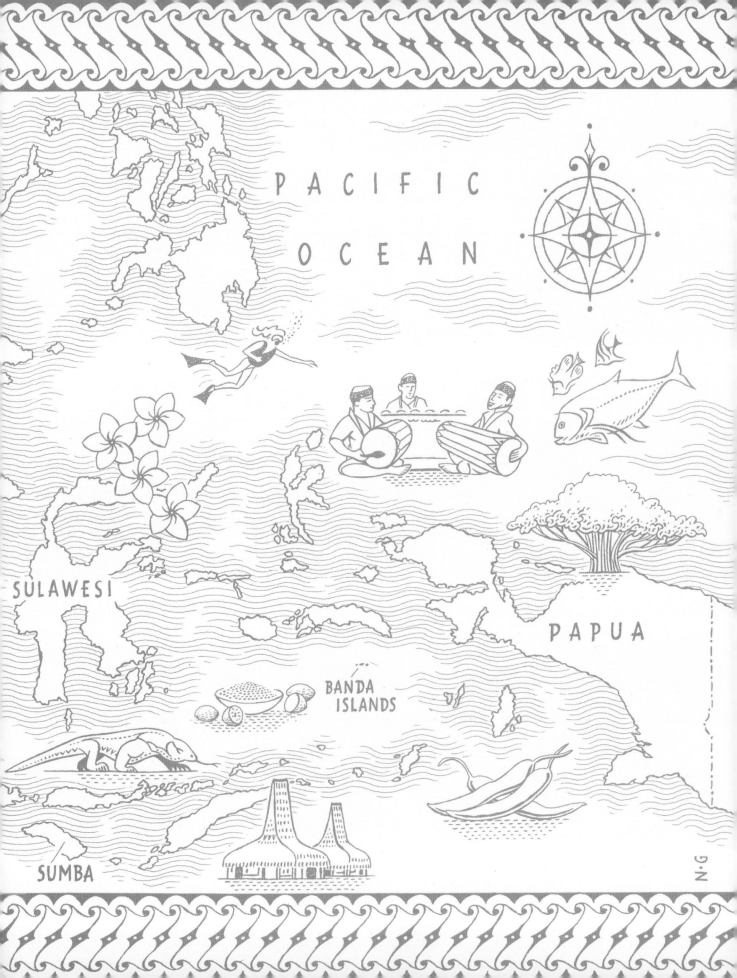

PACIFIC

OCEAN

SULAWESI

PAPUA

BANDA
ISLANDS

SUMBA

N·G

A CULINARY *journey*
through the ARCHIPELAGO

Sumatra

The steamy rainforests of Indonesia's most westerly island are the only place where orangutans, rhinos, tigers and elephants coexist. Yet despite the wildness of this island (one of the world's largest), Sumatrans have long been outward-looking. Aceh, on the northern tip, was once the capital of a spice empire, a buzzing hub for Indian and Arab traders. It was here that Islam first took root and you can taste the legacy of the spice trade in the food. There are blends of cinnamon, nutmeg, cloves, fennel seed and star anise. Or maybe you'll be entranced by even more exotic ingredients including salty bonito, turmeric leaves, a numbing version of Sichuan pepper and marijuana, used to give food an earthy buzz. Try the Sumatran lamb korma for a taste of the exotic complexities of Aceh cooking (without the narcotic hit).

The Minangkabau people of west Sumatra build curved rooftops shaped like the horns of their treasured water buffalos. They have developed a sophisticated cuisine that has travelled afar to become Indonesia's most popular. No town in the archipelago is without a Padang restaurant, named for the region's largest city. They serve delectable dishes, rich with coconut and scented with kaffir lime. The crowning glory is rendang, beef or buffalo that is slow-cooked until caramelised and infused with chilli, lemongrass, turmeric and ginger.

Java

A land of volcanoes, steep rice terraces, shadow puppets and tiered temples. Java is the centre of Indonesian politics, economy and culture; and home to more than half the populace. Traditionally Java has been an interior agricultural society, not swayed by external influences. The things that have been adopted, such as Islam, have been modified by long-held local customs. Fresh spices, palm sugar and shrimp paste sing from the food in a similar palate to Thailand.

It is said that as you move West to East, proclivities change from sour to sweet to savoury tastes. West Java has an affinity with neighbouring Sumatra and the food combines Javanese sophistication and lightness with Sumatran abundance. There is delicate spicing and fresh vegetables often served raw. The capital, Jakarta, is a heaving megatropolis of every culture and so the food

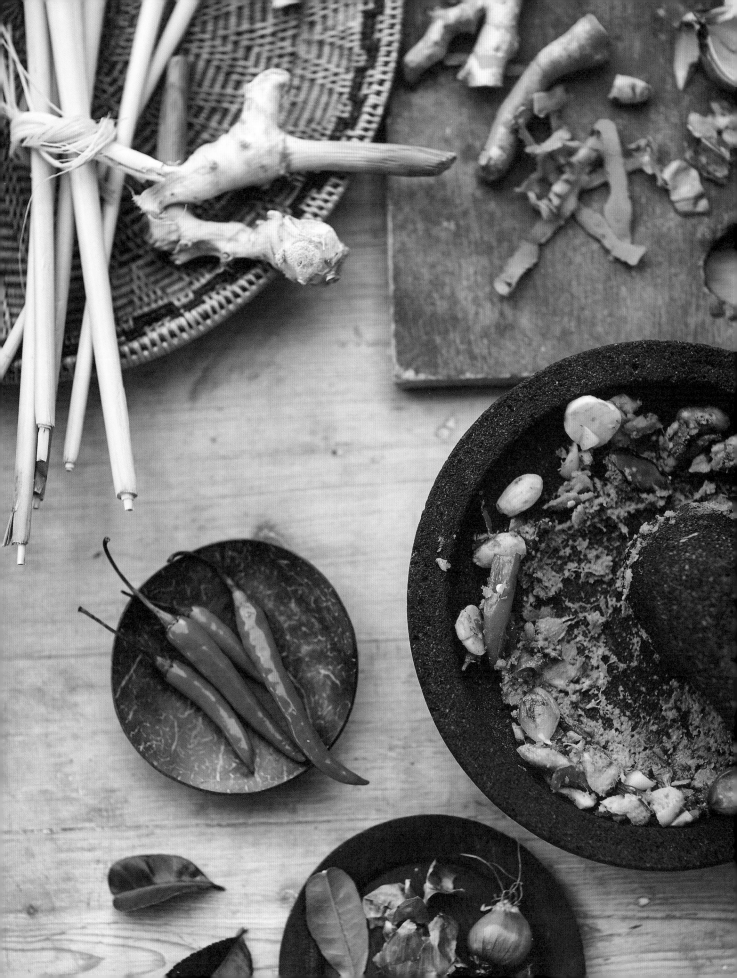

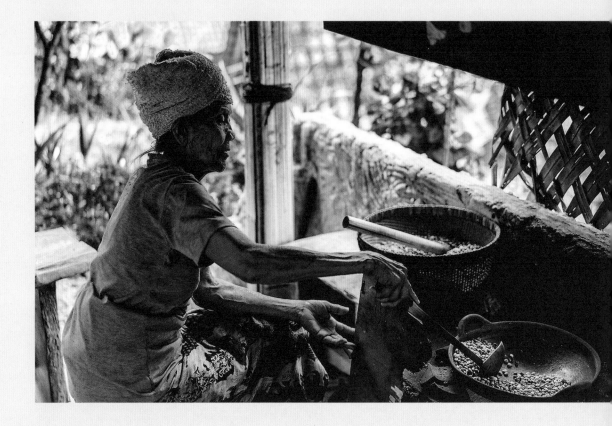

has taken its own identity, intensified in all flavours. A dish that typifies the passion for sour is *asinan*, a moreish pickled vegetable salad swathed in peanut sauce.

In the batik-making heartlands of Central Java, royalty is key to society. The spectacular temples of Buddhist Borobodour and Hindu Prambanan are remnants of powerful empires. Today the sultan's courts of Yogyakarta and Solo still hold sway in these traditional societies with regal splendour. To match the refined culture of dances, gamelan and handicrafts, the food is subtle and delicate. There are cones of turmeric-tinted rice, chicken in coconut milk and sweet coconut salads lightened with lemon basil. Sugar is pervasive (a controversial legacy from colonial sugarcane production), reaching its heights in *gudeg* – sugary-sweet jackfruit.

Head east through volcanic landscape and the food gets more dramatic too. Like neighbouring Bali, there is a taste for spiced food with big flavours. With a maritime culture, seafood is widely eaten – try fish grilled in banana leaf, releasing the scent of basil and lemongrass as you open. The island of Madura, linked to the mainland by a sea bridge, is famous for its food. Its chicken sate and soto ayam (chicken soup) deserve to be famous worldwide.

Bali

Tourists are drawn to Bali, whether for surf, parties or the self-discovery bucket list. However, it's not hard to see through to the artistic culture at the centre of daily life. The Balinese follow a unique form of Hinduism where duties to ceremony and community take precedence. Beautifully crafted daily offerings of flowers, food and incense scatter the streets, houses and temples. Feasts prepared by the men for religious ceremonies are more elaborate than daily food, but both have complex spice pastes singing with symbolism and flavour. Don't miss *babi guling*, suckling pig steamed by hot stones in an earth oven, or green bean *lawar* with its coconut dressing.

Sulawesi

There is a cultural connection between the Minihasan people of north Sulawesi and the Philippines island of Mindanao. Both use lots of ginger, lemongrass, lemon basil and, most of all, chillies. Dishes have more than a lick of fire, with chilli pastes used in one-to-one ratio with the quantity of meat or seafood. *Rica rica* is the hallmark cooking style – try with clams or ribs. There is also a Portuguese/Dutch influence and if you visit you'll want to seek out a bakery for coffee and European-style pastries.

Kalimantan

The Indonesian part of the jungle-tangled island of Borneo is known as Kalimantan. This is a place for exploration and adventures. Stay in a Dayak longhouse on the bank of a rainforest river, see orangutans in the wild, eat vegetables cooked inside a bamboo stem over an open fire. Or, in the towns, try food heavily influenced by Chinese cuisine. The floating markets on the south of the island are a magical sight with women in headscarves loading baskets of vegetables and dried fish onto their canoes to sell on the waterways at sunrise.

Eastern Islands

Spreading eastwards from the Wallace Line that divides Asia and Australasia lie chains of islands, some jungle green, others toasted earth savannas. Between their borders of white sand are the world's best diving sites and almost unbelievable wonders, from the dragons of Komodo and straw skyscrapers of Sumba to the pink sand beaches on Lombok and technicolour volcanic lakes on Flores. At the far east are the tribal lands of Papua, where sweet potatoes make up seventy percent of the diet. Indeed, in many eastern islands the national staple of rice is replaced by roots and corn.

The Banda Sea is strewn with small islands, each with their own charms and history, with the island of Run, once traded for Manhattan, the most storied of them all. These, you see, were the original Spice Islands and the focus of a ferocious race to control the spice trade. It was here Columbus was seeking when he found America. In 1677 the British and Dutch held claims on each other's islands on opposite sides of the Earth, and made an exchange. The Dutch gained control of Run, the Brits got New Amsterdam, which they renamed New York.

Today the scent of cloves still blows on the wind. Whilst cracked whole nutmegs from towering evergreen trees are used in the cooking, more delicate seafood preparations are favoured. The freshest fish are grilled over smoky coals, perhaps with a simple tamarind glaze.

HOUSEKEEPING

In this collection I have chosen and adapted recipes for home cooking, the food millions of Indonesian women (and it is mainly still women) get up before dawn to make daily for their families. Chefs and home cooks across the archipelago generously welcomed me into their kitchens to share their secrets but I don't claim my recipes are entirely authentic – I've written them to work in my London kitchen with ingredients I can source here. I rely too heavily on weights and measures rather than instinct inherited from generations of cooks. Indeed, I have never met an Indonesian cook who follows a recipe. I am an Englishwoman who has lived in Indonesia and loves the food – it has inspired and influenced how we eat in our family. This is my way of bringing the flavours of a country I love home with me, edible souvenirs I can relish and share.

Spice pastes called bumbu form the foundation of most of the recipes. Don't be daunted by long ingredient lists – these are simple to make using fresh aromatics that are widely available: garlic, shallots, ginger, chillies, lemongrass, lime leaves.

There are five key store-cupboard ingredients I recommend sourcing from an Asian supermarket before starting your culinary adventure: kecap manis, a treacly soy sauce that adds depth of flavour and sweetness; Indonesian palm sugar (*gula jawa*), which is teak brown with a wonderful smoky, toffeed yet also savoury edge; tamarind paste for a sour tang that brightens other flavours; shrimp paste, a fermented unguent that gives background notes of umami and salt; and crisp-fried shallots, sold in plastic tubs for finishing any dish with their sweet-savoury crunch. Fuller ingredient glossaries are dotted through the book (see Contents page 5).

Specifying serving sizes is a little tricky (I have often given a range) as one dish doesn't typically take centre stage. Rather an Indonesian table will have many components, often four to five dishes, with rice at the centre. As the food is served at room temperature it is perfect for making in advance. There are menu ideas at the bottom of most recipes, but the trick to balancing a meal is to choose dishes from different chapters, so varying richness and texture. When cooking for extra people, I suggest more dishes rather than scaling up. I also tend to make more than I think we'll eat as the food lends itself to leftovers, revitalised the next day with fresh vegetables and fiery chilli sambal.

BALANCING *a* MEAL

Just as we seek flavour balance in dishes, a meal should have balance as a whole. To help you create Indonesian menus, I have organised the recipes based on texture and flavour. For a daily meal I would serve rice with two 'main' dishes chosen from different chapters and at least two accompaniments, such as a sambal, pickle or something crunchy. One main might be wetter or a stir-fry, complementing a richer, drier or more substantial one.

Tangy pickles pair well with creamy coconut milk curries or chilli-rich stir-fries. Crunchy counterparts and complex flavours add interest to lighter, brothy dishes. Choose intense, twice-fried chilli sambals for stir-fries, and thinner, tangy sambals for grilled fish and meats. For a more elaborate meal (see overleaf), select a range of dishes, each with a different main ingredient, textures and flavours, but limit yourself to one or two that need last-minute assembly. Not everything needs to be home cooked – make a spread for people to help themselves to by adding rice crackers, *emping (melinjo* nut chips), fried peanuts mixed with baby dried fish, cucumber slices, lime wedges and little dishes of sliced chillies for those who like heat to nibble cautiously on throughout the meal.

There are suggested dish pairings at the bottom of most recipes. Here are a few menus for inspiration.

An introduction to Indonesian cuisine

Chicken sate with Peanut sauce
 (pages 42 and 179)
Blackened snapper with colo
 colo sambal (page 95)
Beef rendang (page 52)
Yellow coconut rice (page 159)
Sweet coconut & basil salad
 (page 135)
Water spinach with roasted
 tomato sambal (page 149)
Black rice pudding with
 salted coconut cream (page 212)

Drink: Sweet tamarind jamu
 (page 224)

A vegetarian feast

Tofu or sweetcorn fritters
 (pages 37 and 40)
Martabak (page 47)
Snake beans with coconut milk
 (page 121)
Sweet & spicy mushroom tongseng
 (page 73)
Aubergine with shrimp paste
 (omitting shrimp paste!) (page 101)
Tempeh with red chilli & palm sugar
 (page 185)
Acar pickles (page 191)
Sambal of your choice (pages 175–8)
Perfect steamed rice (page 156)
Chocolate & lemongrass ice cream
 (page 199)

Drink: Cucumber limeade (page 227)

One dish meals

Gado gado (page 136)
Laksa (page 127)
Mie goreng (page 169)
Nasi goreng (page 160)
Pickled salad with sour
 peanut dressing (page 146)
Rubber noodles with chicken
 (page 167)
Shredded chicken salad
 with lemongrass & lime
 (page 145)
Soto ayam (page 123)
Vegetable urap with fresh
 spiced coconut (page 132)

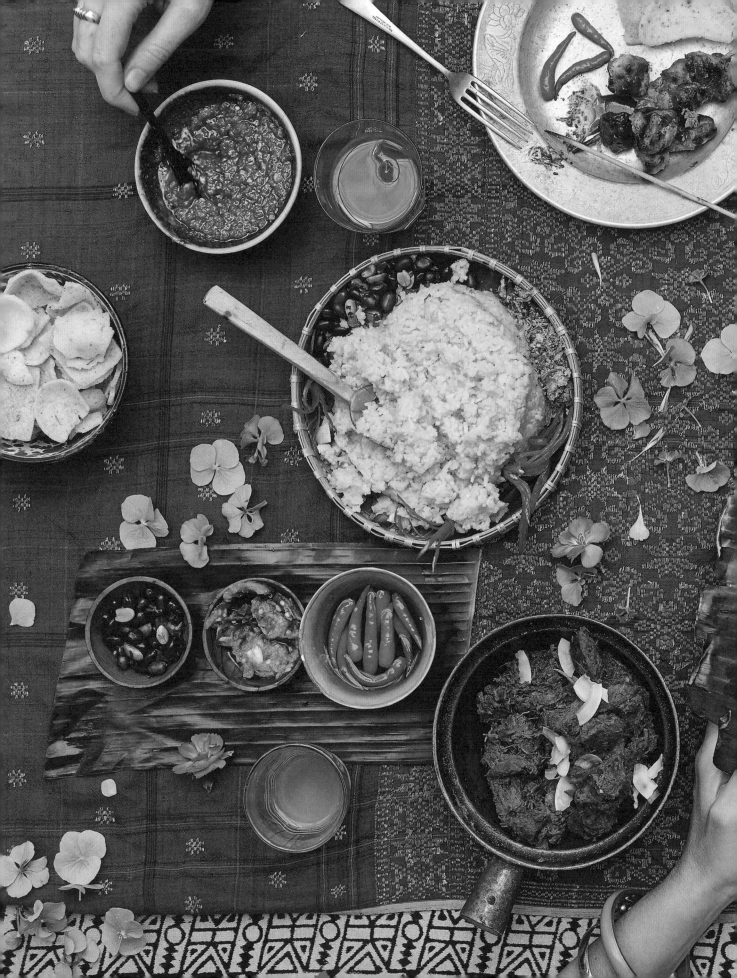

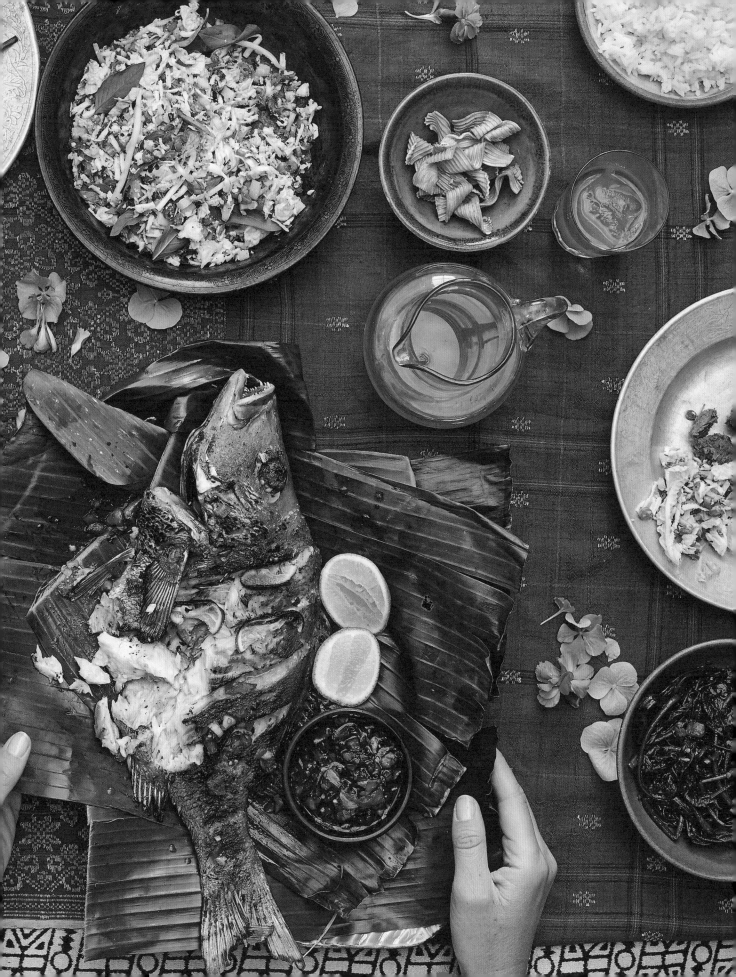

An
INDONESIAN
Kitchen

Indonesian kitchens tend to be functional rather than beautiful as they are not at the heart of the home. Traditionally there is a small building set apart from the living area because wood-fired stoves billow and fill any space with smoke. I have been in plenty of soot-blackened bamboo and straw kitchens and have squatted with cooks on the separate terrace outside to prepare ingredients. I have also joined cooks in gleaming modern kitchens, some where we have spurned the work surfaces to spread out the food to chop on the floor instead. As Indonesian cooking is so tactile, with touch, taste, smell and intuition replacing weights and measures, it somehow feels right to be surrounded by your ingredients.

There are few items of equipment needed in an Indonesian kitchen. Something to grind or crush ingredients is key. Typically, this is a flat-bowled mortar called an ulek. Made of volcanic stone, the rough surface helps break down spices as a pestle is rocked back and forth over them. A food processor is just as commonly used today, but never without concession that the old method is superior. Fat cross sections of tree trunk make chopping boards used with a weighty cleaver. Spoons are coconut shells on bamboo handles. Graters are punched from tin. Conical rice steaming baskets are woven from rattan and banana leaves used as a natural food wrapping. Then there will be pans and often a wok, which uses less oil for deep-frying and adds flavour in stir-frying.

IT *starts with* BUMBU

The bass note to almost every Indonesian recipe is a spice paste called bumbu. This gives depth and resonance with a combination of heat, pungency, sharpness and spice. Candlenuts are often added, which give body.

Start by finely slicing fibrous lemongrass and galangal and roughly chopping everything else. A shallow bowl mortar made of volcanic stone, an ulek, is the traditional way to grind the spices. Begin with the fibrous ingredients and whole dried spices, next the softer ginger and chilli, followed by candlenuts, then the shallots and garlic and finally the shrimp paste, palm sugar and tamarind. Use the arced pestle to briefly bash the ingredients as they go in, then start grinding in a back and forth rocking motion, rather than pounding. Skilled hands can make a paste in minutes, but it takes practice.

An alternative, and one I usually favour for ease and speed, is a high-speed blender or food processor. You may need to add a little oil, water or coconut milk to help the blades do their work. Every cook I met in Indonesia, whether they chose to use a food processor or not, told me that the ulek gives superior results. This is perhaps because the grinding, as opposed to finer and finer chopping of the food processor, extracts more flavour. I have to say I can't taste a difference as long as you don't make the bumbu too watery and don't blend to uniform smoothness – texture and flecks of chilli red are good.

The bumbu is usually fried before the next steps of the recipe. This should be done in plenty of oil to unlock the flavours. You want to get the fragrance of the spices, not caramelise them. The paste is ready when it smells 'enak' (delicious), the oil begins to separate from the spices and the paste has darkened by just a shade.

I like to make a bumbu for each recipe I am making – it doesn't take long and you get more variety. However, some savvy cooks prefer to have a master bumbu ready that they can add to many dishes, adjusting the flavours at the end with final flourishes. It is a useful standby to fill an ice-cube tray with and store in the freezer, ready to pop one or two out to add to your cooking.

Master bumbu

200 g (7 oz) red Asian shallots, peeled
100 g (3½ oz) garlic cloves, peeled
150 g (5½ oz) large red chillies, seeded
90 g (3 oz) turmeric, peeled
50 g (2 oz) kencur, peeled
35 g (1¼ oz) galangal, skin scrubbed
35 g (1¼ oz) ginger, peeled
40 g (1½ oz) candlenuts or blanched almonds
1 tablespoon shrimp paste, toasted (see page 189)
1 tablespoon coriander seeds
2 teaspoons black peppercorns
75 ml (⅓ cup) oil
1 lemongrass stick, bruised
2 salam leaves (optional)

Roughly chop the first seven ingredients and add to a high-speed blender or food processor with the candlenuts, shrimp paste and dried spices (not the lemongrass or salam leaves). Blend to a paste, add 100 ml (scant ½ cup) water and blend again.

Heat the oil in a large pan and add the spice paste, lemongrass and salam leaves. Cook over a medium heat until the water has evaporated, the oil is separating from the spices and the paste smells beautifully fragrant. With a quantity this large, this can take half an hour or more. Portion into ice-cube trays and freeze for future use.

CRUNCHY SNACKS & STREET FOOD

Chapter One

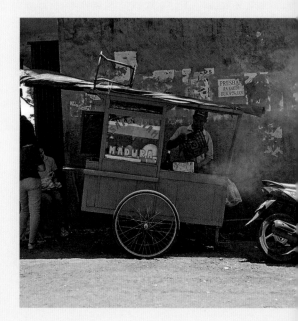

The
KAKI LIMA
Cacophony

You'll hear the clacks, trings and chimes of food vendors before you see them. As they roam the streets with crunchy snacks and street food, a mobile orchestra is created advertising their wares. The rujak seller sounds a low horn, chicken noodles are called with a reverberating tap of bamboo whilst a clang of the wok means a nasi goreng cart is near. Customers are lured out by bicycle bells, clanking spoons and drawling songs through loud speakers.

Kaki lima, meaning 'five feet', is the name given to the painted wooden food carts – the three wheels of the cart and two of the vendor make five. There is usually a supporting cast of oversized sauce bottles on rattling glass shelves: amber, deep brown, cloudy and clear, the secret unguents and potions to the signature recipe. There are also simple bicycle *warungs* and edible treats carried roadside in woven plastic baskets to tempt drivers at traffic lights. These ambulant vendors and roving restaurants gather on beaches at sunset, outside mosques and temples and at swarming night markets.

Maybe you'll choose soft *bubur* rice porridge or crisp squares of *martabak* pancakes with a curried filling. Sate is charred over smoking coconut embers and slathered with peanut sauce, whilst grilled sweetcorn drips with chilli butter. *Bakso* noodles are cooked to order on kerosene burners and tipped into small plastic bags with meatballs and hot broth to take away. Gado gado is assembled from baskets of vegetables, then wrapped in palm leaves, ready to open into a disposable plate.

Snacks are eaten around the clock wherever people come together – at big ceremonies and cockfights to small village gatherings beneath the banyan tree. They make up about a third of daily food in Indonesia. However, even if full from snacking, locals will claim they haven't yet eaten as a meal is not a meal unless it has rice.

Crunchy vegetables with sour spice dipping sauce

50 g (¼ cup) dark palm sugar (gula jawa)
1 large red chilli
3 tablespoons tamarind paste
sticks of crunchy vegetables
 and fruit, to serve

Falling between 'good morning' and 'good afternoon', there is a special greeting for the brightest hours of the day: *selamat siang*. When the sun is high in the sky, a snack of crunchy fruit or vegetable sticks with this thick, glossy *rujak* dressing awakens the senses and gives energy when you are starting to fade. So addictively good is it that you shouldn't wait for tropical heat. With four simple elements, it comes together in minutes and is a masterclass in balancing hot with sour, sweet with salt – a technique essential to Indonesian cookery. Start a meal with this and your guests will be enraptured.

Thinly shave the palm sugar with a knife and put into a small saucepan with 75 ml (⅓ cup) water. Heat gently to first melt the sugar, then turn up the heat to medium and bubble for about 5 minutes to get a dark syrup – watch it carefully towards the end or it can quickly turn to toffee (if this happens you can always rewarm with a little extra water to get a pourable syrup). Leave to cool.

Remove half the chilli seeds and membrane and set aside in case you want to add some more heat later. Roughly chop the chilli and use a pestle and mortar to crush with the remaining seeds and a generous pinch of salt into a rough paste. Mix in the palm sugar syrup and tamarind.

Taste with a vegetable stick – you want the flavours to balance and tamarind pastes vary in strength. Adjust each element a little at a time until you find perfect harmony.

Serve with a platter of vegetable and fruit sticks to sweep through the dark puddle of sauce as you eat.

Note
Choose fruits and vegetables that are a little sharp and crunchy. I like a simple pairing of daikon sticks and green apple wedges. You could also try cucumber, carrots, green mango, jicama, starfruit, pomelo or pineapple.

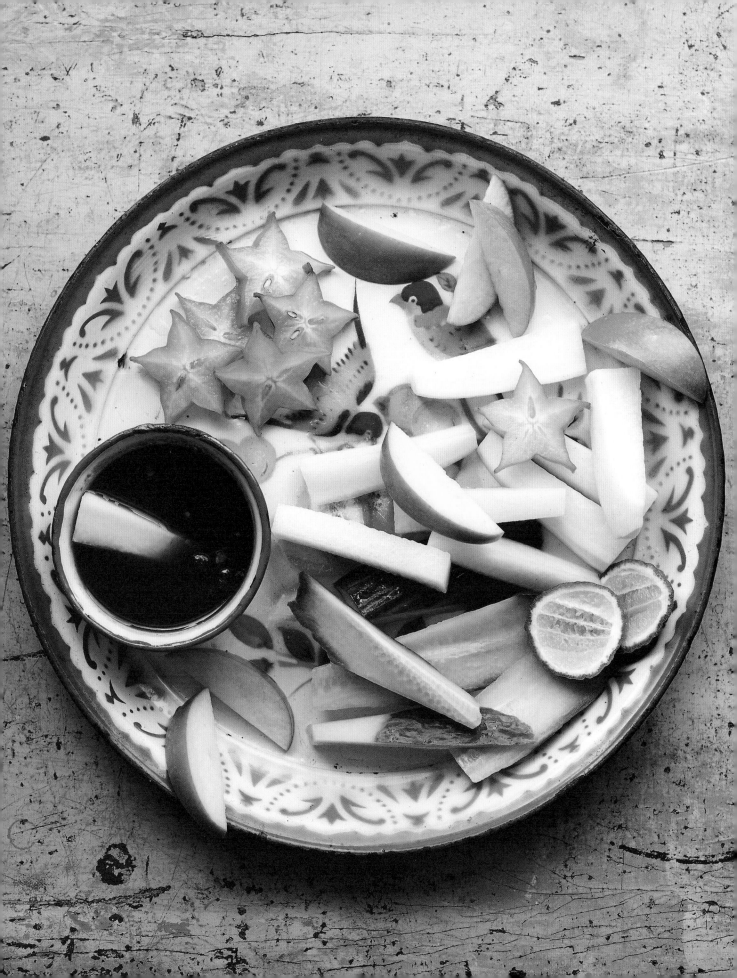

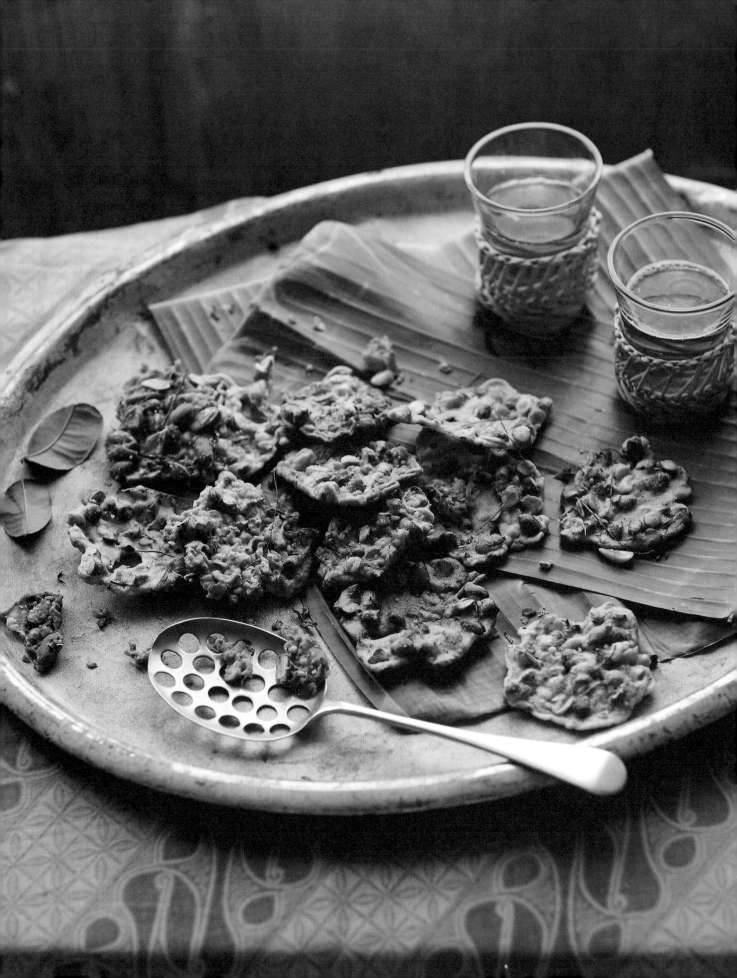

Peanut & lime leaf crackers

Makes 10–15 crackers

75 g (½ cup) raw skin-on peanuts
1 garlic clove
1 candlenut or 2 blanched almonds
1 teaspoon coriander seeds
½ teaspoon salt
60 g (⅓ cup) rice flour
½ teaspoon crushed black peppercorns
2 lime leaves, deveined and
 finely shredded
oil, for deep-frying

Shatteringly crisp, nutty, salty, a fragrant citrus hit from coriander seed and lime leaves, and the lingering warmth of black pepper. This is everything you could hope for in a snack. *Kaki lima* vendors will deftly ladle batter straight into a vat of oil, expertly letting it slide down the edges to set, then shuffling it into the bubbling centre for a final crisping. I go for the foolproof method of cooking on the base of a frying pan.

Chop the raw peanuts in half – a bit of a fiddle but it helps the batter hold them better.

In a pestle and mortar, pound the garlic, candlenut or almonds, coriander seeds and salt to a paste. Mix with the rice flour and gradually add 100 ml (scant ½ cup) water, whisking as you go to make a very thin batter. Sprinkle in the peanuts, black pepper and lime leaves.

Heat 3 cm (1¼ inches) of oil in a frying pan over a medium heat. When hot enough for bubbles to form around the handle of a wooden spoon, swirl in tablespoons of the batter, making round discs and trying to spread the lime leaves and peanuts among each. They will rise towards the surface when ready to turn. Flip, colour the bases and flip again for a final crisping. Remove when crisp and light golden. Leave to drain on paper towels whilst you fry the rest.

Store in an airtight container for up to 2 weeks.

Coconut & lime leaf omelette

Serves 2

3 duck eggs or large eggs
65 g (2 oz) grated fresh or
 rehydrated coconut
3 small red Asian shallots, finely sliced
1 garlic clove, finely sliced
½ large red chilli, seeded and sliced
1 lime leaf, deveined and finely shredded
1 tablespoon oil, for frying

All right, bear with me – I know this sounds like an extraordinary combination, but do try it. The coconut gives body and a little sweetness, there is delicate fragrance from the lime leaves and using duck eggs will make your omelette rich and golden. End the subtlety by serving with a fiery Red chilli sambal (page 175). The perfect breakfast or light lunch.

Beat the eggs with the coconut and all the aromatics. Season generously with salt and pepper.

Heat the oil in a small frying pan over a medium-high heat, swirling to coat the base and sides. Pour in the omelette mixture and encourage it into a circle. Cook until the underside is golden and the edges well set. Carefully turn, lower the heat a little and cook until the omelette is set with the faintest wobble and the edges are crisp.

Serve at room temperature, cut in wedges with a spicy sambal.

Note
Make an omelette including a handful of leftover brown or white rice and red ribbons of chilli, as they do in Java. Serve with a generous scattering of Spicy coconut flakes (page 182).

Disco nuts

5 garlic cloves, peeled
2–4 bird's eye chillies, roughly chopped
10 lime leaves, deveined and torn
1 generous teaspoon salt
1 large egg white
40 g (scant ¼ cup) sugar
250 g (1¾ cups) roasted peanuts
225 g (1½ cups) plain flour
1 teaspoon baking powder
oil, for deep-frying

Whenever we visit a roadside *warung* my son Otto rushes to pore through the baskets filled with locally made crunchy snacks. Once he returned jubilantly with a sachet of spice-crusted peanuts with aromatic shards of fried lime leaves. There was no looking back; these are the most addictive snack ever. That they are sometimes called disco nuts doubles the joy!

Using a pestle and mortar, pound together the garlic, chillies, lime leaves and salt – the leaves will stay in large pieces.

In a large bowl whisk the egg white until frothy. Whisk in the sugar, then the pounded spices.

Add the peanuts, turning them in the egg white, then dust over the flour and baking powder. Stir until just coated, adding 3–4 tablespoons water to help the batter bind to the nuts. Break up any large clumps.

Heat 5 cm (2 inches) of oil until hot enough for bubbles to form around the handle of a wooden spoon. Add the nuts in two or three batches and fry until crisp and deep golden. Stir regularly as they fry, again breaking up clumps. Don't worry if nuts float free from the batter – these are good too. Remove with a slotted spoon and drain on paper towels. Cool completely before eating and store in an airtight jar for up to 4 weeks.

Note
Tumble over salads, both the nuts themselves and any crumbs of crisped batter, for an umami-rific crunch. If I have disco nuts on hand (and I usually try to) I add them to the Pickled salad with sour peanut dressing (page 146) in place of the fried peanuts. The combination is electrifying.

I.F.C.

Serves 4

4 chicken legs, skin on
700 ml (scant 3 cups) coconut water
 (1 large young coconut)
3 small red Asian shallots,
 roughly chopped
3 garlic cloves, roughly chopped
3 cm (1¼ inches) ginger, skin scrubbed,
 roughly chopped
1 teaspoon coriander seeds
1 teaspoon salt
2 tablespoons plain flour
oil, for deep-frying

Indonesian Fried Chicken is the fast food of choice. There are as many variants as there are islands in the archipelago, but to my mind this cult version from Yogyakarta is the ultimate. Chicken legs are poached in spice-scented coconut water, which both flavours and tenderises the meat. The final frying gives a crunchy golden crust.

Marinate the chicken in the coconut water, all the aromatics and salt for a couple of hours in the fridge.

Transfer everything to a pan. The chicken should be fully covered with liquid, so top up with water if needed. Cover and bring to a rolling boil. Turn off the heat and leave the pan covered for the chicken to cool slowly in the broth. After 50 minutes the meat should be cooked through and tender. Strain the boiling liquid and use for soup – the flavour is fantastic.

Dry the chicken legs well and keep in the fridge until you are ready to eat. Season the flour with salt and pepper and use to give the chicken legs a dusty coating.

Heat oil for deep-frying in a large pan or wok. When it reaches 170°C (325°F) or bubbles form around a spoon handle, add the chicken. Fry until golden brown.

Menu ideas
I like the Balinese pairing for fried chicken – a salad made from cucumber, thinly sliced raw Thai aubergine (eggplant) and lemon basil leaves. Squeeze over lime juice and you have the perfect fresh contrast to the crisp, oily meat. You'll want the Sweet tomato sambal (page 176) too as it beats ketchup hands down.

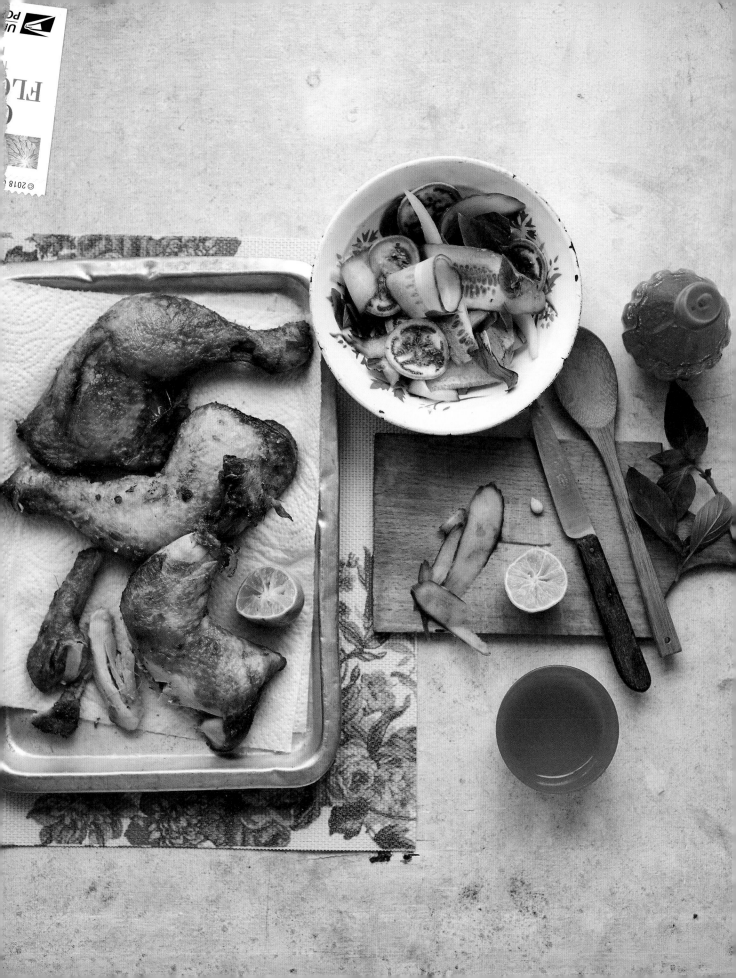

Beef & coconut patties

Serves 2, or 4 as small bites

250 g (9 oz) minced beef
125 g (4½ oz) finely grated fresh or
 rehydrated coconut
1 egg, lightly beaten
2 garlic cloves, crushed
1 teaspoon coriander seeds, crushed
½ teaspoon ground black pepper
½ teaspoon salt
¼ teaspoon ground cumin
oil, for cooking

These baby burgers, made bouncy and light by the addition of coconut, are the quickest way to transport yourself to the tropics. Serve as a snack with a peanut dipping sauce (page 179), or turn them into a meal with some steamed rice, pickled cucumbers, chilli sambal and a generous scattering of crisp-fried shallots.

Use your hands to scrunch and mix all the ingredients except for the oil together in a large bowl. Squadge into small, flat patties, about 2 cm (¾ inch) thick. Pat each with a little oil on both sides, then put in the fridge to firm up for at least an hour.

Heat a frying pan or griddle over a high heat and let it get really hot (or, of course, these are perfect for a barbecue). Cook the patties for about 3 minutes per side or until cooked to your liking. They should still be juicy and tender inside.

Tofu fritters

Makes about 22 fritters

600 g (1 lb 5 oz) firm tofu, drained
2 lime leaves, deveined and very
 finely chopped
1 spring onion (scallion), finely sliced
1 tablespoon chopped Chinese
 celery leaves
4 eggs, beaten
oil, for deep-frying

Bumbu spice paste
½ teaspoon coriander seeds
5 garlic cloves, peeled
3 small red Asian shallots, peeled
1 large red chilli, seeded
1 cm (½ inch) ginger, peeled
1 cm (½ inch) turmeric, peeled,
 or ¼ teaspoon ground turmeric
3 candlenuts or 6 blanched almonds
1 teaspoon salt
½ teaspoon sugar

'Strong arms are the secret for good food,' Nyoman tells me as she rhythmically grinds the spice paste for her famed *tahu perkedel.* 'And cooking from the heart.' You could forego the grinding and use a blender for this heady aromatic mix, but don't omit the care and love, a key component for these ethereally light, exceptionally delicious fritters.

Start by making the bumbu spice paste. Roughly chop all the fresh ingredients, then grind to a paste either with a pestle and mortar or in a food processor (with a just little water if needed to help the blades turn). Don't make it too smooth – some chilli flecks are good here.

Transfer the bumbu to a large bowl and add the tofu. Mash together with a fork. Add the lime leaves, spring onion, celery leaves and two of the eggs. Mix well to a scrambled egg texture.

Form the tofu into slightly squashed golf balls, working gently. You want them strong enough to hold together, but don't squeeze too hard, which will make them dense rather than fluffy.

Heat 3 cm (1¼ inches) oil in a frying pan until bubbles form around the handle of a spoon. Working quickly, dip each fritter first into the remaining beaten egg, then into the oil. Don't overcrowd the pan. Fry until crisp and golden all over. Drain on paper towels whilst you cook the rest.

Serve the crisp fritters with sambal and napkins.

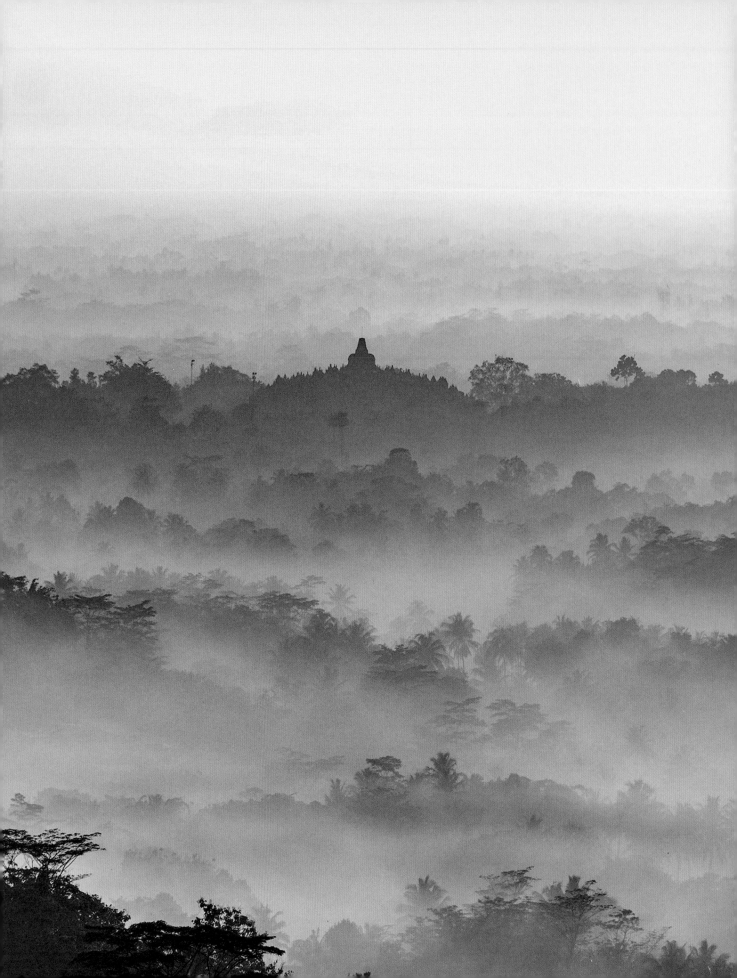

Ginger – *jahe*

Four related rhizomes (underground stems) – ginger, galangal, kencur and turmeric – are key components of bumbu spice pastes. The most familiar is ginger, but they each bring something a little different to the party. Ginger's job is to provide sweet warmth that can build to a spicy kick. All these recipes call for fresh rather than dried ginger. For spice pastes, peeling often isn't needed unless the ginger is very mature and the skin has toughened – just give it a good scrub and assess any parts that should be cut off.

Galangal – *laos*

The second key rhizome and a favourite for its lemony, woodsy, slightly piney flavour. Galangal looks very like ginger, but the skin is paler and ringed with brown concentric circles. Inside the flesh is creamy white and very hard, meaning it must be sliced rather than grated. Scrub clean, then either chop and grind into bumbu spice pastes or cut into slices and bruise with the heel of a knife to release the flavours before dropping into the pot, where it will magically work to heighten all the other flavours. Dried galangal has little merit, so buy fresh and store in the freezer where it will keep well. At a push, ginger can be used as a substitute, but the flavours will be different as the ginger will bring more heat and less sharpness.

Kencur

Also known as aromatic ginger or resurrection lily (and I am told it sometimes mistakenly goes by lesser galangal). This knobby rhizome is much smaller than ginger and galangal, with dark, reddish-brown skin and a pale, soft centre. It is a beloved ingredient in Bali and Java for its strong, camphor-like flavour. Peel and use sparingly. Omit if you can't get it as there is no real substitute.

Turmeric – *kunyit*

Glorious, golden turmeric will stain anything it touches, including your fingers. The fresh rhizome looks a little like ginger, but with thinner, nubby fingers and a golden tan to the skin. Inside the flesh is livid orange. Peel first, then chop the fibrous flesh before grating or grinding to a paste (wearing gloves is advised!). Ground turmeric can be easier to use and does a good job of imparting the colour and earthy muskiness, however it lacks the pepper-ginger notes of fresh turmeric. No matter as you will likely be adding other rhizomes anyway. When you do have fresh turmeric, try the health elixir Turmeric jamu (page 224).

Garlic – *bawang putih*

A crucial ingredient used in abundance to add depth to cooked spice pastes and raspy spice when used raw. Indonesian cloves tend to be milder, sweeter and fresher than those we can buy in the West, so they are used generously. Using old or harsh-tasting garlic, especially raw, will off balance a dish. Look for heads that are small and firm with no sprouts.

Shallot – *bawang merah*

Notice the similar name to garlic. The small shallots ubiquitous in Indonesia have coppery skin and pale pink insides, so are called 'red onions', whilst similar-sized garlic cloves are 'white onions'. The two are almost invariably used as a double act and a traditional fairy tale tells of red and white onion sisters, one good and one mischievous, balancing each other. It is shallots rather than onion that are usually used for their sweet, aromatic flavour. Look for small round shallots rather than the elongated European ones, though both these and indeed onion can be used as a substitute. Just keep size in mind – that one shallot in a recipe reckons on something about the size of a large garlic clove. Cut anything larger down to size accordingly.

Lemongrass – *serai*

Containing the same oils as lemon zest combined with a beguiling scent of its own, the flavour of lemongrass is the secret behind so much South East Asian food. The part we buy is usually just the base of the long reedy grass. There is nothing I enjoyed more in Indonesia than being able to pluck my own lemongrass stalks and lime leaves from my garden as I needed them. It is worth seeking out fresh rather than dried. Trim off the hard base and any coarse green top; if the outer layers are woody, remove these too. You will be left with the pearly white heart, streaked with lilac and pale green. Smash it with the base of your knife to release the flavours. Then either finely chop or grind into a bumbu (it does need to be sliced first as the food processor will have a hard job breaking the fibres down). Otherwise a useful Indonesian trick is to tie the whole bruised stalk into a knot and throw it into the simmering pot to perfume the food as it cooks, though if yours is too short to tie then just bruise and add whole. Don't worry unduly about removing it before serving – very often whole spices and aromatics are left in the dish. Whoever's plate it ends up on gets to suck it clean, extracting the last of the flavour.

Torch ginger – *kecombrang*

One of the most striking flowers in the world, torch ginger is also a delight in the kitchen. Growing straight up from the ground like flaming torches, the buds of unfurled waxy pink petals contain layers of flavour: spicy, floral and gingery. They can be finely sliced and added to salads and sambals. If you are lucky enough to get one, try in the Balinese lemongrass sambal (page 178).

Sweetcorn fritters

Makes 12–16 fritters

4 garlic cloves, peeled
½ teaspoon salt
200 g (7 oz) fresh sweetcorn
 (shaved from 1–2 cobs)
4 small red Asian shallots, finely sliced
small handful Chinese celery leaves,
 or white and greens of 2 spring
 onions (scallions), finely sliced
½ large red chilli, seeded and sliced
1 red bird's eye chilli, finely
 chopped (optional)
1 large egg
50 g (¼ cup) rice flour
oil, for frying

Vegetable fritters are a popular street food across Indonesia, something to ward off hunger until a proper meal (read that as one that contains rice – without which you are merely snacking). Fritters, particularly potato ones, are thought to be a Dutch colonial legacy derived from *frikadeller*. I love these sweetcorn *perkedel*: golden crisp, a little chewy and very garlicky.

Crush the garlic with the salt using a pestle and mortar. Add half the sweetcorn and grind to a rough paste.

Scrape into a bowl and stir in the remaining sweetcorn kernels and the aromatics. Season with black pepper. Stir in the egg and finally add the rice flour to bind the batter together.

Heat 1 cm (½ inch) oil in a frying pan until bubbles form around the handle of a wooden spoon. Drop in spoonfuls of the batter without overcrowding the pan. Fry until the undersides are very crisp and golden, then flip and fry the other sides. Drain on paper towels whilst you fry the rest.

Menu ideas
Bring out before dinner with Sweet tomato sambal (page 176). Or serve with Spice Islands tuna (page 92) and Acar pickles (page 191). If you'll forgive the inauthenticity, they are also rather wonderful with smashed avocado, lime juice and Red chilli sambal (page 175).

Sticky rice rolls

Makes 8 rolls

200 g (7 oz) sticky rice
200 ml (generous ¾ cup) light
 coconut milk
1 lemongrass stick, trimmed, bruised
 and tied in a knot
2 salam leaves (optional)
banana leaves, softened, and toothpicks,
 for wrapping (see page 233) (optional)

For the filling
½ quantity Caramelised Chicken
 Floss (page 181)
2 tablespoons coconut milk

Java's answer to sushi rice rolls, here a caramelised meat filling is encased in coconut-scented sticky rice. I like to use homemade chicken floss inside, but you could also use shop-bought *abon* (meat floss) or shred any cooked meat and mix with a little bumbu (page 23), a slick of coconut milk and palm sugar. These are a popular snack across Java, but a central region outside Yogyakarta takes their dedication further with an annual *lemper* day, when the whole village will cook and eat nothing else. In her accomplished book *Indonesian Regional Food & Cookery,* Sri Owen documents how they shape the rice rolls into every part of the human body, from those as large as a thigh to as small as a little finger. No human body part (she was assured) is forgotten.

Soak the rice in cold water for 1 hour. Drain.

Boil the rice in salted coconut milk with the lemongrass and salam leaves until all the liquid has been absorbed by the rice. Stir vigorously towards the end to help the stickiness develop. Transfer to a steamer pan or steamer basket and steam for 20 minutes. Remove from the pan and spread out on a plate to cool.

Moisten the chicken floss with a little coconut milk for the filling. Taste for seasoning.

Divide the rice and the filling into eight. Take one piece of rice in your hands and massage and press it together well – in Indonesia they call this making the rice strong (and enjoy the natural hand cream from the coconut oil!). Press the rice into a flat disc in your palm, sit the filling inside and shape the rice around it in a fat sausage. Repeat.

If you can't get hold of banana leaves, the rolls can be served just like this. Wrapping and heating the rolls will imbue them with a delicate herbal aroma. Wrap each into a tight banana leaf parcel and secure the ends with toothpicks. Heat a frying pan and dry-fry the rolls for just a short time on each side to warm and slightly char the leaves. Leave to cool before serving.

Menu ideas
These make a great meal for two alongside green vegetables, perhaps some Water spinach with roasted tomato sambal (page 149) or Vegetable urap with fresh spiced coconut (page 132), and a scattering of Wok-fried peanuts (page 180). Or serve as part of a larger meal with one roll per person.

Chicken sate

Makes 12 skewers

400 g (14 oz) skinless chicken breast
1 garlic clove, roughly chopped
1 tablespoon kecap manis
oil, for grilling
juice of ½ lime, to serve
Peanut sauce (page 179), warmed

The highlight of any Indonesian street food market is the sate, usually sold by someone from Madura where they are famed for their tasty skewers. The first sign is the glorious smoky smell from coconut husk coals, then you'll see the vendor busily twirling the sate and fanning the embers with practised hands. The sugar glaze makes flames jump and crackle as they cook, charring and caramelising the meat. These are a favourite with children – certainly with my children.

Cut the chicken into a 2–3 cm (1 inch) dice. Mix with the garlic, kecap manis and a pinch of salt. Set aside to marinate for 10 minutes (or if longer, cover and keep in the fridge).

If using bamboo skewers, soak in water to stop them burning whilst the meat marinates. Thread the chicken onto the skewers, keeping the pieces tightly packed together.

The best results are indisputably on a barbecue – add coconut fibres or wood chips for the wonderful smoky notes – but you could also grill or griddle on a high heat. When searing hot, brush your grill with a little oil and cook your sate over a direct heat (keeping the sticks away from the coals). Turn until browned on all sides and cooked through.

Spritz the lime juice over the sate and douse with the warm peanut sauce.

Menu ideas
Sate make ideal finger food for parties. Turn them into a meal by serving with Spice rice (page 163) and Acar pickles (page 191). For a lighter lunch, I love them with a Sweet coconut & basil salad (page 135).

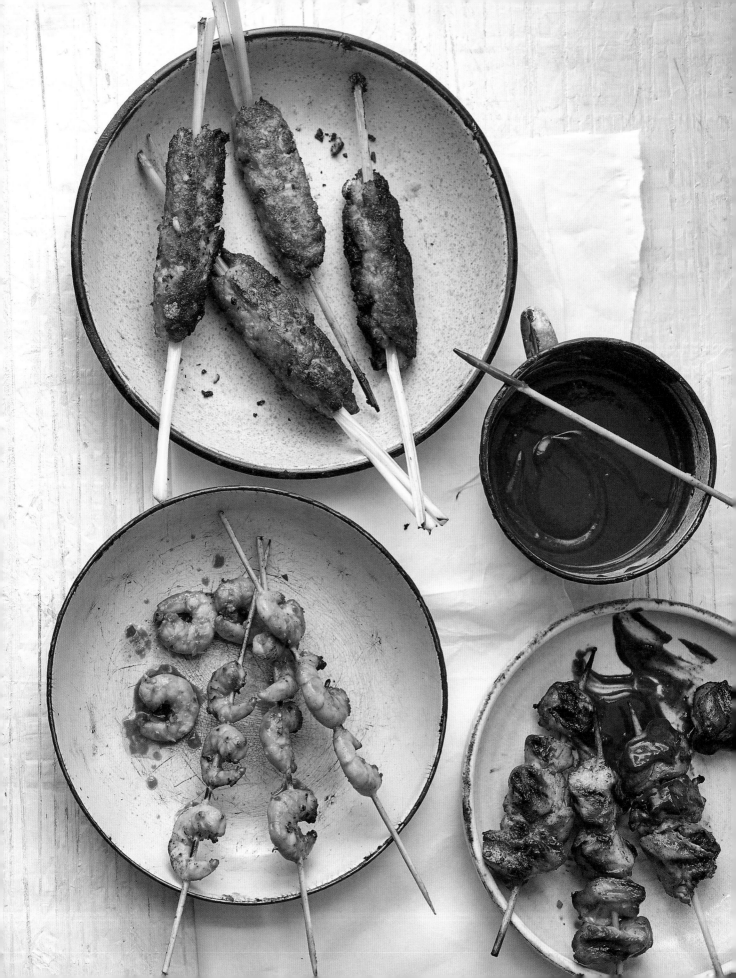

Glazed prawn sate

Makes 4 skewers

12 raw king prawns,
 peeled and deveined

Marinade
3 garlic cloves, crushed
1–2 bird's eye chillies, seeded
 to taste and chopped
2 tablespoons light soy sauce
2 tablespoons lime juice
1 tablespoon oil
1 teaspoon dark palm sugar
 (gula jawa), shaved
½ teaspoon shrimp paste

A sticky soy glaze makes these prawns impossible to resist. They cook on a hot griddle in minutes, but the very best sate are seared over glowing hot charcoals for added smoke in the mix of salty, sour, sweet heat.

Mix together all the ingredients to make the marinade. Toss the prawns in it and chill in the fridge for half an hour.

If you are using bamboo skewers, soak in water to stop them burning.

Thread three prawns onto each skewer, saving the excess marinade. Grill over a hot griddle or barbecue, turning once or twice, and brush with the marinade as you go. Just 2–3 minutes should do it, until they are opaquely pink and delicately cooked – you want the flesh to stay tender.

Menu ideas
Serve as a starter with salad leaves, or as a main course alongside Chicken sate (page 42), Peanut sauce (page 179) and Vegetable urap with fresh spiced coconut (page 132).

Lemongrass fish sate

Makes 10 skewers

3 fat lemongrass sticks
2 lime leaves, deveined and
 finely chopped
150 g (5½ oz) skinless mackerel fillets,
 roughly chopped
100 g (3½ oz) raw peeled prawns
30g (1 oz) grated fresh or
 rehydrated coconut
½ teaspoon salt
1½ teaspoons dark palm sugar
 (gula jawa), grated
1 tablespoon cornflour (optional)
2 tablespoons oil
1 teaspoon soy sauce

Bumbu spice paste
2 large red chillies, seeded
2.5 cm (1 inch) ginger, peeled
1.5 cm (⅝ inch) turmeric, peeled,
 or ½ teaspoon ground turmeric
3 garlic cloves, peeled
3 small red Asian shallots, peeled
3 candlenuts or 5 blanched
 almonds, toasted
1 teaspoon shrimp paste, toasted
 (see page 189)
1 teaspoon coriander seeds, toasted
grating of nutmeg
2 tablespoons oil

In the Hindu ceremonies of Bali, sate plays an important part. Whilst women twist palm leaves into intricate offerings for the gods, men create elaborate meaty offerings from sate sticks. These represent the animal kingdom to complement the women's plant kingdom. Of the many varieties, spiced minced fish and prawn sate are extra special. Wrapped around a stick of lemongrass, they are best eaten with your fingers to get the full fragrant citrus hit.

Cut the lemongrass sticks in quarters lengthways to make thin skewers. Set aside the 10 sturdiest ones for the sate and finely chop the white part of the remaining two pieces and add to the ingredients for the bumbu spice paste.

Roughly chop the remaining fresh ingredients for the bumbu. Blend in a food processor along with the spices, seasonings and oil to make a smooth paste. Scrape into a pan and add the shredded lime leaves. Fry until fragrant, then leave to cool.

Tip the mackerel and prawns into the food processor (don't worry about residual spice in there) and blitz until just minced. Transfer to a bowl and add the coconut, salt, 1 teaspoon of the palm sugar and the bumbu. Mix together. If it seems very moist, you can add up to a tablespoon of cornflour to help bind the mixture.

Use oiled hands to mould the mixture around one end of each of the lemongrass skewers, pressing together firmly to form a kebab. Chill in the fridge until ready to cook.

Mix the remaining palm sugar with the oil and soy sauce and brush over the sate.

The sate are traditionally cooked on a charcoal barbecue, but a hot grill pan makes a perfectly acceptable substitute. Cook for about 5–8 minutes, turning often and basting with more sugared oil as they cook.

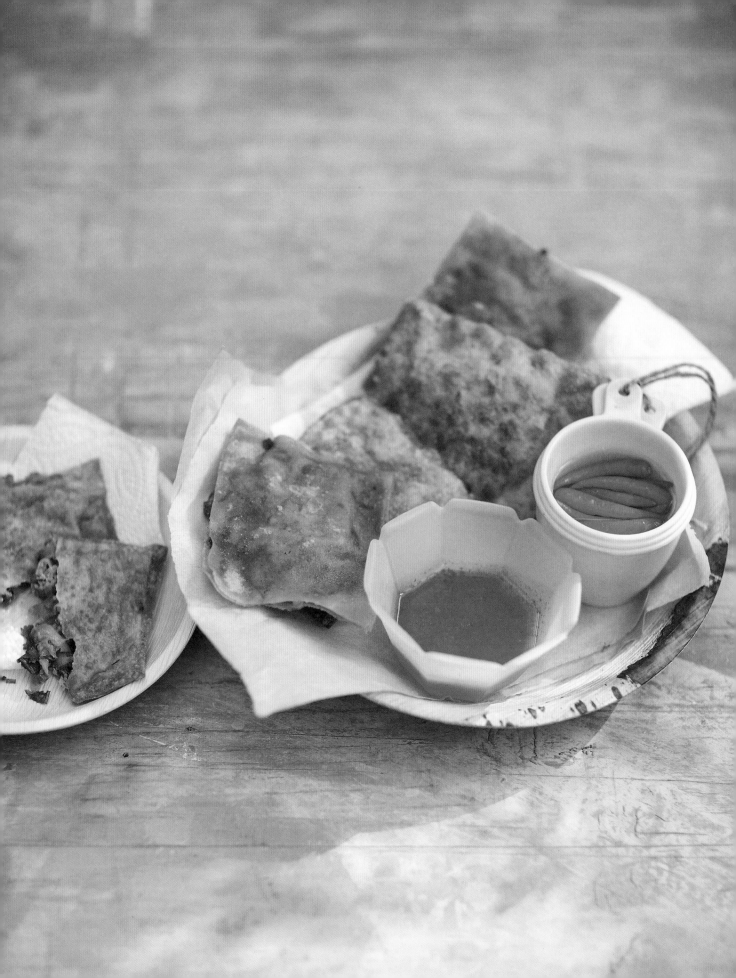

Martabak

Makes 14 martabak

ghee or oil, for shallow frying
160 g (5½ oz) packet wonton wrappers

Filling

1 large onion, finely sliced
2 garlic cloves, finely chopped
thumb of ginger, peeled and
 finely chopped
1 leek, cleaned, trimmed and finely sliced
2 cm (¾ inch) turmeric, peeled and
 grated, or ½ teaspoon ground turmeric
½ teaspoon ground coriander
¼ teaspoon ground cumin
4 spring onions (scallions), white
 and green, finely sliced
75 g (2½ oz) coriander or parsley or
 a mixture, leaves picked
2 duck eggs or 3 eggs, beaten

These crisp, stuffed envelopes of dough are thought to have originated in the Indian community of Yemen and spread through the Indian trading routes in the Middle East and Asia. They have become popular across the Muslim world and are a favourite street food in Indonesia. Watching the street vendors masterfully spinning and stretching elastic sheets of dough until translucently thin, I never dreamt I would be able to make my own at home. Then I discovered the excellent cheat of using wonton wrappers. Spiced meat and egg fillings are common, but I favour these herby vegetarian versions.

To make the filling, heat 1 tablespoon of ghee in a frying pan and cook the onion until well softened and lightly golden. Add the garlic and ginger and cook for a minute more. Stir through the leek and spices and stir-fry, scraping up any brown bits from the bottom, until the leek is completely collapsed and soft. Season generously with salt and pepper and remove from the heat. Let cool completely.

When you are ready to cook the martabak, stir the spring onions, coriander and beaten eggs into the filling. Lay a few wonton wrappers in a flat surface. Spread a spoonful of filling on each square and lay another square on top. It should lie flat with the filling almost to the edge. Press the edges so they are more or less sealed.

Wipe out the frying pan and heat enough ghee for shallow frying over a high heat. Fry the martabak in batches for about 2 minutes on each side. They should be crisp and blistered. Blot well with paper towels before serving.

Note

A spicy dipping sauce is rather essential here. I sometimes make a sweet and sour chilli dip by whizzing together in a food processor 1 red chilli, 2 tablespoons sugar, ½ teaspoon salt, 50 ml (¼ cup) rice vinegar and 50 ml (¼ cup) water. Be warned it is thin, so if you are serving this with martabak as party finger food, add napkins! Otherwise, they make a great starter with a chilli sambal and Acar pickles (page 191).

RICH & CREAMY

Chapter Two

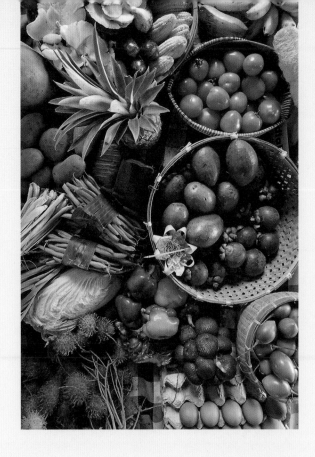

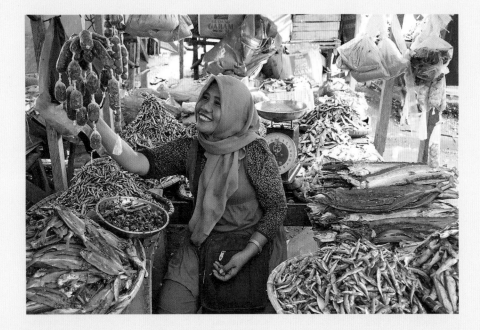

PADANG
Restaurants

In every town and city across Indonesia you'll find a restaurant with a dramatic curved roof sticking out incongruously amidst a flat row of shops selling woven baskets, motorbike parts and plastic household wares. Or, in more modest establishments, the window will be painted with a logo of a house with its roof sweeping upwards like buffalo horns. This is as recognisable an emblem for food as the golden arches in America. Unlike the fast food conglomerate, these nasi Padang restaurants are independent and run by people from West Sumatra, who have cooked their way across the nation.

The roof represents the traditional Sumatran homes where families lived in matrilineal tribes. Boys lived with their mothers when young, then had to move out until they married and went to live in their wife's family house. This left a vacuum for young men with nowhere to go so they set sail to seek their fortune. Rather like the itinerate Cantonese who have set their cuisine as the benchmark for Chinese food around the world, the Minangkabau people of West Sumatra have spread far and wide, but within Indonesia rather than overseas. They have made their cuisine the best known and most popular across the archipelago.

The other way to spot a Padang restaurant is by the towering pyramid of portioned out plates in the shop window. Food is cooked at dawn, stacked up by mid-morning and served until it runs out. There's no menu or ordering system. As soon as you sit down, a waiter will bring a dozen or more dishes, which he balances up his arms with the skill of a circus act, then spreads across the table. It's hard to know what you're getting unless you interrogate the waiter. Some dishes might alarm, but others are sure to tempt and you only pay for what you eat. At the end of your meal, plates are counted and what you haven't touched goes back into common stock.

Minangkabau food is meat and offal dominated with lots of coconut milk for rich, flavourful dishes. With spicing learnt from Indian cooking, the meats are suffused with cumin, coriander, cinnamon, fennel, cloves and curry leaves and, being strictly Muslim, everything is halal. There will likely be creamy lamb or goat curries, chilli-spiked kidneys, mild coconut milk soup, skewered barbecue meat with a thick yellow sauce and, if you are lucky, bone marrow in spicy broth. There will certainly be rendang, the signature dish of beef or water buffalo cooked slowly in coconut milk until dark and caramelised.

Rice is served hot and fragrant in coconut shell-sized scoops. Everything else is at room temperature: wilted cassava leaves, jackfruit curry, skinny aubergines (eggplants) in chilli shrimp paste, fried stink beans, peeled and glossy boiled eggs. Add crunch with airy, puffed beef scratchings and pep things up with a spoonful from the bowl of mulched green chillies as sambals are free to use with abundance.

If you don't have time for the full theatre of dining in, get a takeaway of *nasi bungkus* (wrapped rice). The rice is parcelled up in a waxy palm leaf with an assortment of tempting morsels. These are as common as sandwiches are in the West, but much more fulfilling and with compostable packaging that opens into a plate.

Beef rendang

Serves 4–6

800 ml (3¼ cups) full-fat coconut milk
900 g (2 lb) beef brisket or chuck steak,
 cut into bite-sized pieces
1 tablespoon dark palm sugar
 (gula jawa), shaved
2 teaspoons salt
2 lime leaves
2 turmeric leaves (optional)
1 lemongrass stick, trimmed, bruised
 and tied in a knot
1 cinnamon stick

Bumbu spice paste

8 small red Asian shallots, peeled
5 large red chillies, seeded
4 garlic cloves, peeled
2.5 cm (1 inch) galangal, skin scrubbed
2.5 cm (1 inch) ginger, peeled
2.5 cm (1 inch) turmeric, peeled,
 or 1 teaspoon ground turmeric
½ nutmeg, grated
pinch of ground cloves

It is perhaps the Sumatran specialty of rendang that has captured the world's attention more than any other Indonesian dish. There is something compelling about the beef with its dark caramelised crust and tender inside suffused with gentle spice. What makes it unique is that the cooking passes from braising to frying in the same pan, like a casserole made backwards. As the coconut milk slowly reduces, the beef starts to sizzle in the coconut oil left behind. You are left with the most unctuous meat, slicked with just a little intensely flavoured sauce.

Roughly chop all the ingredients for the bumbu and whizz to a paste in a food processor. Add a good splash of the coconut milk to help the blades do their work. Once smooth, transfer to a large wok or large, shallow casserole pan.

Add all the other ingredients to the wok, making sure there is enough liquid to submerge the meat – add a splash of water if needed. Bring to the boil, stirring to stop the coconut milk splitting. Lower the heat and cook at a slow-medium bubble, more lively than a simmer as the liquid needs to reduce. Cook uncovered for about 2 hours, stirring from time to time. The meat should be tender, most of the liquid evaporated and the oil will have separated from the coconut milk. Remove the lemongrass and cinnamon.

At this stage, the meat and spices that have been braising will start to fry in the hot oil. This is called 'tempering' and needs to be done with care. For about 10 minutes, you will need to stir gently but frequently over a medium heat until the coconut oil becomes thick and brown. The stir-frying then needs to be continuous for the final 15 minutes or so, until the oil has been absorbed by the meat, which will be a dark chocolaty brown.

Leave to rest for half an hour or more before serving at room temperature. Rendang keeps well in the fridge and the flavours only improve with age.

Menu ideas

A scattering of Spicy coconut flakes (page 182) or crisp-fried shallots make a nice addition. Rendang works equally well as part of a groaning buffet spread – maybe alongside Glazed prawn sate (page 44), Sweetcorn fritters (page 40), Aubergine with shrimp paste (page 101), Golden vegetable stir-fry (page 96), Marbled eggs (page 192), Peanut & lime leaf crackers (page 31) and a selection of sambals – or as a main event with Spice rice (page 163), vegetables and Padang green chilli sambal (page 176).

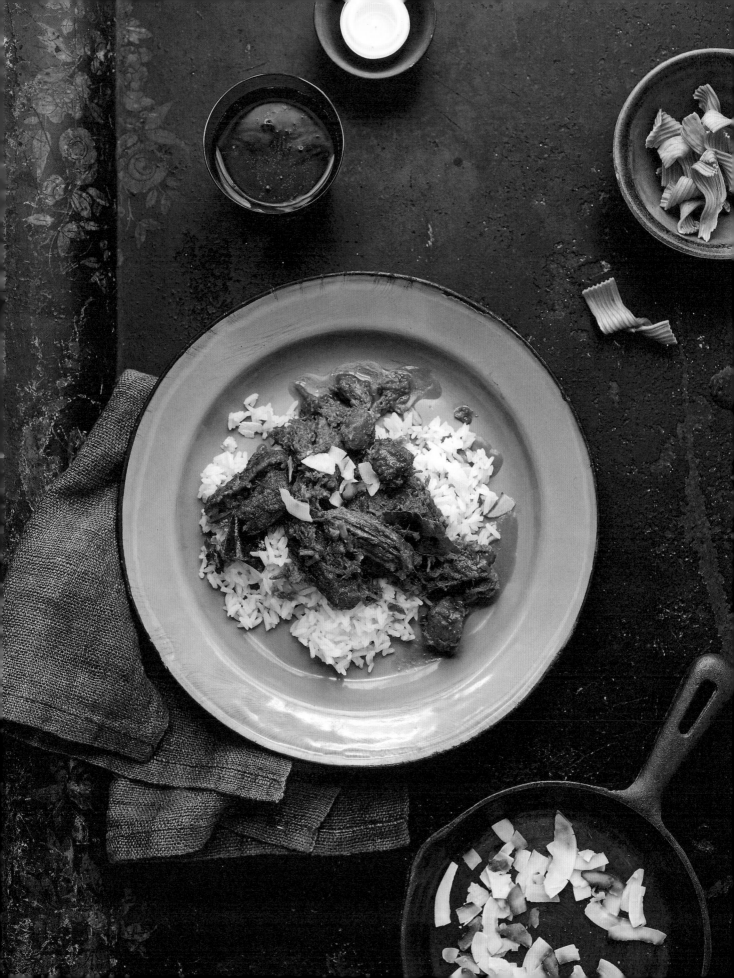

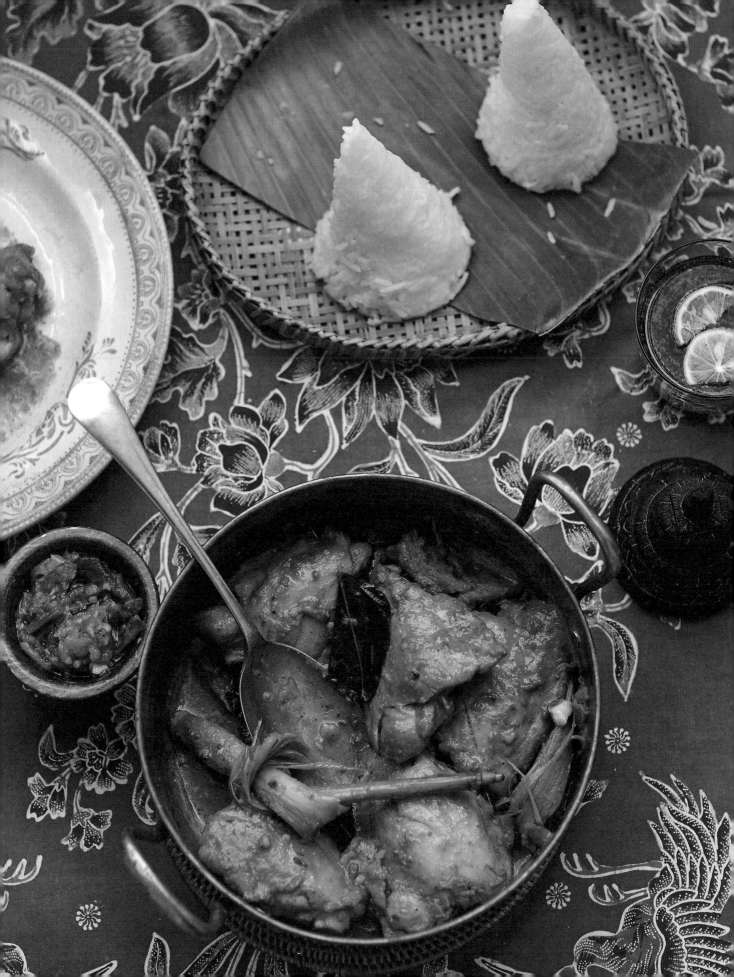

Coconut milk chicken

Serves 3–6

1 tablespoon oil
2 salam leaves (optional)
4 lime leaves
6 chicken thighs, bone in, skin removed
3 lemongrass sticks, trimmed, bruised
 and tied in a knot
3 cm (1¼ inches) galangal, skin
 scrubbed, bruised
240 ml (1 cup) coconut milk
2 teaspoons dark palm sugar (gula jawa)
crisp-fried shallots, to serve

Bumbu spice paste

1½ teaspoons ground coriander
¾ teaspoon ground cumin
½ teaspoon ground white pepper
7 garlic cloves, peeled
7 small red Asian shallots, peeled
3 candlenuts or 6 blanched
 almonds, toasted
½ teaspoon salt

The Islamic festival of Eid al-Fitr, known locally as Lebaran, is celebrated with much joy and festivity. People buy new clothes to wear, travel back to family villages and break the long fasting of Ramadan with a feast. Chicken poached in a creamy, luscious sauce is traditional, as well as being a Javanese favourite year round. With delicate spicing rather than chilli heat, *opor ayam* is perfect for those who like their curries both mild and enchanting.

Start by making the bumbu spice paste. Put all the ingredients in a food processor and grind to a paste, adding a little water to help the blades do their work.

Heat the oil in a large saucepan or casserole pan. Fry the bumbu, salam and lime leaves for about 5 minutes, stirring frequently, until very fragrant. Add the chicken, lemongrass and galangal and turn to coat in the spice paste. Stir in 100 ml (scant ½ cup) water and bring to the boil. Turn the heat to low and simmer uncovered for 15 minutes.

Add the coconut milk and palm sugar to the pan, bring up to a simmer and continue to braise uncovered for another 20–30 minutes, until the chicken is cooked through and tender. Taste for salt. Leave to rest and cool for about 20 minutes before serving.

Serve scattered with crisp-fried shallots (the sort you can buy in Asian stores).

Menu ideas

Rice is needed to sop up the creamy sauce; it's fun to shape individual portions into *tumpeng* using a cone of paper. For a rich and luxurious Lebaran feast, serve with Beef rendang (page 52) or Betawi spiced beef (page 125), Solo coconut rice (page 157) and Padang green chilli sambal (page 176).

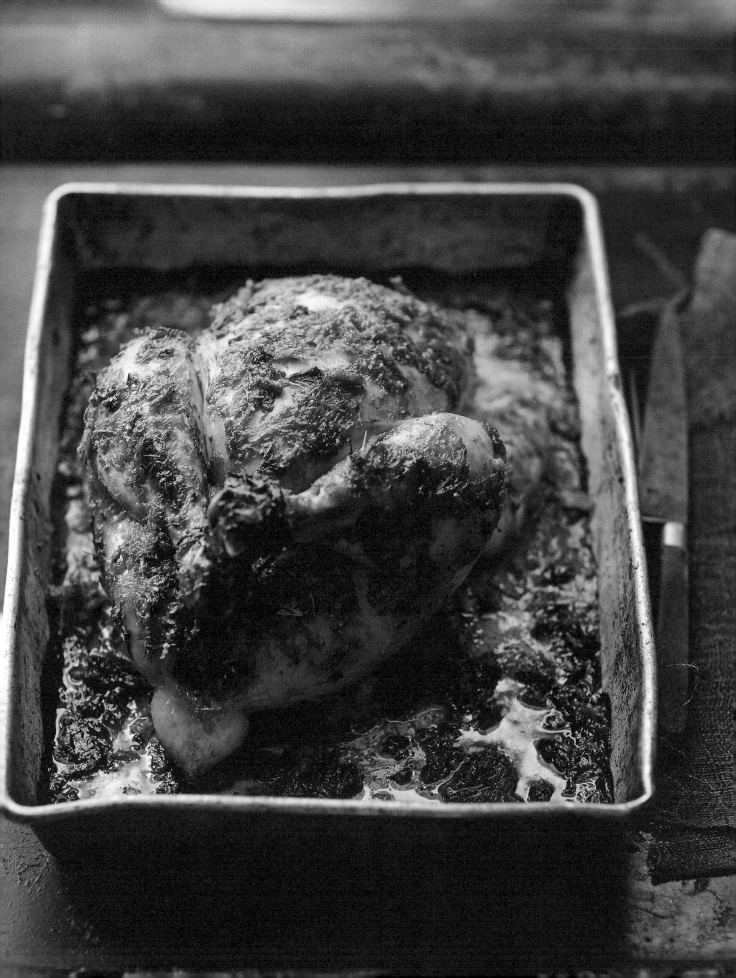

Roasted coconut chicken

Serves 4

1.5 kg (3 lb 5 oz) chicken
1 tablespoon tamarind paste
2 tablespoons oil
400 ml (1½ cups) full-fat coconut milk
2 teaspoons dark palm sugar (gula jawa)

Bumbu spice paste

2 onions, roughly chopped
4 garlic cloves, roughly chopped
2 large red chillies, half seeded
 and chopped
2 lemongrass sticks, trimmed and sliced
4 cm (1½ inches) turmeric, peeled, or
 1 teaspoon ground turmeric
1 teaspoon ground coriander
1 teaspoon salt

Roast chicken gets the spice treatment. The flavour is authentically Indonesian, the method not, but I think you'll love it nonetheless. The bird is bathed in a silky coconut sauce, which thickens and caramelises in the oven forming an irresistible burnished crust.

Find a roasting dish in which the chicken sits reasonably snuggly, just a little room around the edges to hold the sauce. Put the bird inside and paint the skin with tamarind paste. Leave to come up to room temperature whilst you make the bumbu.

Grind all the bumbu ingredients to a paste in a food processor. Heat the oil in a pan and cook the bumbu for 5–10 minutes, stirring often, until the rawness is replaced with fragrance.

Paint the chicken all over with some of the bumbu, adding a spoonful inside the cavity. Keep the rest of the bumbu in the pan.

Preheat the oven to 190°C (375°F).

Add the coconut milk and palm sugar to the excess bumbu in the pan. Bring up to the boil and simmer for about 5 minutes, stirring all the while. Pour over the chicken.

Roast for 1 hour, or until the chicken is golden and when you stick a knife between the leg and breast, it is just the palest pink (it will finish cooking as it rests). Baste with the coconutty juices occasionally as the chicken cooks to help keep it succulent.

Remove the chicken from the dish and leave to rest somewhere warm for 20 minutes. Spoon off and discard the oil from the roasting dish sauce. Serve the rest with the chicken.

Menu ideas

Sometimes I roast potatoes in the oven at the same time as the chicken, then serve with Sweet & spicy mushroom tongseng (page 73) and Stir-fried greens with garlic & chilli (page 151).

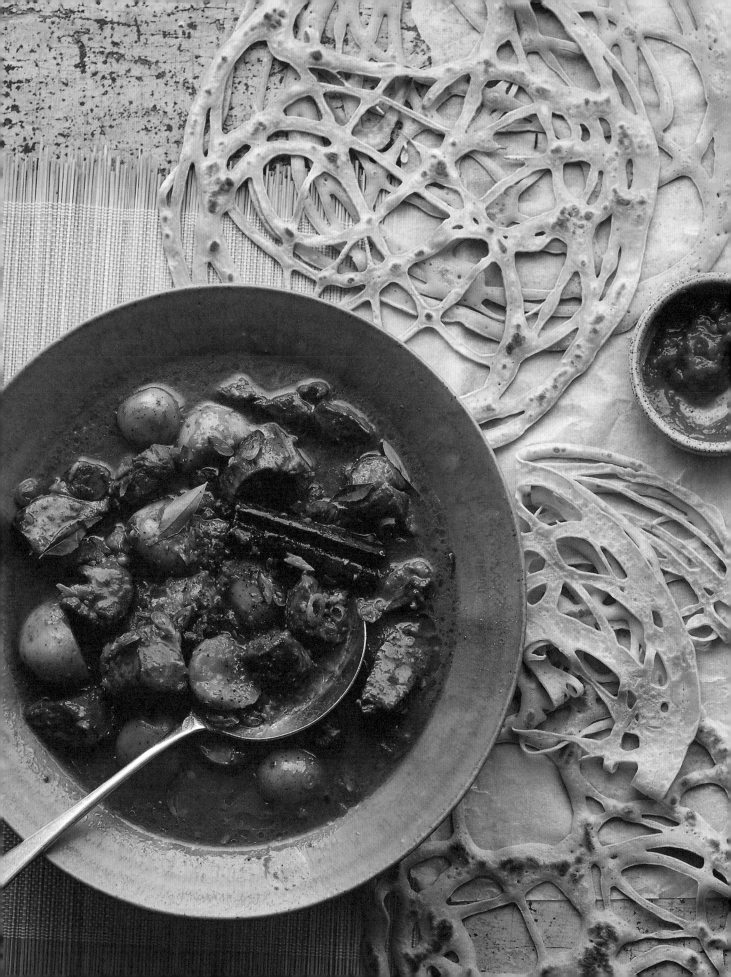

Sumatran lamb korma with golden lace pancakes

Serves 4

Lamb korma

650 g (1 lb 7 oz) boneless leg
 of lamb, cubed
2 tablespoons ghee or oil
1 red onion, finely chopped
4 garlic cloves, finely chopped
1 lemongrass stick, trimmed
 and finely sliced
2 cm (¾ inch) ginger, peeled
 and finely chopped
1 green chilli, finely chopped
1 teaspoon ground coriander
1 teaspoon ground cumin
1 teaspoon ground black pepper
½ teaspoon fennel seeds
1 cinnamon stick
½ cracked nutmeg
4 green cardamom, lightly cracked
3 cloves
3 curry leaves
300 g (10½ oz) new potatoes, scrubbed
 and halved
150 ml (generous ½ cup) full-fat
 coconut milk

Golden lace pancakes

200 g (1⅓ cups) plain flour
½ teaspoon ground turmeric
½ teaspoon ground cardamom
 (seeds from 4 pods, ground)
2 eggs, lightly beaten
300 ml (1¼ cups) milk
ghee or oil, for brushing

Sumatra, on the west of the Indonesian archipelago, is where Islamic Indian and Arab spice seekers most clearly left their mark. Islam first took root here before spreading across the country, interweaving with and taking over from other religions. The traders also left a taste for complex spicing. This dish shares its name with the Indian korma that influenced it, but the addition of lemongrass and coconut milk roots it firmly to its Sumatran home. Golden pancakes with a swirled lacy texture are the traditional accompaniment, perfect for dipping and scooping as the sauce clings in the gaps.

To make the korma, season the lamb with salt and heat the ghee in a large casserole pan over a high heat. Brown the lamb, in batches if necessary, until it has a good golden crust. Remove to a plate, leaving the fat behind in the pan. Add a little more ghee if needed and lower the heat to medium.

Soften the onion over a medium heat, scraping up any sticky bits of lamb from the pan. Add the garlic, lemongrass, ginger and chilli and cook for a few minutes so the aroma hits you. Stir in all the spices and cook for another minute or two. Return the lamb to the pan along with any gathered juices and the potatoes. Add 400 ml (1½ cups) water and a good pinch of salt. Bring to a bubble, then cover and turn the heat down to a whisper. Simmer for 45 minutes, or until the lamb is tender.

Stir in the coconut milk and simmer uncovered for 20 minutes. The sauce should be rich and slightly reduced, but lots is needed for scooping. Season.

To make the pancakes, whisk the flour in a bowl with the turmeric, cardamom and a pinch of salt. Make a well in the centre for the eggs and milk and whisk to a thin batter. Add 100 ml (scant ½ cup) water, or enough so it drizzles easily from the whisk.

Heat a frying pan over a medium-high heat and brush with a little ghee or oil. You need to create a lacy net in the pan. The easiest way is with a squeezy bottle. Another method is to dip your hand into the bowl, then swirl it over the pan in a continuous figure of eight pattern so the batter drips off your fingers. It takes a bit of practice, but is rather satisfying. You could also pierce holes in the bottom of a paper cup, fill with the batter and swirl over the pan. This is similar to the special roti jala cup sold for this purpose.

Cook until just set and golden on the base, turn and cook briefly on the other side. Fold in quarters and set aside whilst you make the rest. Serve alongside the lamb korma.

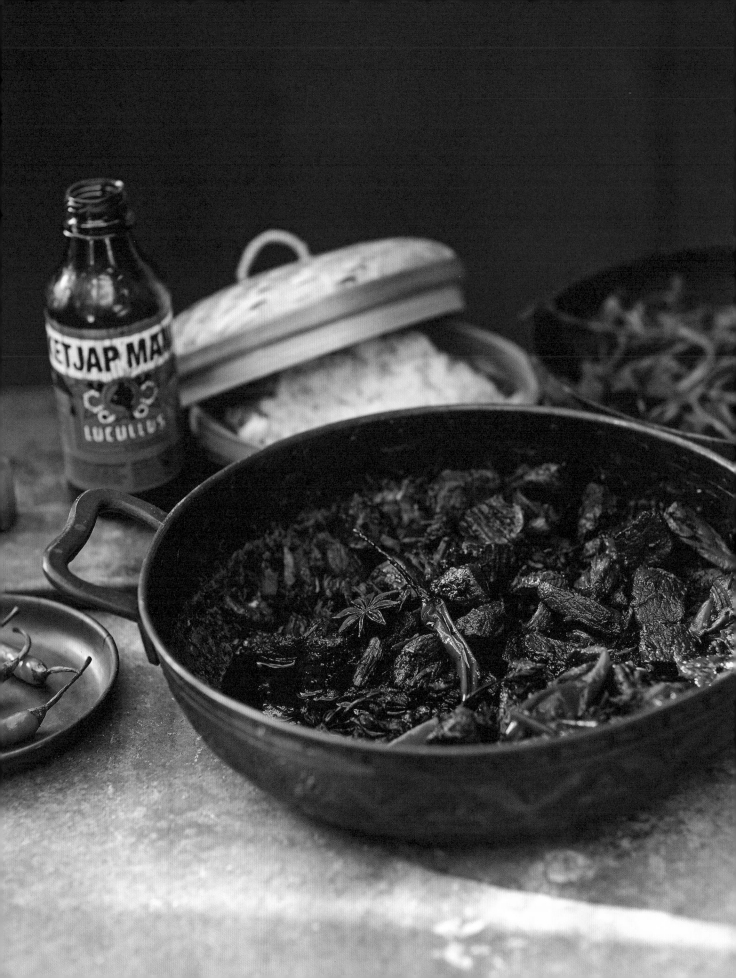

Pork braised in kecap manis

Serves 6

750 g (1 lb 10 oz) boneless
 pork shoulder
3 tablespoons oil
8 small red Asian shallots, sliced
8 garlic cloves, sliced
40 g (1½ oz) ginger, peeled
 and finely chopped
4 tablespoons kecap manis
1½ tablespoons soy sauce
300 ml (1¼ cups) chicken stock
2 star anise
2 large red chillies
3 red bird's eye chillies

The island of Bali is never quiet, its soundtrack punctuated by gamelan music, roaring motorbikes, chirping geckos, the spluttering oil of street food vendors and the chatter of tourists. All except for one day, the annual festival of Nyepi, when the island falls silent. The airport is closed, everyone stays at home and lights are kept low so that demons are tricked into believing the island is uninhabited and stay away for another year. As there is no cooking on the day of silence, a dish like this dark and glossy, salty-sweet pork, which tastes even better a day or two after it is made, is perfect for Nyepi celebrations.

Cut the pork into 3 cm (1¼ inch) cubes – there is no need to trim off any fat, which will render as it cooks, keeping the meat succulent. Season with salt and pepper and set aside.

In a large casserole pan, heat the oil over a medium heat. Add the shallots and garlic and cook until soft and light golden. Add the pork and ginger and cook for a few minutes more, to colour the meat.

Splash in the kecap manis and soy sauce and cook for a minute longer. Top up the pan with chicken stock, just enough to cover – add water if needed – and add the star anise and whole chillies (they won't release too much heat if their skin is not broken).

Bring to a simmer and skim off any scum that rises to the surface. Cover with a lid, adjusting the heat to keep at a faint simmer. Cook for 1½ to 2 hours, until the pork is very tender. Check from time to time and top up with water if the pan looks dry.

When the pork is cooked, skim off any fat and remove the chillies. The sauce should be glossy and sticky. If it is too thin, remove the meat with a slotted spoon and set the pan over a high heat to reduce the liquid. Return the pork to the pan and taste for seasoning. The salt should balance the sweetness of the kecap manis.

Menu ideas
This is a rich braise, which is just as good alongside crushed potatoes as rice. Serve with green vegetables and crunchy crackers.

Potato tuturuga

Serves 2–4

500 g (1 lb 2 oz) potatoes, peeled
1 tablespoon oil
2 lime leaves
250 ml (1 cup) coconut milk
1 teaspoon sea salt
small bunch of lemon basil
 leaves, shredded
small bunch of mint leaves, shredded
juice of ½ a lime

Bumbu spice paste
4 small red Asian shallots, peeled
4 garlic cloves, peeled
3 large red chillies, half seeded
2 cm (¾ inch) ginger, peeled
3 cm (1¼ inches) turmeric, peeled,
 or 1 teaspoon ground turmeric
6 candlenuts or 10 blanched almonds

Lime leaves, mint and lemon basil perfume this spicy, savoury curry. Tuturuga is made by the Minahasen people of North Sulawesi where the name means 'turtle' – the original meat cooked with potatoes in this red spice paste. Today chicken or beef is more typical, but I keep mine meat-free as I think the potatoes cloaked in the spiced coconut milk are the best bit.

Start by making the bumbu spice paste. Roughly chop the fresh ingredients and grind to a paste in a food processor, adding a little water if needed to help it come together.

Cut the potatoes into 4–5 cm (1½–2 inch) chunks.

Heat the oil in a pan that will be large enough to hold the potatoes later. Scrape in the bumbu and fry until fragrant and the rawness has gone. Add the lime leaves and wilt in the heat of the spices. Add the potatoes, coconut milk and salt and top up with just enough water to cover the potatoes. Bring to a slow boil and cook uncovered until the potatoes are tender and the sauce has reduced to a good consistency, about 20–30 minutes.

Leave to cool a little then stir through the lemon basil and mint. Taste for seasoning and brighten the flavours with a zap of lime juice.

Menu ideas
Serve with Rica rodo (page 143) and Fiery Sulawesi pork ribs (page 81).
This also makes a great accompaniment to roast chicken or steamed fish.

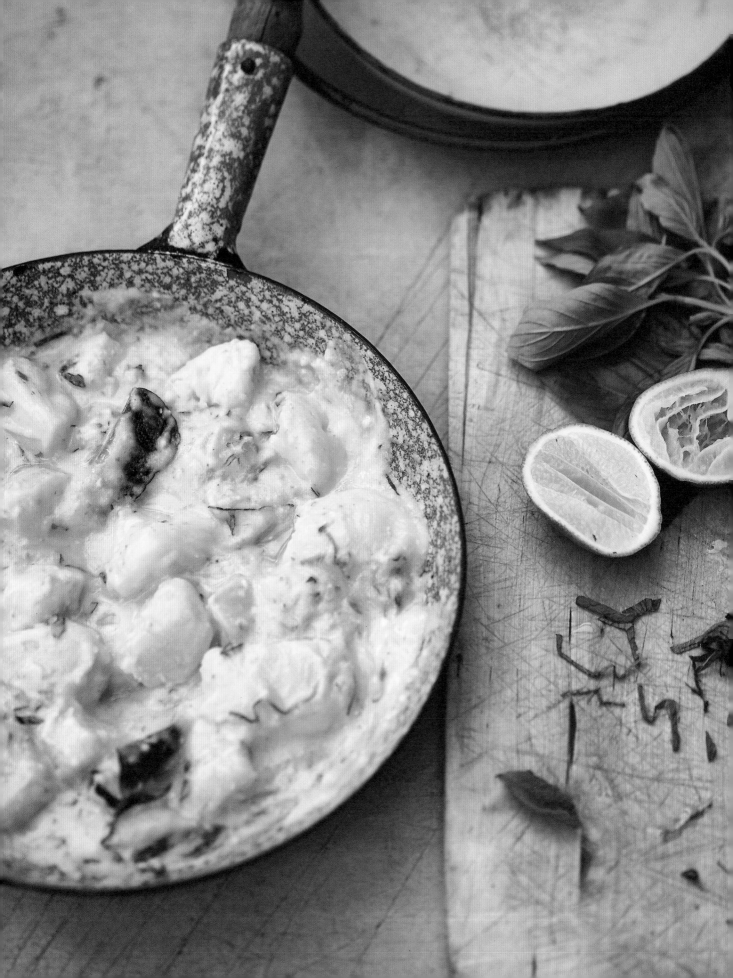

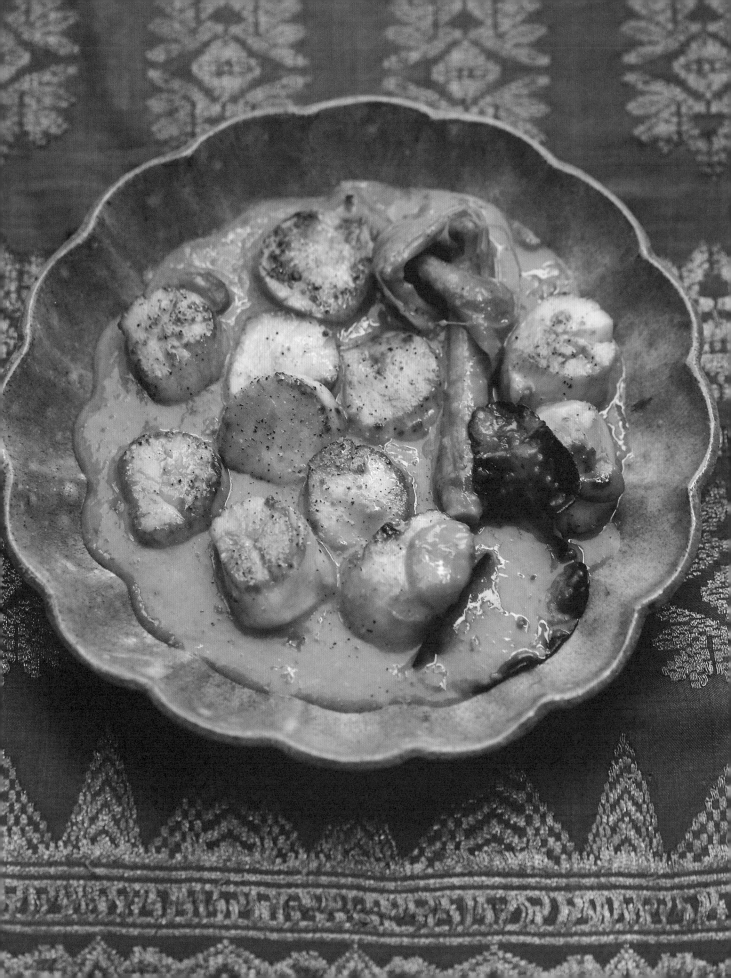

Scallops gulai

Serves 4

500 g (1 lb 2 oz) queen scallops
(shelled weight), cleaned
1½ tablespoons oil
3 lemongrass sticks, trimmed, bruised
and tied in a knot
3 lime leaves
2 salam leaves (optional)
400 ml (14 fl oz) coconut milk
2 teaspoons dark palm sugar
(gula jawa), shaved
1 tablespoon tamarind paste

Bumbu spice paste

1 teaspoon ground coriander
½ teaspoon ground cumin
½ teaspoon ground white pepper
3 candlenuts or 6 blanched
almonds, toasted
6 garlic cloves, roughly chopped
6 small red Asian shallots,
roughly chopped
4 large red chillies, seeded and
roughly chopped
3 cm (1¼ inches) turmeric, peeled,
or 1 teaspoon ground turmeric
2 cm (¾ inch) ginger, peeled
1 teaspoon salt

With Indian influences, a gulai sauce is spicy, sunny coloured and coconutty. It is a hallmark of Padang cuisine but popular across the archipelago, cloaking meat, fish, offal, seafood or vegetables. I once had a particularly good village version with crunchy young bamboo shoots. Here I have chosen seared scallops, which cook in minutes. If you make the sauce in advance (which it is best to do anyway as this will give the complex flavours time to mellow and meld) this makes a very speedy meal.

If the scallops have a little white bit at the side, remove it as it will become tough when cooked. If you have small queen scallops you probably won't have to halve them, but if you have large ones slice in half horizontally. Keep in the fridge until needed.

To make the bumbu spice paste, put all the ingredients in a food processor and grind to a paste, adding a little water as needed to help everything come together.

Heat 1 tablespoon of the oil in a deep frying pan and add the bumbu, lemongrass, lime leaves and salam leaves. Fry – splashing in a little of the coconut milk to loosen the paste if it starts to get too dry – until everything is very fragrant and all the raw taste has gone.

Add the remaining coconut milk, palm sugar and tamarind paste. Bring to a simmer and cook gently for 5 minutes, stirring often to stop the coconut milk splitting. Taste for seasoning. You can make in advance up until this point and in fact the flavours will only improve by being kept until later or stored overnight in the fridge.

Fish out the lemongrass and warm the sauce through.

Dry the scallops well with paper towels. Drizzle with the remaining oil and season with salt and pepper. Heat a griddle pan over a high heat until just smoking. Sear the scallops for about a minute on each side. Drop into the sauce just before serving.

Menu ideas
Serve with Golden vegetable stir-fry (page 96), Tempeh with red chilli & palm sugar (page 185) and steamed rice.

Olah olah

Serves 4–6

3 carrots, sliced on
 the diagonal into discs
1 aubergine (eggplant), cut
 into small wedges
½ Chinese napa cabbage, cut into chunks
2 tablespoons oil
400 ml (14 fl oz) coconut milk
4 tablespoons oyster sauce
3 tablespoons soy sauce
450 g (1 lb) fine green beans,
 cut into thirds
2 bok choy, leaves separated

Bumbu spice paste
2 tablespoons oil
200 g (7 oz) large red chillies,
 halved and seeded
80 g (3 oz) galangal, skin scrubbed,
 roughly chopped
10 small red Asian shallots, peeled
10 garlic cloves, peeled
40 g (1½ oz) candlenuts or
 blanched almonds
2 cm (¾ inch) turmeric, peeled, or
 ½ teaspoon ground turmeric
1 teaspoon shrimp paste,
 toasted (see page 189) (optional)
3 lime leaves
1 lemongrass stick, trimmed and bruised

Our visiting friends so loved this vegetable curry they declared it reason alone for a book on Indonesian food. The veggies are stir-fried, keeping them crisp and vibrant, but the sauce is luscious and rich – the perfect counterpoint. As you make the bumbu spice paste your eyes might widen at the quantities, but these are meant to be big flavours and it works.

Start by making the bumbu spice paste. Heat the oil in a large frying pan and add the chillies, galangal, shallots, garlic and candlenuts – the shallots and garlic go in whole. Fry, stirring often, until the garlic has browned and everything smells wonderful.

Transfer to a pestle and mortar, high-speed blender or food processor with the turmeric and shrimp paste. Add 200 ml (generous ¾ cup) of water and pound or blitz to a smooth purée. Return to the pan along with the lime leaves and lemongrass. Cook over a medium heat, stirring often, until the raw taste has gone and the sauce is fragrant. This will take about 10 minutes – loosen with more water if needed as you don't want the sauce to caramelise and darken. Season with salt and remove from the heat.

Prepare all the vegetables before you start stir-frying. Set a wok over a high heat and add the oil. The carrots go in first and will need about 2 minutes stir-frying to soften before you add the aubergine. Stir-fry a minute or two more, then add the cabbage and stir-fry for 1 minute.

Scrape the bumbu into the pan and toss to coat all the vegetables. Lower the heat and add the coconut milk, oyster sauce and soy sauce and stir again. You will probably need to add some water to loosen the sauce to a creamy curry consistency – and add more as needed as you cook.

Season with salt and pepper and simmer for a few minutes. Add the green beans and bok choy and simmer for a final 2–3 minutes until all the vegetables are tender-crisp. Taste for seasoning before serving.

Menu ideas
This makes a great meal in itself simply with rice and prawn crackers or Wok-fried peanuts (page 180), but it is also a good pairing for dishes from the Dry & Aromatic chapter (page 76).

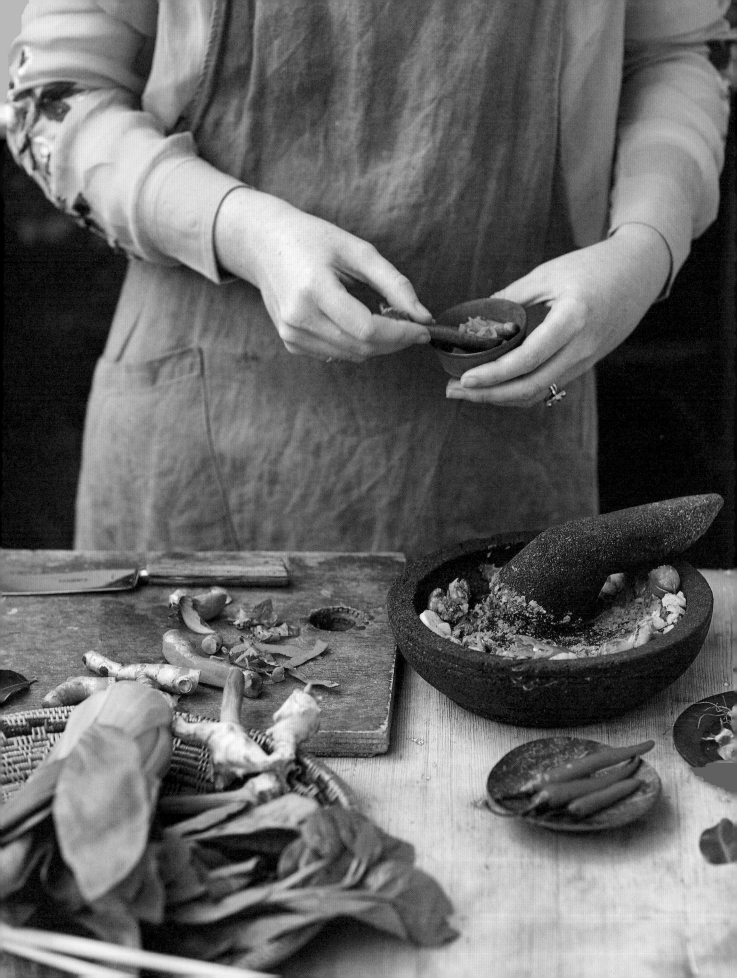

Lime leaves – *duan jeruk purut*

The waxy, dark green leaves of the kaffir lime tree have a citrussy, floral aroma that is to my mind entirely magical and transporting. The leaves can be paired in an hourglass shape or can be solo ovals. Finely shred (pulling out the central vein first) or pulverise, or simply scrunch to release the flavours and drop into the pot. Dried lime leaves are little use – I tried making the kaffir lime sorbet with dried leaves and the taste was impossible to detect, so imagine what use they are in a complex dish with all the other competing flavours. Buy fresh when you find them and freeze until needed. I buy large tubs of frozen lime leaves inexpensively from my local Asian supermarket. (See page 141 for kaffir lime fruit.)

Lemon & Thai basil – *kemangi*

I am crazy for lemon basil with its exquisite fragrance (you've guessed it, lemony) that seems somehow so much more nuanced than sweet basil. It is often used with fish, for which it is a natural pairing, or tossed into soups and salads. The delicate leaves (and flowers too if they are on the stem) are added at the last minute to finish off a dish. Other basils native to tropical Asia can be substitutes. Thai basil, with its anise scent, is usually the easiest to find. Purple, holy, Greek, cinnamon or even sweet basil are fine to use too and each will bring their own character.

Celery leaves – *seledri*

The leaf, not the thin reedy stalk, is the hero in Chinese celery. They have a similar but more intense taste than the pale Western celery leaves and are used as a herb in broths and fritters. Look for sprightly bunches in Asian supermarkets and store in the fridge. You can use regular celery leaves instead (if you can find any as the leaves tend to be scant), but the flavour will be muted.

Curry leaves – *daun kari*

Used in Aceh and Betawi cooking, these are evidence of the Indian influence on these food cultures. Sizzle the glossy dark leaves in oil to release their pungent, slightly citrussy aroma. I am not sure the dried ones are worth it: better to buy fresh when you find them and store in the freezer. Bruise the leaves before cooking to help the flavours escape.

Pandan leaves – *daun pandan*

Also called pandanas or screwpine, these long, reedy leaves act as the vanilla of South East Asia. With a distinctive aroma, they can be scrunched, knotted and dropped into rice, puddings and custards to lend fragrance. They can also be blended with water and the green juice used as a natural food colouring as in the Green coconut pancakes (page 209). The leaves are usually sold frozen in countries where they aren't grown fresh. You can also buy pandan extract, which may or may not have a vivid green colour.

Salam leaves – *daun salam*

Native to Java, salam leaves are a member of the cassia family and are an important herb in Indonesian cooking. They are sometimes called Indonesian bay leaves as they are used in a similar way, simmered in broths and sauces to give a subtly, woodsy flavour that you can't quite put your finger on. Bay leaves don't make a good substitute though and if you can't find them, it is best to leave them out. Salam are dark green when fresh, a crinkled silvery green when dried. The two can be used interchangeably.

Other leaves

There are a host of other aromatic leaves used that I haven't included in these recipes as they can be hard to source outside Asia. Vietnamese coriander is popular in Sumatra, where it is added to dishes with a coconut milk base. Teak leaves lend a deep brown colour for dishes like the sweet Javanese jackfruit curry, *gudeg*. Along with onion skins, guava leaves can be used for staining marbled eggs. Turmeric leaves neutralise strong odours, whilst garlic leaves add punch to soft savoury porridges.

Young jackfruit curry

Serves 4

400 g (14 oz) young jackfruit
500 ml (2 cups) fresh chicken or
 vegetable stock
1 lemongrass stick, bruised and knotted
2 lime leaves
200 ml (generous ¾ cup) coconut cream
1 tablespoon crisp-fried shallots
2 teaspoons dark palm sugar (gula jawa),
 shaved (optional)

Bumbu spice paste
8 cm (3¼ inches) turmeric, peeled,
 or 2 rounded teaspoons
 ground turmeric
4 cm (1½ inches) ginger, peeled
4 cm (1½ inches) galangal, skin scrubbed
7 garlic cloves, peeled
7 small red Asian shallots, peeled
2 salam leaves (optional)
2 candlenuts or 4 blanched almonds
2 tablespoons oil

Jackfruit is the new darling of the vegan set for its meaty texture, but has long been used in Indonesia. It doubles up as a fruit when ripe and sweet and a vegetable when green. This mild, turmeric-tinted curry uses the unripe flesh of a young jackfruit – buy it tinned in Asian supermarkets if you can't find fresh. It will improve immeasurably if you leave it for a day or two after cooking to let the flavours permeate.

If using fresh jackfruit, the fruit has a rubbery sap that is nearly impossible to remove – oil your hands, knife, chopping board and anything else the jackfruit will touch! Trim off the rind and chop the flesh (including the seeds) into chunky wedges about 4 cm (1½ inches) long. If using tinned, drain and rinse.

To make the bumbu spice paste, roughly chop all the fresh ingredients and transfer to a food processor. Whizz to a paste, adding a little water if needed to help bring everything together. Tip into a large pan and cook over a medium-high heat, stirring often, until fragrant and the oil starts to separate from the paste.

Add the jackfruit and chicken stock to the bumbu pan (if you are using tinned jackfruit it will need less cooking, so start with a little less stock – you can always top up if required). Season with the lemongrass, lime leaves and a good pinch of salt. Bring to an enthusiastic bubble and cook for 15 minutes. Check to see if the jackfruit is tender – how long this takes will depend on the variety: anywhere up to an hour. Once it can yield to the pressure of a spoon, turn up the heat to reduce the liquid if needed. Lower the heat to medium, stir in the coconut cream and crisp-fried shallots and cook for a minute or two longer. Taste for seasoning. It needs quite a bit of salt, and you may want to add a little palm sugar to round out the flavour. This curry will taste even better the next day.

Menu ideas
This is creamy with a buttercup yellow sauce, so works well alongside something like Steamed fish parcels (page 114) and a big bowl of fluffy rice. Don't forget a chilli sambal.

Lamb shank red curry

Serves 4

4 small lamb shanks
2 tablespoons oil
small handful curry leaves
6 garlic cloves, roughly chopped
3 cm (1¼ inches) ginger, peeled
 and chopped
3 candlenuts or 6 blanched almonds
2 red onions, chopped
3 cloves
1 cinnamon stick
1 tablespoon ground cumin
2 teaspoons chilli powder
1 teaspoon ground fennel seeds
2 tablespoons tomato paste
 (concentrated purée)
400 g (14 oz) tin chopped tomatoes
125 ml (½ cup) evaporated milk
1 tablespoon dark palm
 sugar (gula jawa)

Sumptuous and celebratory, this is a real feast of a curry. The shanks take a long time in the oven, but the oven does all the work. What emerges is meat falling from the bone and a deep, intense gravy. A final flourish of evaporated milk and palm sugar rounds off the flavours, making the curry rich and interesting.

Preheat the oven to 150°C (300°F).

Season the lamb shanks with salt. In a large casserole pan, heat the oil and brown the lamb on all sides. Remove from the pan, leaving the oil behind.

Add the curry leaves to the hot oil and sizzle briefly until fragrant. Remove with a slotted spoon and set aside to scatter over the finished curry. Keep the oil in the pan.

In a pestle and mortar, pound the garlic, ginger and candlenuts to a paste.

Return the casserole pan to a medium heat, topping up the oil if needed. Add the onion, garlic paste, cloves and cinnamon. When the onion is soft and translucent, add the remaining spices and the tomato paste and cook until fragrant. Stir in the tinned tomatoes followed by 750 ml (3 cups) water, swirling it around the tin first to catch the red residue. Season with salt. Return the lamb to the pan and bring the liquid to the boil. Cover tightly with a lid or foil and transfer to the oven.

Cook for 2–3 hours until the meat is very tender and coming away from the bone. Remove the lamb from the pan and skim off the fat from the surface. Stir the evaporated milk and palm sugar into the pan. Bring to a bubble and cook uncovered for about 10 minutes to thicken the sauce. Taste for seasoning.

Serve the lamb shanks with the sauce spooned over and a crown of fried curry leaves.

Sweet & spicy mushroom tongseng

Serves 4

2 lime leaves
1 lemongrass stick, trimmed and bruised
2 cm (¾ inch) galangal, skin
 scrubbed, bruised
1 tablespoon oil
500 g (1 lb 2 oz) oyster mushrooms
3 tablespoons thick coconut milk
1½ teaspoons dark palm sugar
 (gula jawa), shaved
2 teaspoons kecap manis
1½ large red chillies, seeded and sliced
1 ripe tomato, cut in wedges

Bumbu spice paste

½ teaspoon coriander seeds
4 peppercorns
1 small red Asian shallot, roughly chopped
2 garlic cloves, roughly chopped
1 candlenut or 2 blanched almonds
1 cm (½ inch) ginger, peeled
1 cm (½ inch) turmeric, peeled, or
 ¼ teaspoon ground turmeric

In the countryside of Central Java, not far from the dramatic marvel of the ninth-century temple of Borobudur, is the most surprising restaurant. Jejamuran has separate channels for entrance and exit with an airport-style check-in service. Inside, great halls of people are served nothing but mushrooms. Dishes from across Indonesia, from rendang to sate, are rendered beautifully in fungi. Our highlight was the richly spiced tongseng curry, which is more usually made with goat meat.

Start by making the bumbu spice paste. For this small quantity I find this easiest to do with a pestle and mortar. Start with the coriander seeds and peppercorns, then add all the other ingredients and grind to a paste.

Put the bumbu in a large frying pan with the lime leaves, lemongrass and galangal. Drizzle in the oil and stir-fry until fragrant. Loosen the paste with a ladleful of water.

Add the mushrooms and turn to coat in the spices. Add the coconut milk, palm sugar and a good pinch of salt. Cook for 5–10 minutes. The mushrooms will release liquid as they fry. Towards the end of cooking, stir through the kecap manis, sliced chillies and tomato. Taste for seasoning.

Menu ideas

Serve with Spice rice (page 163), Pork braised in kecap manis (page 61), Jakarta beansprouts (page 147) and a chilli sambal.

Padang-style eggs

Serves 4–8

8 eggs
400 ml (14 fl oz) tin coconut milk
1 lemongrass stick, bruised and
 tied in a knot
½ teaspoon sea salt
1 tablespoon tamarind paste

Bumbu spice paste
5 small red Asian shallots,
 roughly chopped
4 garlic cloves, roughly chopped
5 cm (2 inches) ginger, peeled and
 roughly chopped
2 cm (¾ inch) turmeric, peeled, or
 1 teaspoon ground turmeric
3 bird's eye chillies, seeded

The curry sauce for these eggs is rich and aromatic and a gorgeous mellow yellow. My trick is to cook the sauce and eggs separately, giving them only a cursory meeting at the last minute to warm through. This yields a creamy, orange yolk, not the dusty grey variety.

Boil the eggs for 7–8 minutes, depending on size, and plunge into ice cold water. Remove the shells and set aside whilst you prepare the sauce.

Grind the ingredients for the bumbu in a high-speed blender or food processor, adding a little of the coconut milk to help the blades turn.

Scrape into a pan and cook, stirring, for a few minutes to lose the harsh raw flavours. Add the remaining coconut milk, lemongrass and salt. Turn the heat up to bring to the boil, then reduce to a simmer for 10 minutes, stirring frequently. Add the tamarind paste and taste for seasoning.

When you are ready to serve, warm the sauce, then add the eggs to heat through gently.

Menu ideas
These make a rather good pairing for Java spiced tempeh (page 99) with some green vegetables such as the Water spinach with roasted tomato sambal (page 149) and Chilli-fried potato crunch (page 183).

DRY & AROMATIC

Chapter Three

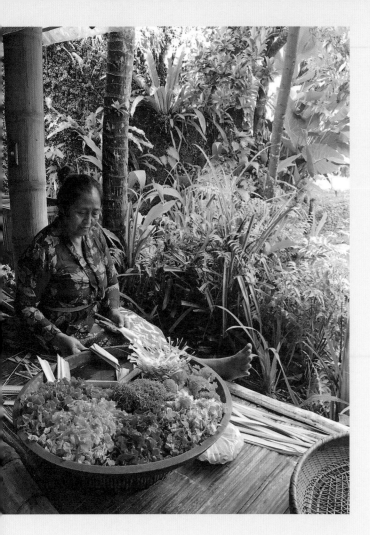

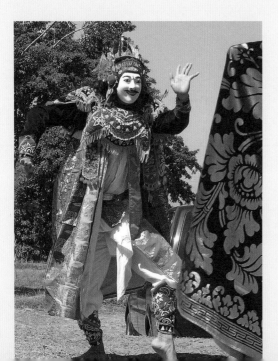

OFFERINGS & CELEBRATIONS

Religion is part of the fabric of Indonesian life, and with this comes extravagant, colourful celebrations. For Muslims in Java, the beat of an enormous drum heralds the evening breaking of Ramadan fast, calling people to food stalls for sticky rice cakes and sweet ices. For Balinese Hindus, the Galungan ceremony of good triumphing over evil is marked with bamboo poles outside every house beautifully decorated with flowers, fruits and coloured cakes, and banquets including sate and lawar (a spiced meat and coconut salad stained red with blood). For the Christian communities in Papua, the Christmas mass is followed by a village feast of pork, water spinach, ferns and sweet potatoes roasted in a fire pit between layers of hot stones.

All the Indonesian religions (Islam, Christianity, Buddhism and Hinduism) are underpinned to some extent by a foundation of animism. This means there is a respect for nature and unseen powers that can both help and harm human interests. Blessings are made for newly planted crops and big festivals of thanksgiving celebrate the harvest with dancing, music and food. Sumatrans have a traditional harvest dance where offering plates are twisted around as though glued to the dancers' hands, the sound of their rings ringing on the china.

Significant life events are also marked with religious feasts called *selematan*. In Java, when a mother reaches the seventh month of pregnancy she will be brought a large cone of turmeric-tinted rice surrounded by six little cones to be sliced and served to the gathering. It is the first of the many milestones that will be marked in the new baby's life.

The reason for these selematan is twofold: protection from the unseen and as an expression of communal solidarity. Gods, family and community are all given great weight and whole villages will come together to honour occasions with food. The cooking can take days and becomes a celebration in itself.

For spiritual offerings on a daily basis, nowhere maintains the practices as seriously as Bali, which is known as 'the island of gods'. Joyful processions often throng the streets to one of the myriad temple ceremonies, with people in traditional sarongs accompanied by music and dancing, mythical barongs. Every day there are exquisitely crafted flower petal offerings placed on the ground, on walls, in shrines. Usually in a small basket freshly woven from banana leaves, they can contain colourful petals, ribbons of scented pandan, oil, salt, money or sweets. They implore the good spirits for assistance with alluring frangipani and incense and appease evil spirits with worldly pleasures such as biscuits, vials of alcohol and clove cigarettes.

Almost everything has a spiritual meaning and the Balinese are very particular about spicing. When preparing food for a temple festival, all six tastes must be present in the correct proportions: salt, sweet, sour, hot, bitter and 'green banana', meaning astringent. This seems a good rule in Indonesian cooking even outside of festival food. Whilst you want the thrilling clash of big flavours, you should also look for a pleasing balance of tastes.

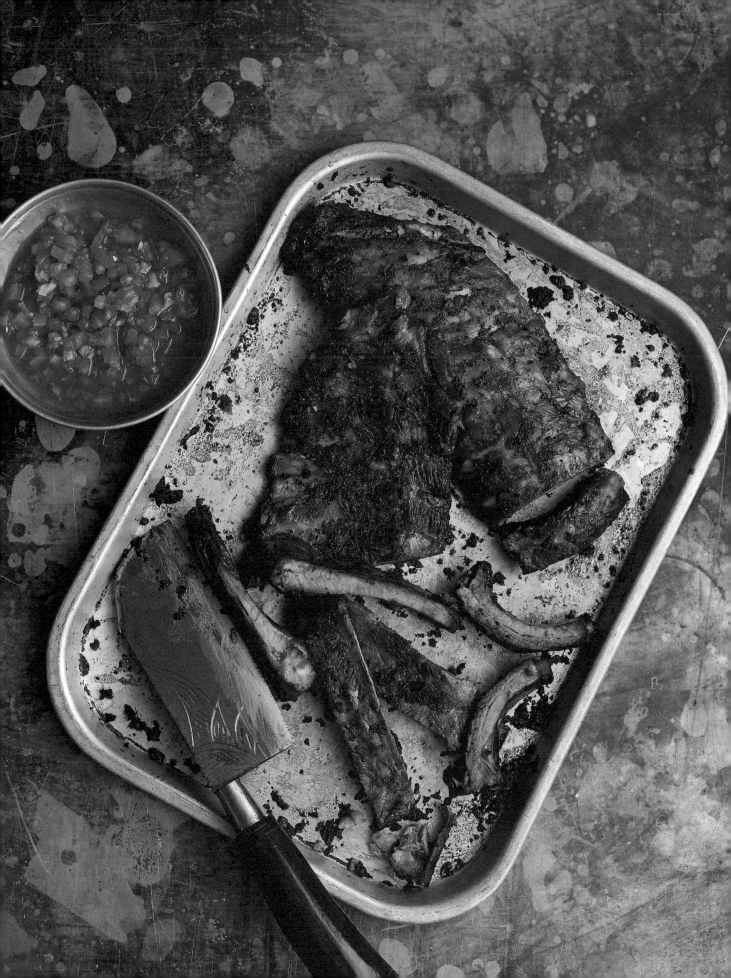

Fiery Sulawesi pork ribs

Serves 4

2 racks of baby back ribs

Bumbu spice paste
5 small red Asian shallots, peeled
5 garlic cloves, peeled
3–4 large red chillies, seeded
5 cm (2 inches) ginger, peeled
2 tablespoons dark palm sugar
 (gula jawa), shaved

Dabu dabu dipping sauce
3 tomatoes, finely diced
2 large red chillies, seeded and
 finely sliced
1 red bird's eye chilli, finely
 sliced (optional)
2 small red Asian shallots,
 finely chopped
juice of a lime
2 teaspoons dark palm sugar
 (gula jawa), shaved
1 teaspoon salt

If you like your food fiery, Mandano in Northern Sulawesi is the place for you. Here fragrant spices and heavy use of chilli typify the food for heat that hits you with shouts, not whispers. As many Minahasan people are Christian (alongside a common persuasion towards blood magic), halal dietary restrictions have not shaped the cuisine. This means bush meats from rats and bats to wild boar and python fill the butchers' markets. A little less exotic, these succulent barbecued pork ribs make a particularly good carrier for the big flavours.

Roughly chop the ingredients for the bumbu, then blend to a paste in a food processor. Add a little water to help it come together, if needed. Season generously with salt and black pepper.

Use a small knife to remove the membrane from the underside of the ribs. Smear half the bumbu into the ribs and lay them in a shallow oven dish. Cover tightly with foil and leave to marinate in the fridge for a few hours.

Preheat the oven to 150°C (300°F). Roast under the foil cover for 2½ hours. Baste once or twice during cooking. The fat should have melted leaving the meat very tender.

Meanwhile make the dipping sauce by combining all the ingredients and taste for heat, sweetness and tang.

Heat a barbecue, grill or griddle pan to high heat. Grill the ribs on both sides until they start to char and caramelise, then smear over the remaining bumbu. Continue grilling until the sauce is dry and fragrant. Eat with your fingers, dipping into the dabu dabu as you go.

Roast pork with turmeric, ginger & garlic

Serves 6

1.5–2 kg (3 lb 5 oz–4 lb 8 oz) pork belly cut from slimmer half, skin on
1 tablespoon oil
400 ml (14 fl oz) tin coconut milk

Basa gede spice paste
50 g (2 oz) small red Asian shallots, peeled
50 g (2 oz) candlenuts or blanched almonds
40 g (1½ oz) ginger, peeled
6 large garlic cloves, peeled
4 bird's eye chillies, half seeded
2 lemongrass sticks, trimmed and sliced
1½ tablespoons ground turmeric
1 tablespoon coriander seeds
1 teaspoon dark palm sugar (gula jawa), shaved
1 teaspoon salt
1 teaspoon black pepper
1 tablespoon oil

The crowning glory of Balinese cuisine is *babi guling*, a perfectly crackled, spice-scented, spit-roasted suckling pig. The whole pig is stuffed with a turmeric-gold paste known as *basa gede* or 'big spice mix'. Such a feast is usually saved for big events: weddings, funerals and tooth filing ceremonies are all cause to pig out. Here is my scaled-down version for the home cook, so there is no need to wait for a celebration.

Roughly chop the ingredients for the spice paste and whizz together in a food processor. Set a quarter aside in the fridge for the sauce.

Score the skin of the pork belly with a sharp knife for crisp crackling. Flip over and prick the meat with a sharp knife. Thickly spread over the spice paste, rubbing it into the meat. Roll the pork into a joint surrounded by skin and use butcher's string to tie tightly at regular intervals. Cover loosely with foil and marinate in the fridge for a couple of hours or overnight.

When ready to cook, preheat the oven to 200°C (400°F). Dry the skin well with paper towels and rub with plenty of salt. Sit on a wire rack over a roasting tray and cook for 30 minutes. Turn down to 180°C (350°F) and roast for a further 2 hours. Finally turn the heat up to 220°C (425°F) and give it a final blast for about 30 minutes to crackle the skin. Leave to rest for 20 minutes.

Meanwhile make the sauce by heating the oil in a pan. Add the reserved spice paste and fry for 5 minutes or until fragrant. Stir in the coconut milk and any juices from the roast pork. Simmer for 5 minutes and adjust the seasoning.

Serve the pork in thick slices with the sauce.

Menu ideas
Green bean lawar (page 150) is the most traditional accompaniment, but Water spinach with roasted tomato sambal (page 149) or Sweet coconut & basil salad (page 135) would also be excellent pairings.

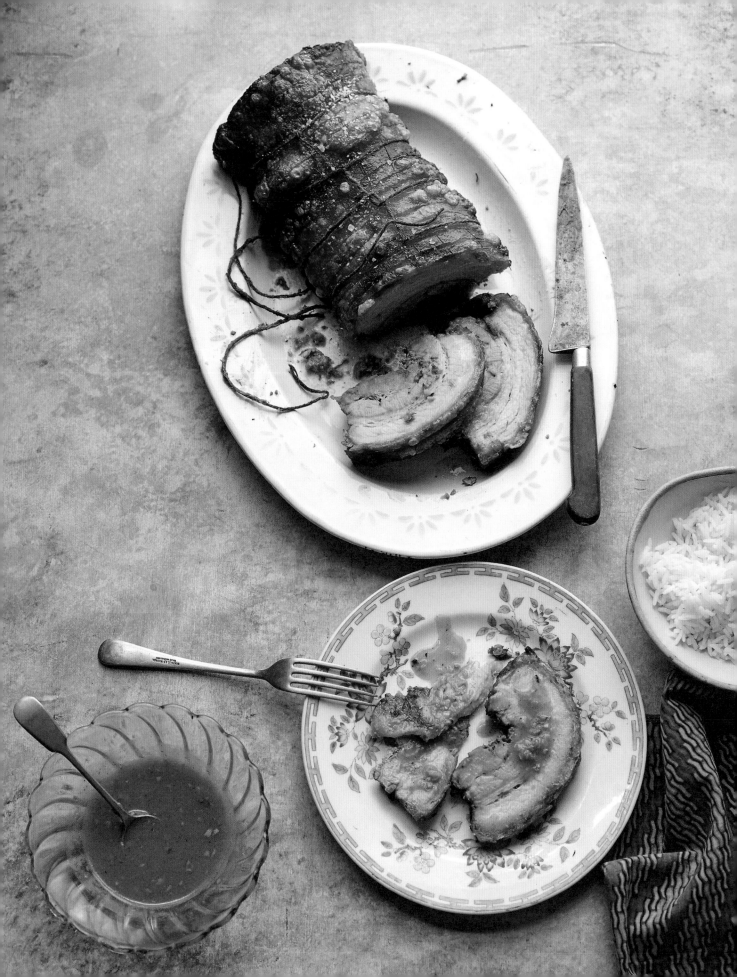

Barbecued sweet soy chicken

Makes 8 drumsticks

8 chicken drumsticks, skin on
2 tablespoons soy sauce
2 tablespoons kecap manis
2 tablespoons dark palm sugar
 (gula jawa), grated
1 tablespoon oil
2 garlic cloves, crushed
2 teaspoons coriander seeds, cracked
1 teaspoon black peppercorns, cracked

Sweet soy dipping sauce
4 tablespoons kecap manis
juice of ½ lime
1–3 bird's eye chillies, finely sliced

A no-fuss recipe for salty, sticky, glazed barbecued chicken. Cold, this makes perfect picnic food, or if I am serving it hot from the barbecue I like to make a dipping sauce where lime juice and chilli are a foil for the irresistible sweetness of kecap manis.

Slash each of the chicken drumsticks three or four times with a sharp knife and put into a bowl.

Mix together all the other ingredients to make a marinade and toss with the chicken. Cover and leave in the fridge for at least 2 hours or overnight if you can. Bring up to room temperature before cooking.

Heat a barbecue until the coals are dusty grey and smouldering hot. Cook the drumsticks for about 20 minutes, turning as needed. Baste occasionally with the leftover marinade to build up a sticky, dark coating. You want the chicken to be charred and crisp but if it is colouring too quickly, move to a cooler part of the barbecue to cook more gently. Use a skewer to make sure there are no pink juices and the chicken is cooked through (a meat thermometer should read 74°C/165°F).

Meanwhile mix all the ingredients together for the dipping sauce. Serve alongside the chicken.

Note
Alternatively, you can roast the chicken with its marinade in the oven at 200°C (400°F) for 50 minutes. Turn and baste with the marinade and juices several times during cooking.

Menu ideas
Leave the chicken to cool before packing up for your picnic. Also take the Sweet coconut & basil salad (page 135), Acar pickles (page 191) and lots of emping crackers. You'll probably want either Peanut sauce (page 179) or a chilli sambal to dip them in. A thermos of icy Bir pletok (page 228) and some tropical fruits will finish it off perfectly.

Spice-stuffed smoked duck

Serves 4

1.25 kg (2 lb 12 oz) duck
1½ tablespoons tamarind paste
1 large oven smoking bag

Bumbu spice paste
10 garlic cloves, peeled
8 small red Asian shallots, peeled
thumb of ginger, peeled
thumb of galangal, skin scrubbed
thumb of turmeric, peeled,
 or 1 tablespoon ground turmeric
5 large red chillies, seeded
2 red bird's eye chillies
2 tablespoons oil
1 tablespoon kecap manis
1 tablespoon dark palm sugar
 (gula jawa)
1 tablespoon sesame seeds
1 teaspoon ground coriander
1 teaspoon smoked salt
1 teaspoon ground black pepper
pinch of ground cloves
grating of nutmeg

For special ceremonial occasions in Bali, cooking becomes a community activity and elaborately prepared dishes are crafted to honour the gods. *Bebek betutu* is one such creation, where duck is bathed in a spice paste and cooked for a whole day in a terracotta pot buried under rice husk embers. The meat is unbelievably tender and imbued with smoke and spice. I have adapted the traditional technique for a home oven with a smoking bag (or covered roasting tray) making it a more manageable feast, but a feast nonetheless.

Preheat the oven to 150°C (300°F).

Rub the duck skin all over with the tamarind paste and a scrunch of salt. Set aside at room temperature whilst you prepare the bumbu.

Roughly chop the aromatics for the bumbu and put everything in a blender with 275 ml (generous 1 cup) water. Whizz to a thin paste.

Paint the bumbu all over the outside of the duck, stuffing the rest into the cavity.

Tuck the duck and its spicy coating into an oven smoking bag and seal closed. Alternatively, place in a roasting tin in which it will sit quite snugly and cover tightly with a double layer of tin foil. Cook for 4 hours – it should be meltingly tender. Spoon off the top layer of melted fat, shred the meat and serve with its spicy sauce.

Menu ideas
For a full Balinese feast, serve the duck alongside Yellow coconut rice (page 159), Acar pickles (page 191), Green bean lawar (page 150), Lemongrass fish sate (page 45) and Balinese lemongrass sambal (page 178).

Ayam taliwang

Serves 4

1.5 kg (3 lb 5 oz) chicken
3 tablespoons oil
10 garlic cloves, peeled
5 large red chillies, halved and seeded
2 dried red chillies
2 red bird's eye chillies, stems removed
2 cm (¾ inch) kencur (optional)
6 candlenuts or 10 blanched almonds
1 teaspoon shrimp paste
3 lime leaves
3 salam leaves (optional)
2 tablespoons oyster sauce
2 tablespoons soy sauce
2 tablespoons coconut milk
juice of a lime, plus extra to serve

Two worlds are divided by the ribbon of water that separates Bali and Lombok. A pair of perfect volcanic cones, their peaks shrouded in cloud, stand like giant sentinels guarding the narrow Lombok Strait between the two islands. To the west lie the Asian lands of elephants, tigers and orangutans, to the east the Australasian lands of marsupials, cockatoos and komodo dragons. On the short boat ride across you pass over the Wallace Line that demarcates these two ecosystems. When English naturalist Alfred Wallace made this journey in the nineteenth century he was struck by the complete change in flora and fauna, sparking revolutionary work on evolution. For all the natural splendour of Lombok, it is ayam taliwang that captivated me most. It is not only its name that is irresistible, this is truly everything you could hope for in grilled chicken. The skin is burnished and glazed, contrasting with succulent meat inside. There is a fiery smack of charred chilli and deeply smoky savouriness from the garlic. Putu, a chef in Lombok for forty years, shared his mother's recipe with me, which I have adapted to cook in the oven at home.

Lay the chicken on a large board, breast side down. Use kitchen scissors to remove the backbone by cutting down either side of it. Flip the bird and press firmly on the breast to flatten. Season and rub with a little oil. Set aside to come to room temperature whilst you make the sauce.

Heat half the oil in a frying pan and add the garlic, chillies, kencur, candlenuts and shrimp paste. The garlic cloves go in whole, the dried and bird's eye chillies have their seeds in. Cook until the garlic is slightly browned and everything is aromatic. Leaving the oil behind in the pan, transfer to a blender and add a pinch of salt and 250 ml (1 cup) water. Blitz until smooth.

Return to the pan with the residual oil and add the lime and salam leaves. Cook on a medium heat, stirring, to thicken. Once it has lost its rawness, turn down the heat, add the oyster and soy sauces and coconut milk. Simmer for a few minutes, then turn off the heat. Scrape three quarters into a bowl, stir in the juice; season. To the pan, add the rest of the oil to make a marinade.

Preheat the oven to 200°C (400°F). Heat an ovenproof griddle or large pan (cast iron is ideal) and when sizzling hot lay in the chicken, breast side down. Use a spatula to press the skin into the pan, letting it turn golden, blister and crisp – about 4 minutes. Paint the underside of the chicken with the red oily marinade, then flip and paint the rest on top. Transfer to the oven to cook.

Check after 35 minutes. When cooked through the juices will be clear and if you have a meat thermometer it should reach 74°C (165°F). Leave the chicken to rest for 15 minutes before serving with the sauce and an extra spritz of lime.

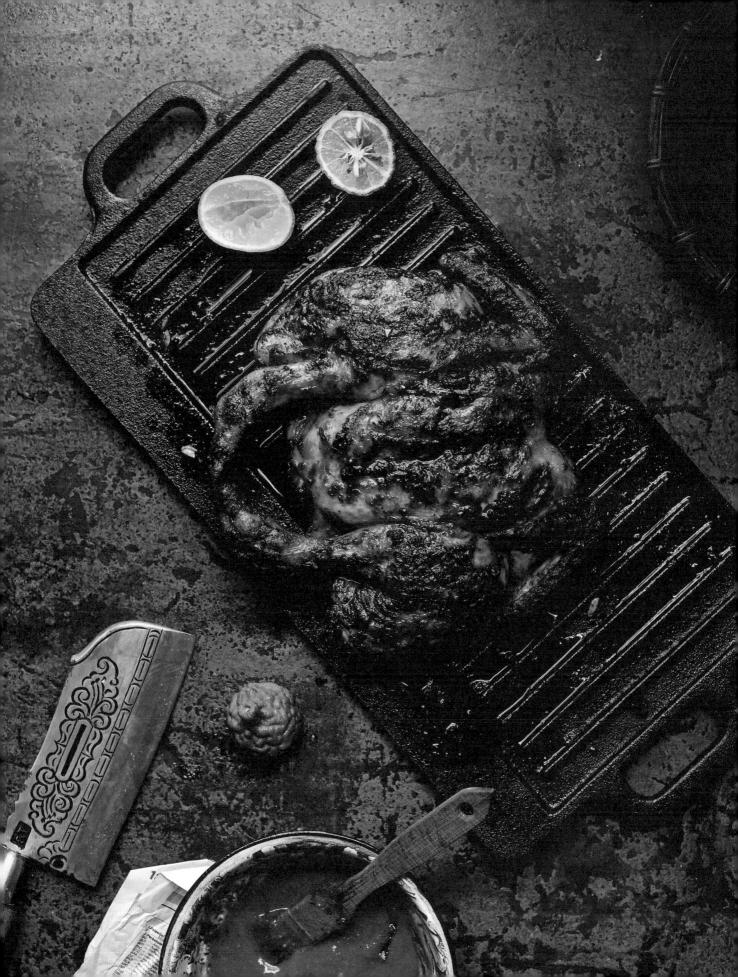

Five minute stir-fry beef

Serves 2

300 g (10½ oz) finely minced
 lean beef
1 tablespoon oil
6 garlic cloves, finely chopped
1 large red chilli, seeds in, finely sliced
1 red bird's eye chilli, seeds in,
 finely sliced (optional)
2 tablespoons kecap manis
1 tablespoon soy sauce
handful fresh beansprouts
large bunch of Thai basil,
 leaves picked
juice of a lime

A wonderful Indonesian phrase is *jam karet,* meaning 'rubber time'. It describes a relaxed attitude to timing, flowing through life like a meandering river enjoying the journey rather than worrying unduly about speed or punctuality. This is a recipe for the opposite of days, a stir-fry that gets a flavour-packed meal on the table in five minutes flat.

Get your ingredients ready before you start cooking as it'll move quickly. Season the beef with a little salt.

Heat the oil in a wok over medium-high heat and swirl to coat. Add the garlic and chilli and cook for just a moment before adding the beef. Quickly break up the meat, incorporating the garlic, then turn the heat to high. Allow the beef to properly brown and caramelise before stirring again. Once it has good colour all over and some flavourful crusty brown bits, stir in the remaining ingredients. The beansprouts will wilt slightly in the heat of the pan.

Serve at once with noodles or crisp salad leaves.

Jackfruit steaks

Serves 4

4 small wedges of young jackfruit
oil, for grilling

Bumbu spice paste
2 small red Asian shallots, peeled
2 garlic cloves, peeled
1 large red chilli, seeded
1 bird's eye chilli (optional)
4 cm (1½ inches) galangal,
 skin scrubbed
3 cm (1¼ inches) turmeric, peeled,
 or 1 teaspoon ground turmeric
3 cm (1¼ inches) ginger, peeled
½ teaspoon coriander seeds
3 tablespoons oil

Amongst the bounty of fresh produce that comes into the Bambu Indah hotel kitchen daily are spiky orbs in brilliant lime green. These are unripe jackfruit, which have firm flesh that becomes pull-apart tender when cooked, rather like an artichoke. With this simplest treatment, the ladies in the kitchen transformed wedges of jackfruit into the most incredible charred and smoky steaks. This is a recipe waiting for the day when you can find the fruit fresh.

The jackfruit has a rubbery sap that is beastly to remove, so oil your hands, knife, chopping board and anything else the jackfruit will touch! Trim off the rind and cut into four chunky steaks, including the seeds.

To make the bumbu spice paste, roughly chop all the fresh ingredients. Put everything in a food processor and blend to a purée. Season with salt and pepper. Cook in a pan for 5–10 minutes, stirring often, until the mixture darkens slightly and the oil begins to separate from the paste.

Remove half of the bumbu and set aside. Add the jackfruit to the pan and cover with water. Bring to the boil and cook for 15 minutes, or until tender, topping up the water as needed. Drain.

Rub the steaks with the remaining bumbu and season with salt.

The best results are indisputably on a barbecue – add coconut fibres or wood chips for the wonderful smoky notes – but you could also griddle over a high heat. When searing hot, brush your grill with a little oil and cook the jackfruit over a direct heat. Turn until charred and golden on all sides.

Menu ideas
Make a barbecue meal, serving this alongside sate (pages 42–45), Ayam taliwang (page 86) or Barbecued sweet soy chicken (page 84) and Fiery Sulawesi pork ribs (page 81). To accompany, choose Acar pickles (page 191), Sour & spicy pineapple relish (page 186) and Yellow coconut rice (page 159).

Cardamom – *kapulaga*

This floral-peppery spice came to Indonesia by way of the Indian spice traders. Whilst in India it is most often used in milky sweets, here it finds its way into savoury dishes. The pods can be cracked and added whole or the sticky black seeds inside can be ground for a more intense aroma. It is always tempting to add a little more to harness its mysterious flavour, but use too much and the musky aroma is replaced by a medicinal taste. Like all seductive perfumes, it is best used sparingly.

Cinnamon/cassia – *kayu manis*

Translating as 'sweet wood' the kayu manis used in Indonesia is primarily the native cassia rather than the true Sri Lankan cinnamon. Both are reddish-brown quills of sweet, spiced tree bark. Cassia is thicker and coarser with a slightly more pronounced taste that suits the big flavours of Indonesian cooking well, but use whichever you can find.

Clove – *cengkeh*

An Indonesian native, one of the Old World's most revered spices was once only grown on two small islands in the Moluccas. This dried flowerbud of a tropical tree has a warm pungent flavour that punctuates savoury rather than sweet dishes in Indonesia. Its most common use is in *kretek* cigarettes that are said to cool the throat after a hot meal. They crackle when smoked, giving off a tobacco-clove aroma that is a signature scent of the country.

Coriander seed – *ketumbar*

The roots and leaves are not much used, but the seeds are a favourite for their earthy, lemony taste. They were brought over from India by the spice traders and have found a comfortable home in Javanese and Balinese food, where they feature heavily in spice pastes. In so many cuisines, cumin and coriander are always paired together, but I like how Indonesian food often pulls out coriander seed to have a starring role on its own. It is worth grinding your own seeds to get the full aroma, which is quickly lost once ground.

Cumin – *jinta putih*

Another spice brought from India, it is in the west of Indonesia where cumin is most used. The sweetness of coconut milk curries is often offset by a pungent, earthy, almost bitter hit of cumin seeds. Cumin leaves are also used in Bali and North Sulawesi.

Fennel seed – *adas manis*

It was the Arab traders who introduced this quietly sweet, liquorice-scented spice from southern Europe. The pale green seeds are used in some curries, particularly pairing with lamb or goat.

Nutmeg & mace – *pala*

Along with cloves and pepper, nutmeg was the cause of centuries of global trade and conquest. The Banda Islands in eastern Indonesia are the original home of the fragrant brown seed and three-quarters of the world's supply are grown in Indonesia to this day. Surrounding the seed is a lacy web of red mace, then a tart and spiced yellow fruit, which is prized as much as, or perhaps more than, the seed in the islands where they grow (the mace on the other hand is not much used locally). Use nutmeg to add warmth and scent to curries, meats and cakes. The seed can either be finely grated or cracked and added in large pieces to infuse the cooking liquid in a similar way to a cinnamon stick.

Star anise – *bunga lawang*

A beautiful eight-pointed star with an intense liquorice flavour. The fragrance usually takes your mind to Chinese cooking, but Indonesians, particularly Sumatrans and West Javanese, also use these dried flowers to scent meat braises.

Spice Islands tuna

Serves 4

4 x 125 g (4½ oz) tuna steaks,
 cut 3 cm (1¼ inches) thick,
 skin removed
4 tablespoons tamarind paste
2 tablespoons soy sauce
oil, for frying

In the Spice Islands of Eastern Indonesia, simple preparations triumph over complex spice pastes. Here tuna is marinated in the soft tangy pulp of the tamarind fruit. In the heat of the pan it caramelises to a gentle sweetness. Choose tuna steaks with visible streaks of fat, which will keep the tuna succulent as it cooks.

Coat the tuna fillets in a mixture of the tamarind and soy sauce. Cover and leave to marinate at room temperature for up to an hour. Discard any excess marinade before cooking.

Set a frying pan over a high heat and add a thin layer of oil. When it is shimmering hot, carefully lay in the tuna fillets. Cook for just over 1 minute on each side. This should leave a dark and sticky caramelised crust and the insides rare and tender.

Menu ideas
Serve alongside Sweetcorn rice (page 162) and Sour & spicy pineapple relish (page 186). Or you could cook the tuna on the barbecue instead and serve alongside Jackfruit steaks (page 89) and maybe a curry dish such as Scallops gulai (page 65).

Blackened snapper with colo colo sambal

Serves 2

1 whole red snapper or bream
(about 600 g/1 lb 5 oz), gutted,
cleaned and scaled
1 lime
1 teaspoon ground turmeric
1 tablespoon oil

Colo colo sambal

2 tomatoes, chopped
2 small red Asian shallots, chopped
2 bird's eye chillies, seeded and sliced
2 sprigs lemon basil, leaves chopped
2 tablespoons kecap manis
2 tablespoons lime juice

The deep seas surrounding the Spice Islands in Eastern Indonesia have the best fish you could hope to eat anywhere. Malukun people know that only the simplest cooking is needed for spectacular results. Fresh from the water, whole red snappers are grilled, usually over coconut embers, until charred and smoky-sweet. A wonderfully vibrant tomato sambal is spooned over for a fresh kick.

Slash the fish on the diagonal to make three or four slits on each side. Halve the lime and cut one half into slivers. Rub the turmeric and a pinch of salt into the fish and stuff the lime pieces into the slits. Tuck any remaining pieces into the cavity along with a little more salt. Squeeze over the remaining lime juice then brush the fish with oil. Set aside whilst you make the sambal.

Combine all the ingredients for the colo colo sambal and taste for seasoning. You are after a fresh and punchy sauce with a salsa-like consistency.

Preheat a griddle pan or barbecue. Cook the fish without moving for about 7–10 minutes until the skin is charred and the fish inside the slits on the lower side looks white and flaky. Carefully turn with a wide spatula, trying not to tear the skin, and cook the other side for 7–10 minutes. Serve with the colo colo sambal spooned over the top.

Golden vegetable stir-fry

Serves 4

2 tablespoons oil
1 egg
1 lemongrass stick, trimmed
 and well bruised
2 lime leaves
½ teaspoon salt
1 teaspoon sugar
200 g (7 oz) sweetcorn, fresh or defrosted
100 g (3½ oz) baby corn, sliced into
 3 cm (1¼ inch) on diagonal
100 g (3½ oz) carrots, cut into julienne
50 g (2 oz) fine green beans, sliced into
 3 cm (1¼ inches) on diagonal
2 spring onions (scallions), sliced into
 3 cm (1¼ inches) on diagonal
3 tablespoons Chinese celery
 leaves, shredded

Bumbu spice paste

3 cm (1¼ inches) turmeric, peeled,
 or 1 teaspoon ground turmeric
2 garlic cloves, peeled
3 candlenuts or 6 blanched almonds
1 teaspoon coriander seeds
½ teaspoon peppercorns

Sunshine colours of gold, orange and turmeric-stained yellow sing in this vegetable stir-fry. A good accompaniment for a rich meal.

Start by making the bumbu spice paste. Roughly chop all the ingredients and use a pestle and mortar to grind them to a rough paste.

Heat a wok over a medium-high heat. Add the oil and scramble the egg until dry and crumbly (I know this will be against your instincts, but go with it). Add the bumbu, whole lemongrass and lime leaves and mix well. Season with the salt and sugar.

Add the sweetcorn, baby corn and carrots and stir-fry until beginning to soften. Don't be concerned by a crowded pan; this is typical in Indonesia unlike the flash stir-fries of China. Add the green beans and spring onions and continue to stir-fry until cooked through.

Serve scattered with Chinese celery leaves.

Menu ideas

For a vegetarian meal it makes a good pairing for Padang-style eggs (page 74) or Tofu fritters (page 37). Or try it alongside Lemongrass fish sate (page 45) or Roasted coconut chicken (page 57). I can happily eat this on its own too, in which case this amount serves two.

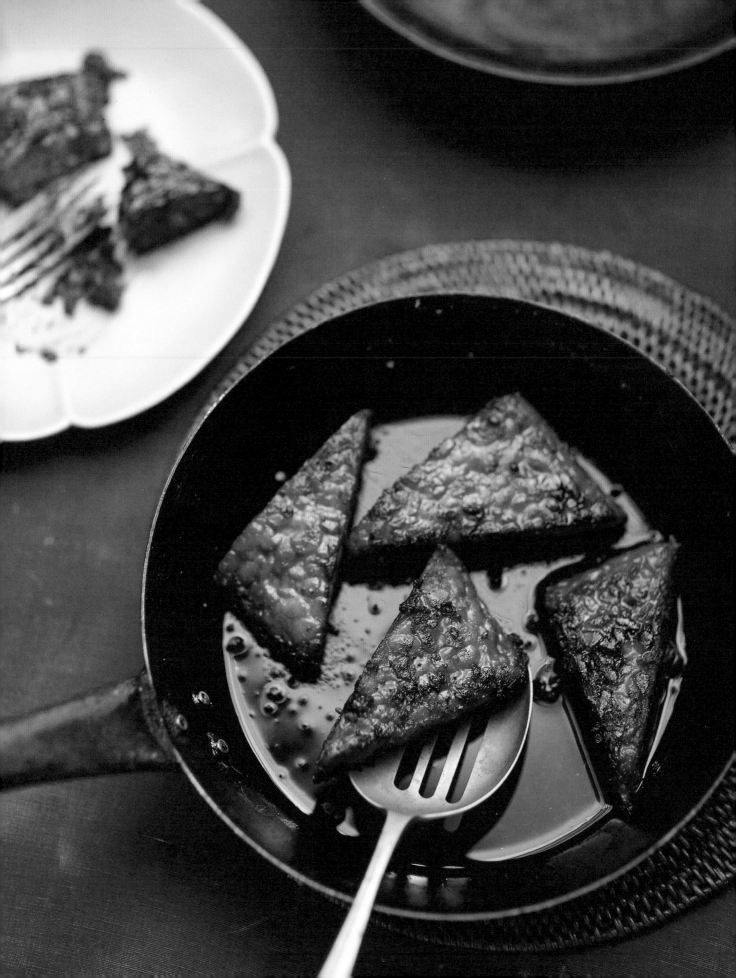

Java spiced tempeh

Serves 4

250 g (9 oz) tempeh
1 lemongrass stick, bruised and
 tied in a knot
2 salam or lime leaves
75 g (2½ oz) dark palm sugar (gula jawa)
1 teaspoon salt
250 ml (1 cup) fresh coconut
 water (optional)
oil, for frying

Bumbu spice paste

3 small red Asian shallots, peeled
3 garlic cloves, peeled
1 teaspoon coriander seeds
½ teaspoon black pepper
2 candlenuts or 4 blanched almonds

Because of tempeh's nutritional credentials, you can find it in most health food shops. This Indonesian staple is a firm vegetarian protein made of fermented soya beans, but don't dismiss it as beige and bland. Unlike tofu, it is textured with the whole beans and has a savoury, nutty edge. Here it is twice-cooked, first braised to infuse with sweet spice and then fried to crunch and caramelise the edges. The combination is irresistible.

Start by making the bumbu spice paste. Roughly chop the fresh ingredients then whizz everything together in a food processor or high-speed blender, adding as much water as needed to help everything come together to a rough paste.

Slice the tempeh into triangles, about the size of a samosa. Put into a pan and scrape in the bumbu. Add all the remaining ingredients apart from the oil and top up with enough water to half cover the tempeh. Bring to the boil and cook at a good bubble for 1–2 hours, carefully stirring occasionally. The braising liquid will darken and reduce, in the end leaving only a thick sauce coating the tempeh, which will be tender and spice-infused. Add a little more water if it is reducing too quickly.

The tempeh can be eaten now, but the sweetness is mellowed and flavour enhanced by frying. When you are ready to eat, heat 1 cm (½ inch) oil in a frying pan and brown the slices for a few minutes on each side.

Menu ideas

Make a substantial vegetarian feast by serving alongside rice, Padang-style eggs (page 74), Sumba creamed corn (page 142), Rica rodo (page 143) and a spicy sambal.

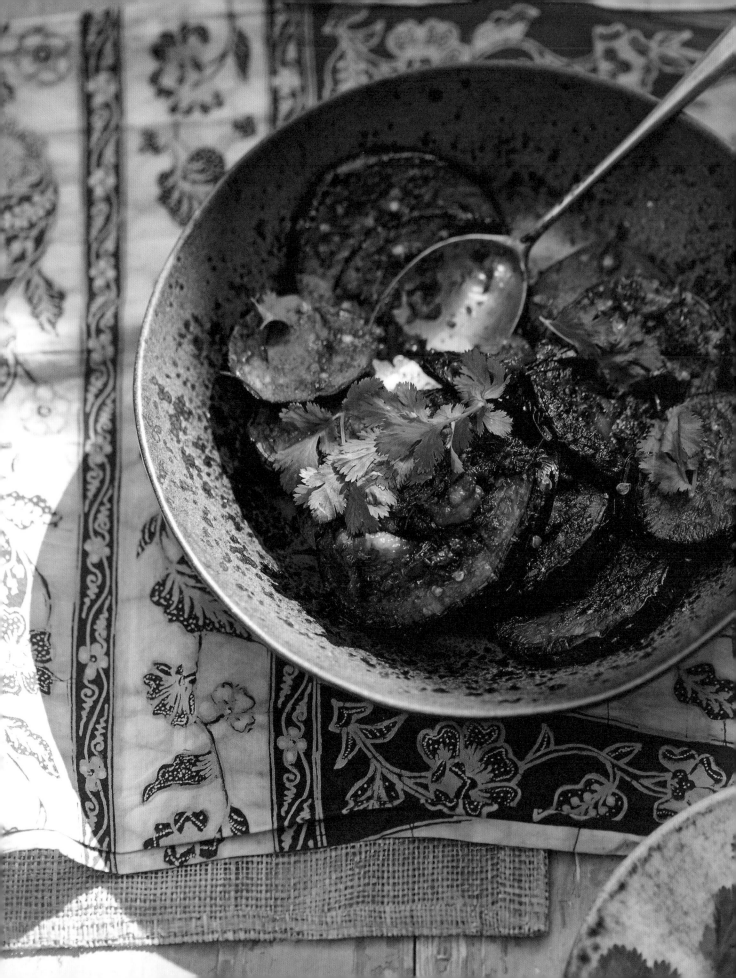

Aubergine with shrimp paste

Serves 2

4 tablespoons oil
200 g (7 oz) aubergine
 (eggplant), sliced into
 1 cm (½ inch) thick rounds
1 teaspoon shrimp paste
2 lime leaves, deveined and
 finely shredded
½ teaspoon dark palm sugar
 (gula jawa), shaved
juice of ½ a lime
coriander (cilantro), to serve

Bumbu spice paste
1 tomato
1 large red chilli, seeded
1 small red Asian shallot, peeled
1 garlic clove, peeled

Terasi (dried shrimp paste) usually lies in the background in Indonesian cooking, adding an undetectable savoury note that brings other flavours into sharp focus. Like fish sauce, the smell is pungent and not to everyone's taste, but in combination it works its magic and can become addictive. Here is a dish for terasi's admirers, where it takes on a starring role alongside silky stir-fried aubergine (eggplant).

In a frying pan over a high heat, add half the oil and swirl to coat the pan. When hot, add the rounds of aubergine in a single layer, cooking in batches if necessary. Cook for about 5 minutes, turning occasionally, until the skin is wrinkled and the flesh is golden and tender. Set the aubergine aside.

To prepare the bumbu spice paste, roughly chop all the ingredients and crush to a rough paste with a good pinch of salt using a pestle and mortar, food processor or high-speed blender.

Return the frying pan to medium heat and add the remaining 2 tablespoons oil. Add the shrimp paste, use a spoon to break it up and let it sizzle in the heat. Add the tomato chilli bumbu and cook, stirring, for a few minutes. Add the lime leaves, palm sugar and about 4 tablespoons water. Return the aubergine to the pan and splash over the lime juice. Stir-fry until the aubergine is completely cooked and the sauce clings to it.

Serve with a verdant scattering of coriander leaves.

FRAGRANT BROTHS
& TANGY SAUCES

Chapter Four

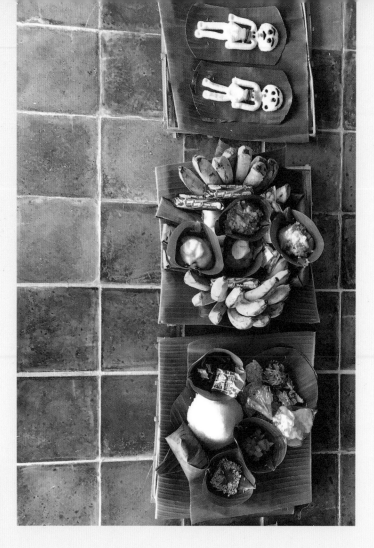

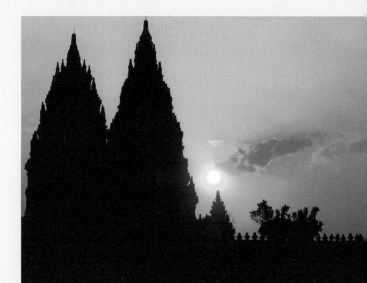

EATING *in the* ROYAL COURTS

Indonesia is home to numerous dormant kingdoms. So extensive are royal families that I have often found myself dining with a Balinese price or Sumatran princess, but it is in Java where the trappings of royal rule are most closely maintained. The sultans' residences are the traditional palace complexes, known as Kraton, and important events are celebrated with much pomp and circumstance. The Sultan of Yogyakarta keeps dwarves and albinos at court to harness their mystical powers. In the Palace of Solo, rice towers twice the height of a man are served on feast days.

I met with Princess Moertiyah of Solo in her palace office, watched over by ancestral sultans from their gilt frames. Sugary tea and snacks were brought for us: bamboo shoot spring rolls and spongy coconut pancakes. She tells me that whilst celebratory meals have about 30 different dishes, daily food in the Kraton is no different to home cooking found elsewhere. Unlike much of Asia, Indonesia's cuisine is one of the people rather than influenced by the royal kitchens. The king chooses his food and which of his wives will serve him each day. Her father favours Dutch comfort food (a legacy of the close ties between the royal families and colonialists); macaroni cheese is apparently a palace favourite.

I had the rare privilege of being invited into the Kraton kitchen on a day when *sesaji*, or offering foods, were being prepared. Twice weekly, elaborate dishes are made for the 'unseen' or spirits to keep harmony between the living and the dead.

Palm leaf platters carpeted the floor, each topped with edible arrangements. Parcels of steamed root vegetables sweetened with palm sugar, mounds of grated coconut piled on brown and white *serapi*, black soya beans crisped with tamarind and sea salt. A *bekakak* man and wife were modelled with anatomical detail in sticky rice and food colouring.

The royal kitchen compound is four hundred years old, the kitchen itself older. Sun streamed through the open roof tiles and the air was filled with the aroma of steaming rice from the cone-lidded pan of *nasi liwet* cooking over glowing coals. Old teak wardrobes bristled with kitchen equipment. Small fish were laid out on tiles to dry in the sun. Traditional stoves were left unused as freestanding terracotta braziers burned, each fanned by a female chef squatting low on the floor.

Royal cooking is a woman's job. The seventy-seven-year-old head chef is the ninth-generation cook in her family to hold the honorific 'Chief Taster'. Her daughter cooks in the palace also and one day her granddaughter will follow. She tells me the recipes we are making today haven't changed over the passing generations: 'The food is for the spirits and they don't like change.'

Timur tamarind fish broth

Serves 4

1.5 litres (6 cups) fresh fish or
 chicken stock
1–2 tablespoons tamarind paste
1 tablespoon dark palm sugar (gula jawa)
3 small red Asian shallots, finely sliced
2 garlic cloves, finely sliced
200 g (7 oz) catfish, grouper or cod fillets,
 cut into chunks
2 ripe tomatoes, cut into thin wedges
juice of a lime
handful lemon basil or Thai basil
 leaves, to serve
1–2 bird's eye chillies, sliced, to serve
extra lime wedges, to serve

From Nusa Tenggara Timur, and in particular the far eastern island of Alor, there is this blissfully simple soup of fish poached in a tangy, spicy broth. Make sure you use good stock and adjust the tastes as you go, as getting the balance of sweet and salty right will help make the sourness of the tamarind and lime come alive.

Pour the stock into a large pan and add 1 tablespoon of the tamarind paste, the palm sugar, shallots and garlic. Season with salt if the stock isn't already. Bring to the boil, then reduce the heat and simmer for 5 minutes. Taste and adjust the seasoning. Tamarind pastes vary in strength so add as much as is needed to get a pleasingly tangy broth balanced by just a little sweetness.

Lower in the fish, bring back to a simmer and poach for about 3 minutes, until almost cooked through. Add the tomatoes and cook for another minute. Remove from the heat, squeeze in the lime juice and taste again for seasoning.

Serve in soup bowls with lemon basil, sliced chilies and lime wedges at the table for people to add to their own bowls. A little chilli goes a long way in a hot broth, so add judiciously.

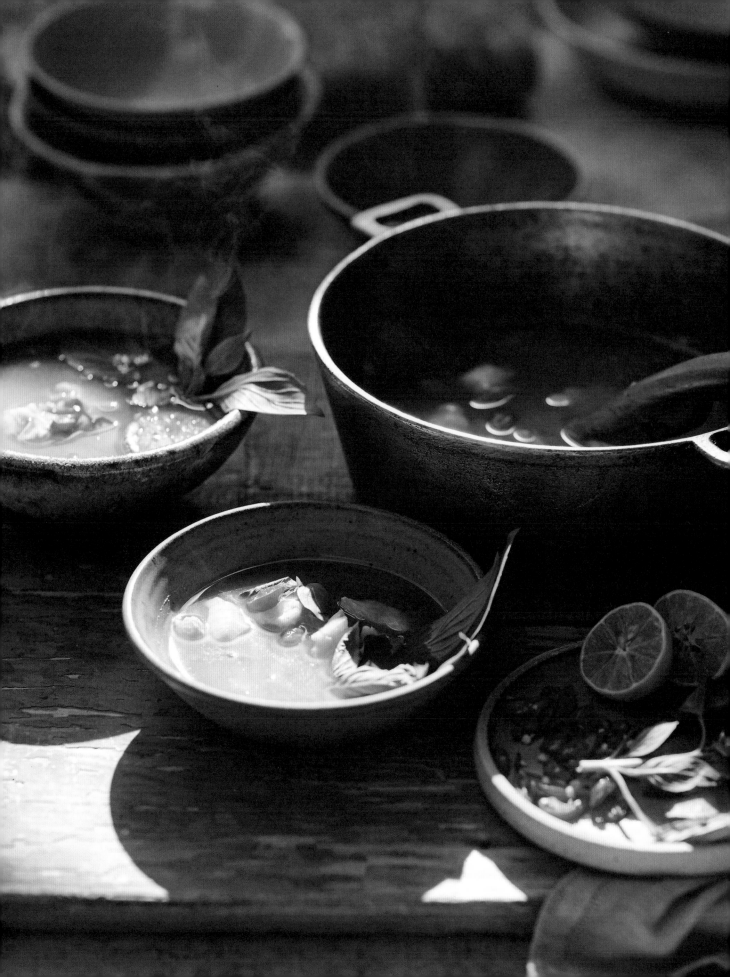

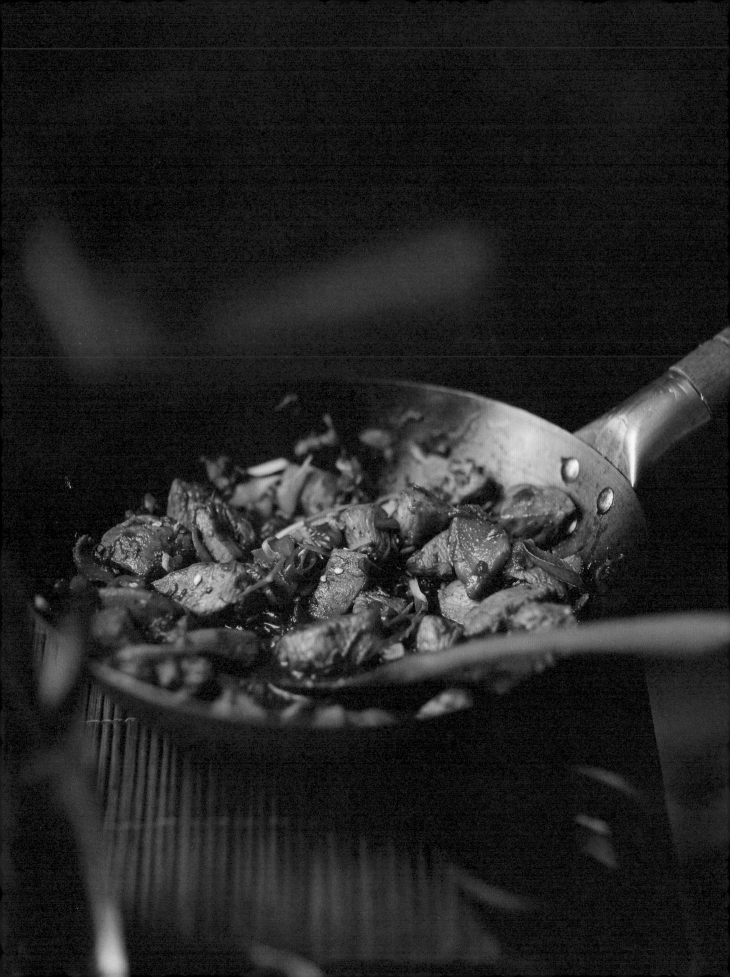

Sweet ginger chicken

Serves 4–6

4 chicken breasts, cut into chunks
2 tablespoons oil
1 onion, finely chopped
7 garlic cloves, sliced
8 cm (3¼ inches) ginger, peeled, sliced
 thickly and smashed
1 large red chilli, seeded and sliced
3 spring onions (scallions), sliced
1 large tomato, roughly chopped
2 tablespoons oyster sauce
1 tablespoon soy sauce
1 tablespoon dark palm sugar
 (gula jawa), shaved
1 tablespoon kecap manis

The Chinese influence on this chicken stir-fry is clear, but the sauce has an added treacly depth from Indonesian palm sugar and kecap manis. It is dark and glossy and permeated by the husky heat of fresh ginger. A perfect speedy supper, popular with children.

Season the chicken with salt and black pepper. Prepare all the other ingredients for stir-frying as you'll need to move quickly once it gets going.

Heat the oil in a large wok or frying pan over a high heat. Stir-fry the chicken until half cooked through, then remove from the pan, leaving the oil behind.

Over a medium heat, soften the onion. Add the garlic and smashed ginger slices and cook for a minute. Then add the chilli and spring onion and stir through. Finally, in goes the tomato. Stir-fry everything for a minute more.

Return the chicken to the wok and add 175 ml (¾ cup) water. Season with oyster sauce, soy sauce and palm sugar: umami, salty, sweet.

Bubble until the chicken is cooked through and succulent and the liquid has reduced to a glossy sauce. Finally, stir through the kecap manis and taste for seasoning.

Menu ideas
Serve with Mie goreng (page 169) or make a vegetable stir-fry known in Indonesia as *cap cai* – wok-fry spring onions (scallions), ribbons of chilli and lots of garlic, add a colourful variety of seasonal vegetables and perhaps some black fungus. Season with oyster sauce and soy sauce.

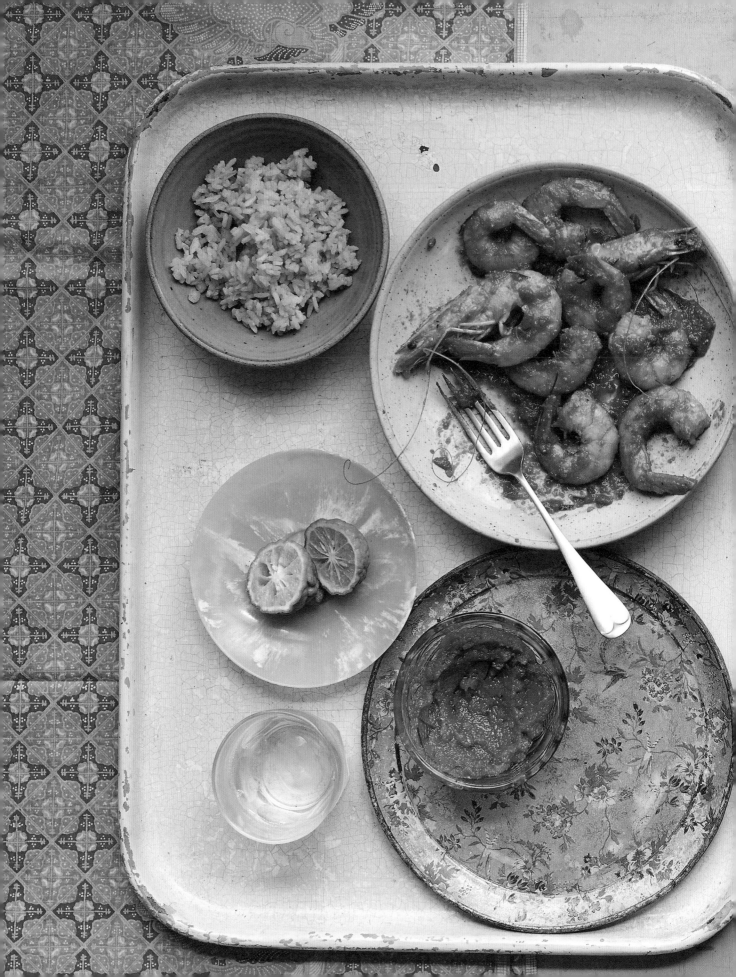

Prawns with red chilli sambal

Serves 4

10 small red Asian shallots,
 roughly chopped
6 garlic cloves, roughly chopped
9 large red chillies, seeded
3 large tomatoes, roughly chopped
3 tablespoons oil
3 lime leaves, deveined and
 finely shredded
1½ teaspoons sugar
360 g (13 oz) peeled raw prawns
juice of 1–2 limes

This speedy dish is packed with zesty, spicy South-East Asian flavours. It has definite heat from all those chillies, but not eye-wateringly so. Carefully remove the seeds and surrounding membrane so it is the taste rather than fire that hits you.

In a food processor or high-speed blender, blitz together the shallots, garlic, chillies and tomatoes to a rough paste.

Heat the oil in a large frying pan over a medium heat. When hot, scrape in the paste and add the lime leaves. Season with the sugar, salt and black pepper. Cook for about 10 minutes, stirring often, until it darkens a shade and has lost its rawness – the aroma should be sweet rather than harsh.

Loosen the sambal with a good splash of water, enough to help it form a thick sauce. Add the prawns and simmer for about 5 minutes or until the prawns lose their glassiness and are just cooked through and pink. Squeeze in the lime juice and taste to see if any of the flavours need balancing – sweet, salty and sour. Serve at once.

Menu ideas
Try this with Yellow coconut rice (page 159) for a good colour contrast. Pungent and fresh, it makes a neat pairing for something rich like the Snake beans with coconut milk (page 121) or Beef rendang (page 52).

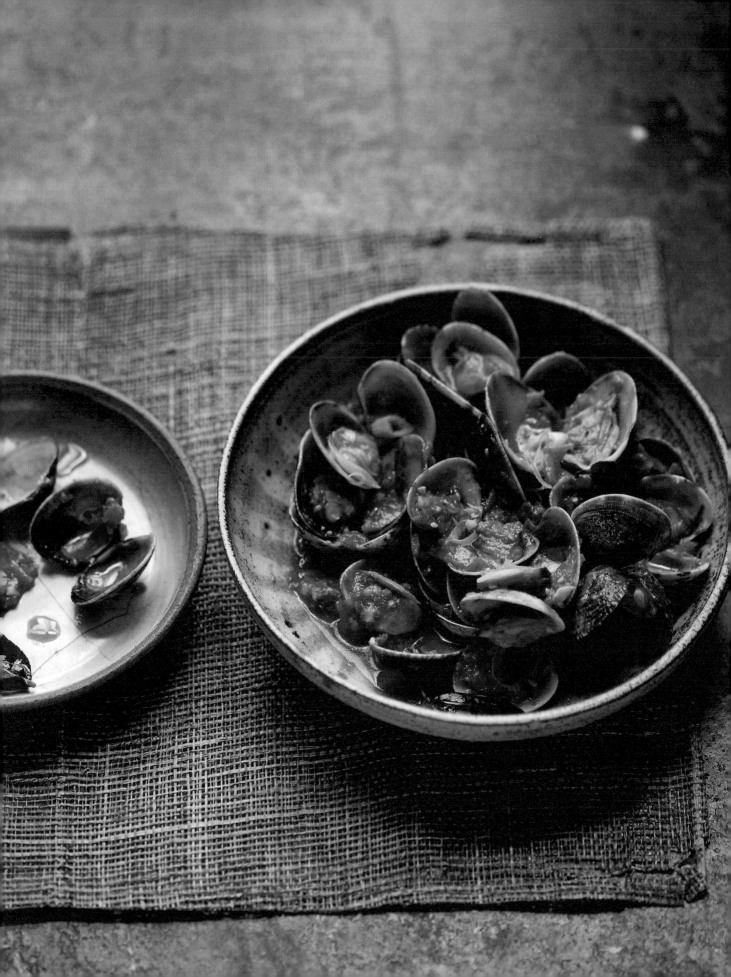

Rica rica clams

Serves 4

1 kg (2 lb 4 oz) clams, cleaned
2 tablespoons oil
3 tomatoes, chopped
4 lime leaves
bunch of spring onions
 (scallions), chopped
lime juice, to taste

Bumbu spice paste
4 large red chillies, mostly seeded
4 small red Asian shallots, peeled
4 garlic cloves, peeled
thumb of ginger, peeled
juice of a lime
½ teaspoon salt

Rica rica is a spicy signature of Sulawesi. The 'c' is pronounced 'ch' as in chilli. And chillies are a key component, though I tend to make these clams hot rather than incendiary. Do add an extra bird's eye chilli to the spice paste if you like; Minahasan people would approve.

Soak the clams in well salted water for 20 minutes to remove any grit.

Meanwhile, make the bumbu spice paste. Roughly chop all the aromatics and put them in a food processor or high-speed blender with the lime juice and salt. Whizz together to make a rough paste.

Heat the oil in a lidded pan and scrape in the bumbu. Fry, stirring often, until fragrant and it has lost the harsh raw edge. Toss through the tomatoes, lime leaves and spring onions and cook for a couple of minutes more.

Add the clams, clamp on the lid and cook, shaking the pan occasionally. After 2–3 minutes the clams should have opened; discard any that do not. Taste the sauce and add salt and lime juice to taste.

Steamed fish parcels with lemon basil

Serves 4

4 x 150 g (5½ oz) skinless
 white fish fillets
juice of ½ a lemon
2 tablespoons oil
200 ml (generous ¾ cup) coconut milk
30 g (1 oz) lemon basil or Thai basil
1 bird's eye chilli, seeded and sliced
1 large tomato, sliced into 8 rounds

Bumbu spice paste
1 lemongrass stick
1 large red chilli, seeded
1 bird's eye chilli (optional, for heat)
3 small red Asian shallots
3 garlic cloves
2 cm (¾ inch) galangal, skin scrubbed
1 cm (½ inch) ginger, peeled
1 cm (½ inch) turmeric, peeled, or
 ½ teaspoon dried turmeric

banana leaves or foil, for wrapping
 (see page 233)

Opening your own banana leaf parcel at the table to reveal a delicately fragranced fish fillet brings pleasing drama to a meal. If you can't find banana leaves, use foil instead, but they are worth seeking out in Asian supermarkets for the subtle herbal taste they impart.

In a bowl, toss the fish fillets with lemon juice, salt and pepper and leave to marinate out of the fridge whilst you prepare the bumbu.

Trim the lemongrass to the pale white and lilac part, bruise with the handle of a knife then finely slice. Roughly chop the remaining bumbu ingredients and blend everything to a paste in a food processor or high-speed blender. Adding a little water will help the blades bring everything together. Heat the oil in a small frying pan and cook the bumbu over a medium heat, stirring often, for about 10 minutes until the raw garlic taste has gone and the oil separates from the spices.

Add the coconut milk and bumbu to the fish, turning to coat the fillets well.

Cut eight pieces of softened banana leaves, each large enough to wrap a fillet. Lay them out in double thickness. Lay a generous layer of lemon basil leaves on each and sit a fillet on top, making sure you include all the coconutty marinade. Scatter a little chilli over the top followed by two slices of tomato, then bury under another mound of lemon basil. Wrap the parcels well, securing with bamboo skewers or a ribbon of banana leaf. If you have time, leave to marinate in the fridge for up to 4 hours.

Preheat the oven to 180°C (350°F).

Space out the parcels on a baking sheet. Bake for 20 minutes and leave to rest for 5 minutes before opening the parcels at the table.

Note
We tried spiced fish parcels in Java that my husband loved so much he would have them as the lead recipe. The 4 fish fillets are coated in a bumbu spice paste made from the following: 4 large red chillies (seeded), 2 lime leaves, 3 candlenuts or 6 blanched almonds, 3 garlic cloves, 1 lemongrass stick, 2 cm (¾ inch) kencur, 1 cm (½ inch) turmeric, 1 teaspoon coriander seeds, 1 tablespoon tamarind paste, 1 teaspoon salt, ½ teaspoon sugar, 1 egg and 1 tablespoon oil. Wrap in parcels and cook as above.

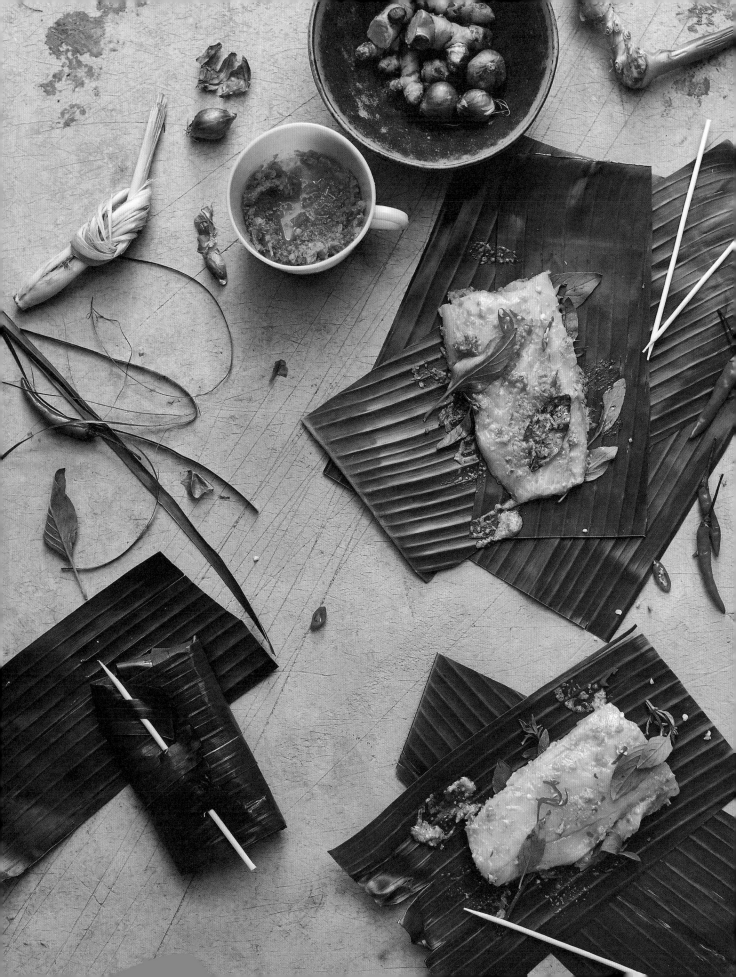

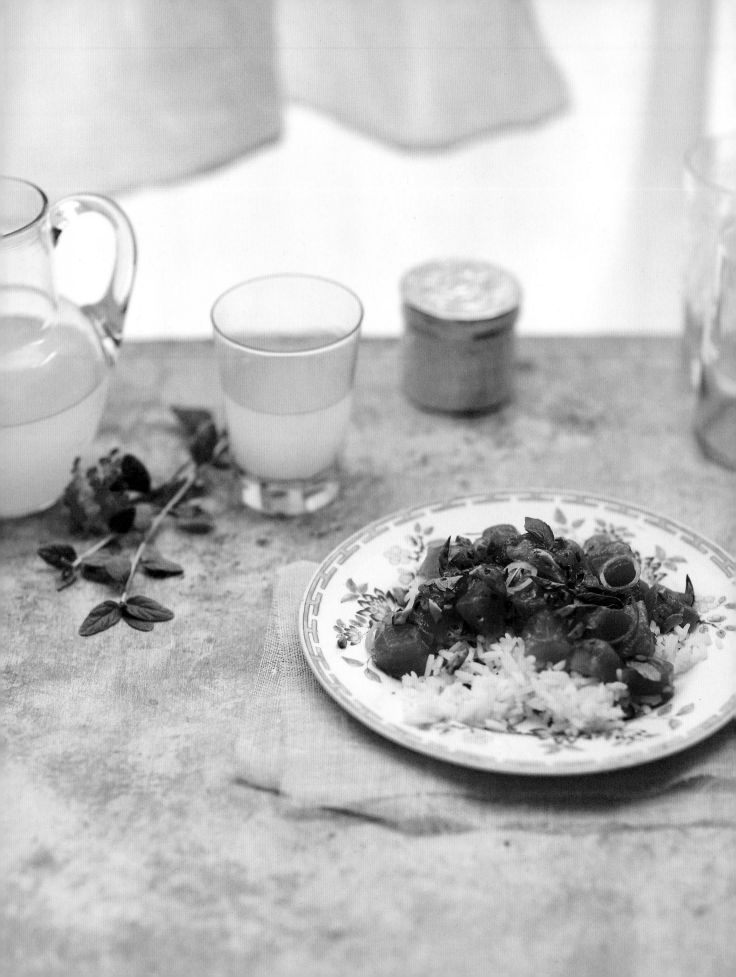

Tuna gohu

Serves 2

200 g (7 oz) freshest sushi-grade tuna
juice of a lime
sea salt flakes
5 small red Asian shallots, finely sliced
1–2 red bird's eye chillies, seeded
 and finely sliced
2 tablespoons virgin coconut oil,
 melted but not hot
handful lemon or Thai basil leaves
handful Wok-fried peanuts (page 180)
 or roasted peanuts, lightly crushed

Island nations the world over have found wonderful ways with raw seafood. This dish comes from Ternate in North Maluku and is often referred to as Ternate sashimi as a nod to the Japanese style of preparing fish. Given that it is slightly 'cooked' with a bath of acid lime, it is actually closer to Hawaiian poke, Peruvian cerviche or Filipino kinilaw. All use a base of raw fish and onions marinated in citrus or vinegar. Hawaiians add roasted candlenuts, soy sauce and spring onions (scallions), whilst Peruvians and Filipinos pep things up with chilli as well as sour fruits in the kinilaw. Hot contender for best of the lot is the Indonesian version: fried peanuts, lemon basil, chilli and a bonus slick of coconut oil.

Cut the tuna into roughly 1 cm (½ inch) cubes.

In a bowl, make a dressing by combining the lime juice, salt, shallots and chillies. Whisk in the melted coconut oil and taste for seasoning.

Toss the tuna with the dressing, then mix in the lemon basil leaves. Scatter over the crushed peanuts and serve at once.

Note
In Maluku, cassava or banana would be the most likely carbohydrate served with this. However, it does make great bowl food served with sticky rice.

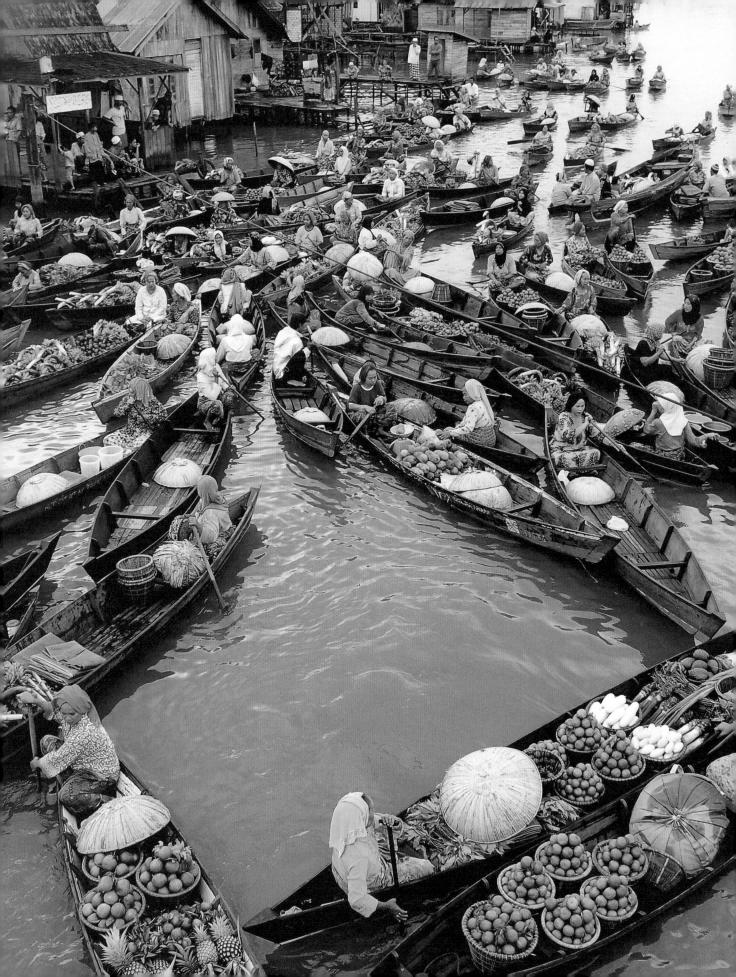

Chilli – *cabe*

Such a defining feature of South-East Asian food, it is hard to believe that chillies were brought from the Americas by the Europeans only five hundred years ago and aren't a native ingredient. You won't find many meals without them, whether they are pounded into a bumbu spice paste at the base of a curry, enlivening a salad with ribbons of colour, or turned into a punchy chilli sambal to up the heat at the table. It is not simply fire they are there for – Indonesian food doesn't have to be spicy and cooks make sure that chilli heat doesn't overpower the food. Chillies are also chosen for their flavour.

There are three main types used. The first is a large, glossy chilli, which is sweet, juicy and usually only mildly spicy. They are there primarily to give colour and taste rather than heat as they lose much of their pungency when cooked. Ruby red when ripe, if picked earlier the same chillies are dark green with a sharper character. Other than for green chilli sambal, red are more used. Lombok is the most common variety in Indonesia, whereas Holland chillies are the best to source outside the country – they are a hybrid created by Dutch botanists eager to cook Indonesian food at home. Cayenne peppers or the generic red/green chillies sold in the UK are good substitutes.

The second type is small and potent, there for the heat. The bird's eye or Thai chilli is the best stand-in for the myriad varieties of little chillies used. As they vary in heat wildly, adjust the quantity according to your variety and your taste. As with the larger chillies, red are used more often than green. Indonesians call someone with fiery passion a *cabe rawit* – a bird's eye chilli!

The third weapon in the arsenal is the small, sun-dried chilli. These are used more in Malaysian cooking than Indonesian, but are sometimes added to give a ruddy, earthy heat and smoky depth to cooking. Sizzle them in hot oil to release the flavours. A dried bird's eye is a good choice, but you could choose any small dried chilli or use chilli flakes instead.

The general rule is the smaller the chilli, the hotter it is (this is not steadfast though, perhaps more accurate is the uglier chillies are hotter, the incendiary ones having misshapen, wrinkled skin). Most of the heat lies in the placental part holding the seeds and opinion is divided as to whether to remove this or not. In many parts of Indonesia, the seeds of the larger chillies are removed as their texture and surrounding heat is not wanted, whereas other cooks have told me removing the seeds deprives the chilli of its full potential. Certainly seeds are rarely removed from bird's eye chillies. Most common is for both size of chilli to be used in tandem in a dish – a seeded red chilli for flavour and a whole bird's eye for heat.

Sambal

A hot relish that is essential to an Indonesian meal. Indonesians let people adjust the spice of their food to their own level with sambals. They range from the simple crushed chilli paste, sambal oelek, which is easy to buy in Asian grocers and if needed can be used instead of fresh chilli in cooking, to more exotic and characterful sambals. See page 175 for recipes.

Black pepper

Before chillies arrived on Indonesian shores, it was left to pepper to provide the heat. The fruits of a climbing vine ripen from green to red and eventually to black. White peppercorns are the inner seeds with the dark outer layer removed. They have more heat but a less complex flavour. Both white and black peppercorns are much used in bumbu spice pastes, the choice often determined by the colour of the dish (black can muddy a pale coconutty curry, though I can't say I mind this and prefer the flavour). Fresh green peppercorns are used in some Balinese lawars.

Long pepper

A popular ingredient in early European cooking, long pepper mysteriously fell out of favour as black pepper took over as king. The nubbled and elongated peppercorns have a sharp, sweet and hot taste with more nuance. You could almost be tasting a spice blend rather than a single berry, as there are notes of nutmeg and cinnamon. Try it in your pepper grinder to change things up.

Javanese sea bass & spinach curry

Serves 4

3 lemongrass sticks
2 thumbs of galangal, skin scrubbed
2 tablespoons oil
6 salam leaves (optional)
1 tablespoon ground turmeric
6 cardamom, lightly cracked
1 star anise
300 ml (1¼ cups) chicken or fish stock
200 ml (generous ¾ cup) coconut milk
1 tablespoon dark palm sugar
 (gula jawa), shaved
4 x 100 g (3½ oz) sea bass fillets,
 cut into large chunks
200 g (7 oz) baby spinach leaves

A creamy yet light fish curry with a slight smoky note from the toasted spices and a gingery hint of galangal. This recipe comes from Central Java where I was shown it by Chef Didik, who rolled his rrrs hypnotically as he spoke, especially when expressing delight at the aromas wafting from the pan. He used a freshwater snakehead fish, which he first fried in a turmeric-tinted bumbu. I have simplified the recipe for quick, one-pan cooking.

Use the handle of a knife to smash the lemongrass and galangal, then roughly chop them both to release the flavours. Heat the oil in a large pan and add the lemongrass, galangal and salam leaves. Fry to slightly caramelise in the heat.

Add the turmeric, cardamom and star anise and cook for a minute longer. Splash in the stock and coconut milk and season with salt and the palm sugar. Bring to a quiet bubble, lower the heat and simmer for 5–10 minutes to infuse the flavours. It can be made in advance up to this stage.

Strain the sauce and discard the flavourings, which have done their work. Taste for seasoning.

Return the sauce to the pan and bring back to the boil. Add the sea bass and simmer for 5 minutes or until the fish is just cooked and flaking. Stir through the spinach leaves to wilt into the sauce before removing from the heat.

Menu ideas
Serve with Sweetcorn rice (page 162) and blanched vegetables tossed with Spicy coconut flakes (page 182).

Snake beans with coconut milk

Serves 4

1 tablespoon oil, for frying
500 g (1 lb 2 oz) snake beans or
 green beans, trimmed and cut
 into short lengths
1 lemongrass stick, trimmed and bruised
250 ml (1 cup) coconut milk

Bumbu spice paste
3 garlic cloves, roughly chopped
1 bird's eye chilli, roughly chopped
2 cm (¾ inch) ginger, peeled
2 cm (¾ inch) galangal, skin scrubbed
2 cm (¾ inch) turmeric, peeled,
 or ½ teaspoon ground turmeric
2 teaspoons coriander seeds
2 tablespoons tamarind paste
2 tablespoons dark palm sugar
 (gula jawa)
½ teaspoon salt

Snake beans lie like arm-length curls of green rope next to the green beans in the markets. They can be used interchangeably, but snake beans tend to take a little longer to yield to the heat of the pan. Here they are cooked not for crisp greenness, but taken beyond until silky and tender in a comforting cloak of spiced coconut milk.

Grind all the bumbu ingredients together in a food processor, adding a little water to help everything come together to a paste.

In a large pan, heat the oil and fry the bumbu for a couple of minutes until very fragrant. Add the beans along with a splash of water and stir to coat in the spices. Cook for a minute or two before adding the lemongrass stick and coconut milk.

Cook, stirring often, until the beans are very tender, about 10–15 minutes.

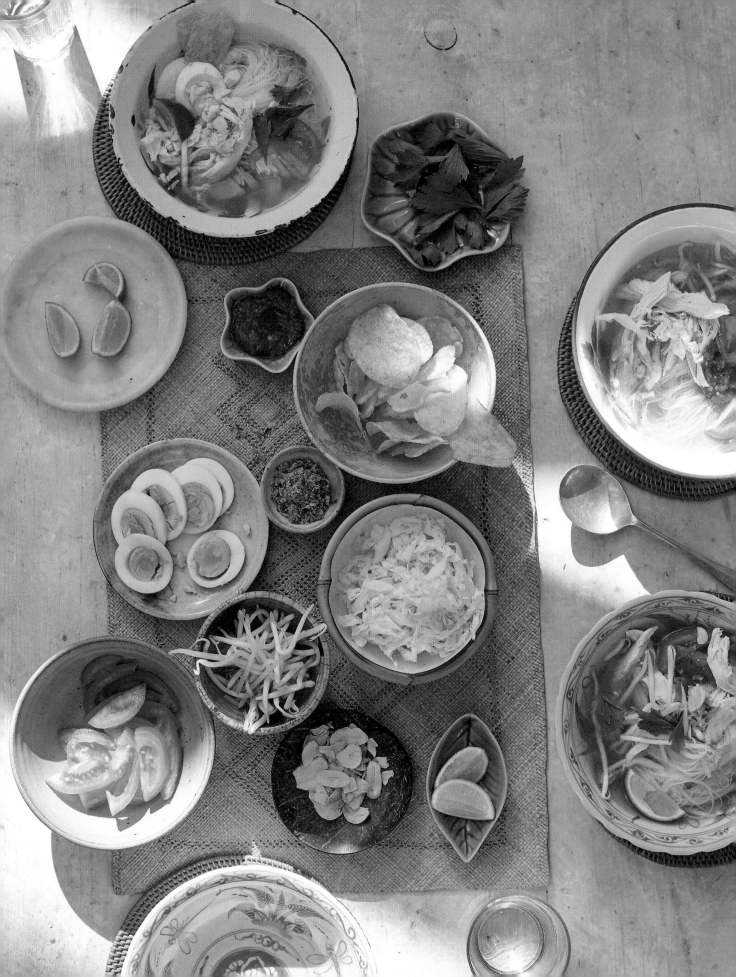

Soto ayam

Serves 6

Bumbu spice paste
4 garlic cloves, roughly chopped
4 small red Asian shallots,
 roughly chopped
1 teaspoon coriander seeds
2 cm (¾ inch) turmeric, peeled,
 or ¼ teaspoon ground turmeric
2 cm (¾ inch) galangal, skin scrubbed
2 cm (¾ inch) ginger, peeled
2 tablespoons oil, for frying

Broth
1 small chicken, trimmed of any
 extra fat in the cavity
3 spring onions (scallions), chopped
4 cm (1½ inches) ginger, skin scrubbed,
 thickly sliced and smashed
3 lime leaves
2 lemongrass sticks, smashed and
 roughly chopped
1 teaspoon salt

To serve
bowlful glass noodles or vermicelli
 rice noodles, soaked in hot
 water until soft
4 limes, quartered
4 hard-boiled eggs, sliced
½ Chinese napa cabbage,
 finely shredded
4 juicy tomatoes, sliced
bowlful beansprouts
bowlful good potato crisps
handful Chinese celery leaves
crisp-fried shallots
Sambal oelek or Fermented
 sambal (see pages 175 or 177)

Night falls quickly in the tropics. With little warning, soon after six, there is darkness. The evening insects begin their hum and geckos chirp in reply. To me, nowhere holds more magic at night than the land along a river gorge, deep in the heartland of Bali. It is here that our great family friend and ecological visionary Linda Garland created a paradise dotted with thatched huts, bamboo gazebos and covered bridges. She referred to it as an 'edible landscape' as all the vegetables, fruits, herbs and spices for her food came from the estate. The darkness of nights at Panchoran estate was broken only by a blanket of stars and flickering oil lamps made of coconut. For dinner, a series of delicious dishes would come out from the kitchen. This chicken soup is one of my favourites, a dish Linda inherited from her Madurese mother-in-law. Different elements are served in small bowls so everyone can layer their own flavours.

Make the bumbu in a food processor or high-speed blender. Blitz all the ingredients, adding a little water to help the paste come together.

Heat the oil in a pan large enough to hold the chicken. Fry the bumbu until softened and aromatic. Add all the ingredients for the broth and cover the chicken with cold water. Bring to a rolling boil and immediately turn the heat right down. Poach the chicken for 1 hour. The water must not boil; it needs to be gentle with small bubbles popping at the surface at irregular intervals to keep the chicken tender and the stock clear.

Remove the bird from the pan and strip off the meat. Store in the fridge for later. Return the carcass and any skin to the broth and continue to simmer for another half an hour, or longer if you have time. You want the broth to extract all the flavour from the bones. Strain out the aromatics and skim the fat off the surface. Taste the broth – if it is too watery then boil hard to reduce and concentrate. Adjust the seasoning after reducing. Reheat before serving if required.

Shred the chicken meat and put into one serving bowl. Snip a pair of scissors into the bowl of noodles to cut them to more manageable lengths for serving. Each of the other elements should go into separate bowls, large or small. Bring to the table along with the hot broth and let everyone help themselves, adjusting their bowls of soup to their taste. Don't let them omit lots of lime juice though, the most crucial element!

Hot & sour duck

Serves 4

4 duck breasts, skin on
handful mint leaves, shredded,
 to serve

Bumbu spice paste
6 large red chillies, 4 or 5
 of them seeded
6 small red Asian shallots, peeled
2 garlic cloves, peeled
4 cm (1½ inches) ginger, peeled
5 candlenuts or 10 blanched almonds
4 tablespoons tamarind paste
1 teaspoon ground coriander
3 cm (1¼ inches) turmeric, peeled,
 or 1 teaspoon ground turmeric

Sweet and sour gets all the glory, though too often the sweetness overbears, stifling the flavour of everything else and leaving little sourness to detect. In Indonesia a hot-sour combo is more popular and works so well with duck. This sauce has it all – there are complex layers of flavour and a deep savouriness, it is smooth and luscious without being rich, and the punch of chilli heat and tamarind sour really shine through. Adjust to your taste, leaving as many chilli seeds as you dare when making the bumbu and upping the ante with chilli powder at the end if you want more fire.

To make the bumbu, roughly chop all the ingredients and blitz together in a grinder or food processor. Add a little water if needed to help the blades turn to get a dark rust paste.

Score the duck skins with criss-cross cuts and dust with sea salt. Put skin-side down in a cold wok or frying pan and set over a medium-low heat. This gradual heating will help render the fat, leaving a crunchy golden crackling. After about 12 minutes, turn and cook for another 4 minutes for medium-pink. Remove the breasts to rest on a board skin-side up, leaving a couple of tablespoons of the fat behind in the wok for later.

After resting for 10 minutes or so, slice the duck breasts on the diagonal into thin rags.

Return the wok to a medium-low heat to warm the duck fat. Add a small spoonful of the bumbu and if it sizzles gently, scrape in the rest. Cook, stirring periodically, until the bumbu has darkened a shade, the fat is separating from the paste and everything smells warm and appealing. It will likely take about 5 minutes or more. Add the duck and any juices along with 2 tablespoons of water and continue stir-frying for a couple of minutes more. Taste for seasoning; it will need salt and you can always change the balance of hot to sour with an extra hit of chilli powder or tamarind paste. You want the flavours strong and punchy as they'll be muted by the accompanying rice. Serve scattered with mint leaves.

Menu ideas
Serve with Solo coconut rice (page 157), Stir-fried greens with garlic & chilli (page 151) and some rice crackers for crunch.

Betawi spiced beef

Serves 4

600 g (1 lb 5 oz) beef shin or
 stewing steak
1 tablespoon oil
6 cm (2½ inches) galangal,
 skin scrubbed
3 cm (1¼ inches) ginger, peeled
3 lemongrass sticks
5 salam leaves (optional)
6 lime leaves
½ cinnamon/cassia stick
4 cardamom, lightly cracked
3 cloves
1 star anise
1 tablespoon dark palm
 sugar (gula jawa)
2 tablespoons kecap manis

Bumbu spice paste

¼ nutmeg, grated
1½ teaspoons ground coriander
½ teaspoon ground cumin
½ teaspoon ground black pepper
1 teaspoon salt
5 large garlic cloves, roughly chopped
1 red onion, roughly chopped
3 candlenuts or 6 blanched
 almonds, toasted

A richly spiced dish from the Betawi people of Java. It has a little sweetness as well as tang with complex layers of flavour. Don't be put off by the lengthy ingredient list – the method is simple with long, slow cooking doing all the work, with exquisite results.

Trim the beef of any outer sinew, but leave the inner fat and connective tissue, which will keep the braise tender. Cut the beef into a 3–4 cm (1¼–1½ inch) dice.

Make the bumbu spice paste. Use a food processor or high-speed blender to grind all the ingredients to a paste, adding a little water to help the blades bring everything together.

Heat the oil in a casserole pan and add the bumbu. Fry, stirring often, until the rawness is replaced by a sweet fragrance. Meanwhile halve the galangal and ginger into thick slices and gently bruise them with the handle of the knife. Also bruise the lemongrass and, if they are long enough, tie into knots. When the bumbu is ready, throw these all into the pan with the leaves and whole spices and fry for a minute or two longer. Stir in a small slosh of water to loosen the paste and help the flavours meld.

Add the beef and stir well, coating the beef in the spice paste. Cook for a few minutes to start to brown and caramelise. Add 200 ml (generous ¾ cup) water and the palm sugar and try to tuck all the ingredients below the liquid level. Bring to a simmer and cover with a lid. Cook at the faintest bubble until the meat is very tender, this should take around 2 hours but depends on the cut of meat. Remove the larger aromatics. Stir in the kecap manis, which will make the sauce dark and glossy, and taste for seasoning.

Menu ideas

There is no chilli heat here so I like to pair this beef with the Padang green chilli sambal (page 176) as well as Sweetcorn rice (page 162), Chilli-fried potato crunch (page 183) and Jakarta beansprouts (page 147). For a larger meal, choose a curry from the Rich & Creamy chapter (page 48) as well.

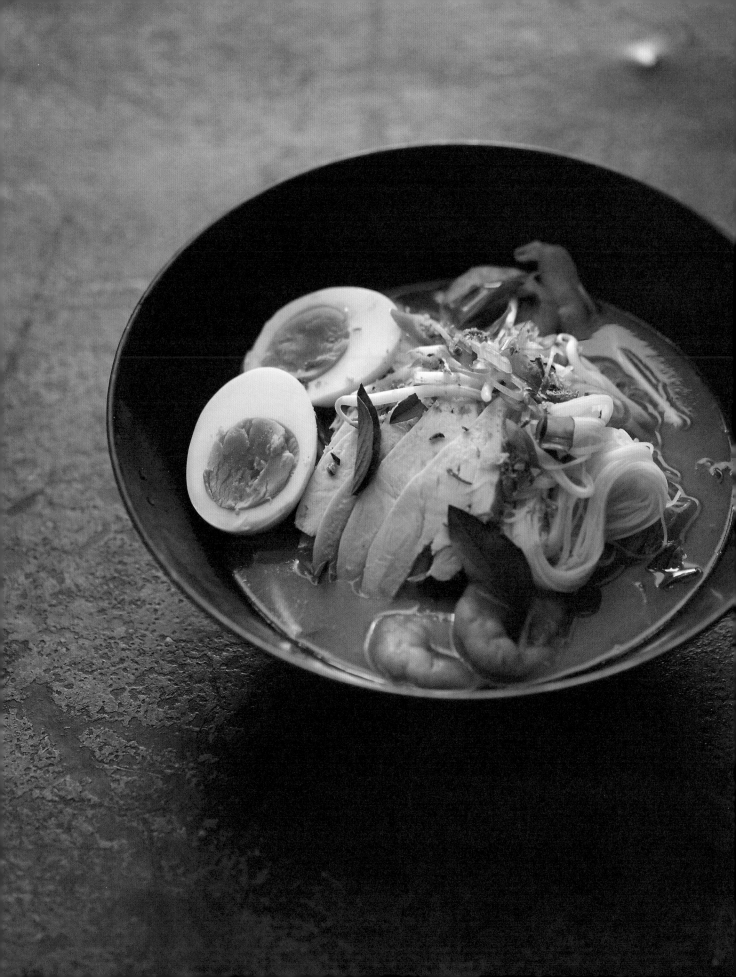

Laksa

Serves 4

2 tablespoons oil
1 star anise
3 cloves
3 cardamom, lightly cracked
5 cm (2 inches) galangal, halved
 and smashed
3 cm (1¼ inches) turmeric, chopped,
 or ½ teaspoon ground turmeric
2 cm (¾ inch) ginger, lightly smashed
1 cm (½ inch) kencur (optional)
3 lemongrass sticks, bruised and knotted
6 lime leaves
3 salam leaves (optional)
2 skinless chicken breasts
500 ml (2 cups) chicken stock
200 ml (generous ¾ cup) coconut cream
2 teaspoons tamarind paste
1 tablespoon crisp-fried shallots
handful peeled raw prawns (optional)

Bumbu spice paste

1–3 red bird's eye chillies, stems removed
1 large red chilli, seeded
3 garlic cloves, peeled
10 small red Asian shallots,
 roughly chopped
3 candlenuts or 6 blanched almonds
1 teaspoon ground coriander
1 teaspoon ground cinnamon
1 teaspoon salt
½ teaspoon crushed black pepper

To serve

200 g (7 oz) vermicelli rice noodles,
 softened in hot water
large handful Thai basil leaves
large handful beansprouts
2 spring onions (scallions), sliced
4 hard-boiled eggs, halved

Like many of the dishes I learnt in Java, this noodle soup has an intimidating number of ingredients. I promise it is worth it; the heady combination of aromas from the dried spices, fresh spices and herbs with a creamy coconut base makes something very special. This recipe was given to me by Sri Sutarti who cooks incredible food for families in the Australian embassy in Jakarta. Adjust the chilli quantities according to your taste. Sri uses 1 large and 5 small red chillies, but in Jakarta they pack less of a punch than the ones I buy in London, so I scale these down. The large red chilli is there for colour, the small ones for fire.

Start by making the bumbu. Put the chillies, garlic and shallots in a pan and cover with water. Bring to the boil and cook until soft. Drain away the fire-fanged liquid and transfer the solids to a food processor or high-speed blender. Add the remaining bumbu ingredients and grind to a paste, adding a little water if needed to bring everything together.

Heat the oil in a large saucepan over a medium heat and add the star anise, cloves and cardamom. Once their aroma rises from the pan, scrape in the bumbu followed by the galangal, turmeric, ginger, kencur, lemongrass, lime leaves and salam leaves. Slosh a little water into the bowl of the food processor or blender, swirl to pick up the residue and add this to the pan as well.

Turn up the heat a little and add the chicken breasts. Fry until the aromatics have lost their harsh rawness and are fragrant and there is a little colour on the meat. Add the chicken stock and 500 ml (2 cups) water. Bring to the boil, then turn down the heat and simmer until the chicken is cooked through. Remove from the broth and set aside for later.

Add the coconut cream and tamarind to the pan. Cook on a slow boil for 5 minutes, stirring often to keep it from separating. Strain out and discard the aromatics if you like, and return the soup to the pot ready to reheat. Taste and adjust the seasoning as needed – the right amount of salt will really make the flavours zing.

Divide the softened noodles into four large serving bowls and top with thin slices of the chicken breast. Add the basil, beansprouts and spring onions.

Reheat the soup, adding the crisp-fried onions. If you are using prawns, add them now and simmer until they lose their glassy rawness and turn pink. Ladle the soup and prawns into each bowl. Top with the boiled eggs and serve at once.

SALAD & DRESSED VEGETABLES

Chapter Five

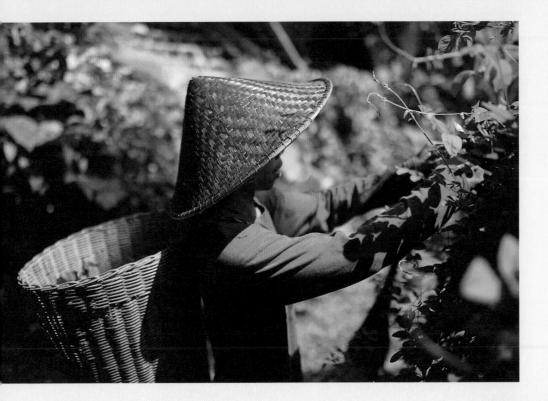

EDIBLE GARDENS
& Forest Farms

There is a kaleidoscopic glare of tropical flowers, reds through pinks, golden trumpets, blowsy orange hibiscus and blood red rosellas. Look closer and everything is edible. Glossy white aubergines (eggplants) grow amidst scented patchouli flowers. Cassava and taro have fiery cones of torch ginger shooting up between them, ready to be sliced into aromatic sambals. Ginseng leaves are peppery, like lamb's lettuce, and the garish lipstick tree's shoots and leaves can be tossed into succulent salads.

Four varieties of wild ginger grow under a protective layer of rice husks, five colours of okra point upwards through the soil like flaming torches. The ruffled blue flowers of butterfly peas are used as a natural food colouring. Twisted tamarind pods hide their sour pulpy fruit inside suede skins. If you catch the fruit of the loofah plant before it dries to the scrubby web we use in the bathroom, it can be stir-fried with fresh white garlic.

This tropical Eden lies in the grounds of the astonishing Bambu Indah hotel outside Ubud. Instead of manicured lawns and ornamental shrubs, every patch of ground between the twisted paths and bamboo huts is utilised. Visionary owner John Hardy presses upon me that land should always be productive as well as beautiful. Most of the food for the hotel kitchen comes from these gardens.

The mantras of eating locally, home-grown and seasonally fit naturally in Indonesia. Even in towns, people will twist off lime leaves to perfume the day's curry as they pass a tree. Fragrant pandan and reedy lemongrass grow wild in courtyard gardens ready to fragrance rice. Bitter herbs are plucked roadside to use in medicinal *jamus*. It is rare that these ingredients need to be bought in markets.

Venture into the rainforest and a new world of foods opens up. Amidst the canopy of waxy green leaves are jewels of exotic fruit, ripening in the sunlight. Bananas are eaten sweet and ripe, or as a vegetable while still green. The palms are sliced and cooked in soup, giving a celery-like taste and texture. Coconuts, yellow, green and brown, are the lynchpin of the local diet. Baby pineapples are both sour and sugar-sweet. Further down, beneath the bamboo with its velvety green coating, lie the shade dwellers. Wild turmeric and galangal are the basis for bumbu spice pastes. Delicate fern fronds are one of my favourite vegetables to mix with toasted coconut and crisp-fried shallots. Spice-scented leaves can be wilted into warm salads.

Warty bittergourds hang from vines strung with buttercup yellow flowers. Temper their bitterness with a rich cloak of peanut sauce. Cylinders of hollow tree trunk are strung between branches for wild bees to swarm and make honeycomb packed with royal jelly. This can be stirred into soft coconut curd, wrapped in palm leaves and grilled.

It is in the dappled light of these otherworldly forests, where monkeys lollop past and shy princess plants curl shut as you brush past them, that the farms of the future could lie. My great friend and bamboo specialist Arief Rabik enthuses about the possibility of mass agroforestry. Instead of stripping the land for intensive farming, growing could happen beneath the understory. With the enormous benefits of biodiversity, productivity and sustainability as well as exotic, nutrient-packed foods, this is an exciting prospect.

Vegetable urap with fresh spiced coconut

Serves 2–4

140 g (5 oz) edible fern tips or seasonal
 greens, roughly chopped
100 g (3½ oz) fine green beans,
 cut in thirds
100 g (3½ oz) beansprouts
1 tablespoon coconut oil
6 small red Asian shallots, sliced
4 garlic cloves, sliced
1 large red chilli, seeded and sliced
100 g (3½ oz) grated fresh coconut or
 80 g (1 cup) desiccated coconut
100 g (3½ oz) cooked black-eyed
 beans (optional)
juice of a kaffir lime or lime
1 tablespoon crisp-fried shallots

On days when I crave the hot sun of Bali, I invariably crave this coconut salad as well. It is fresh, verdant and distinctly Indonesian. I love it with delicate curled fern fronds called pakis, but spinach or indeed any seasonal greens make a fine substitute. It is also lovely with green ribbons of asparagus.

Bring a large pan of salted water to the boil and add the fern tips and green beans. Cook for 2 minutes or until just tender. Add the beansprouts for the last 20 seconds of cooking. Drain and leave to cool. If you have used greens that retain a lot of water, gently squeeze them dry.

Set a wok or frying pan over a medium heat and add the coconut oil followed by the shallot and garlic. Cook, stirring frequently, until pale golden, then add the chilli and cook to just softened. Lower the heat and add the coconut along with a good pinch of salt. If using desiccated coconut, also add a splash of water to soften and help the flavours meld. Cook just for a minute, then remove from the heat and leave to cool.

Toss the vegetables and black-eyed beans (if using) with the spiced coconut and lime juice and taste for seasoning. Scatter over the crisp-fried shallots.

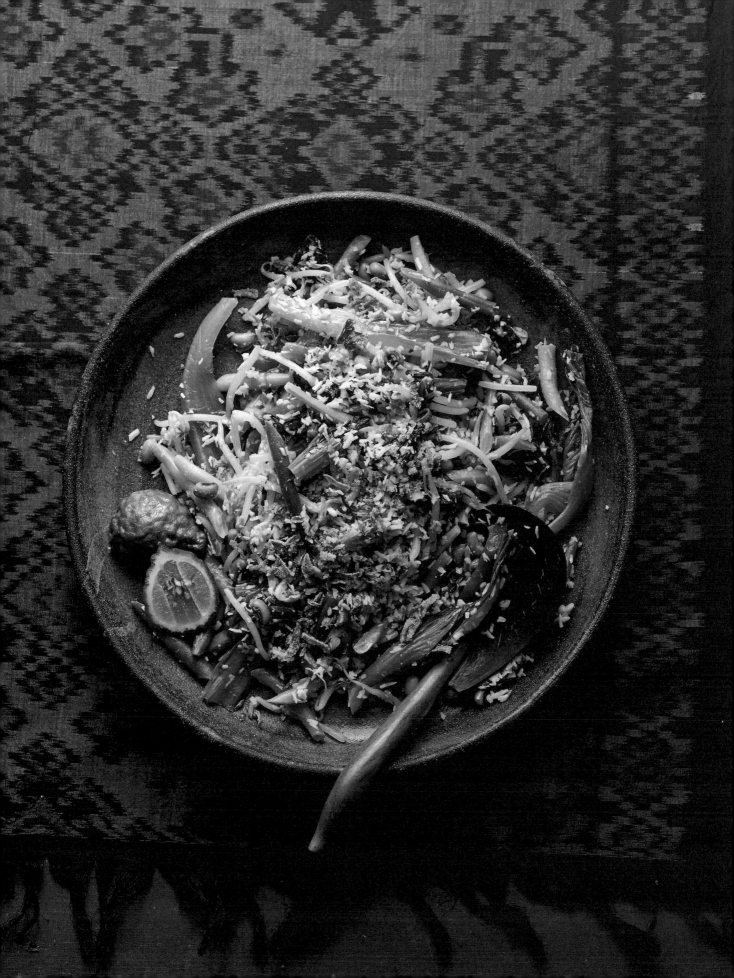

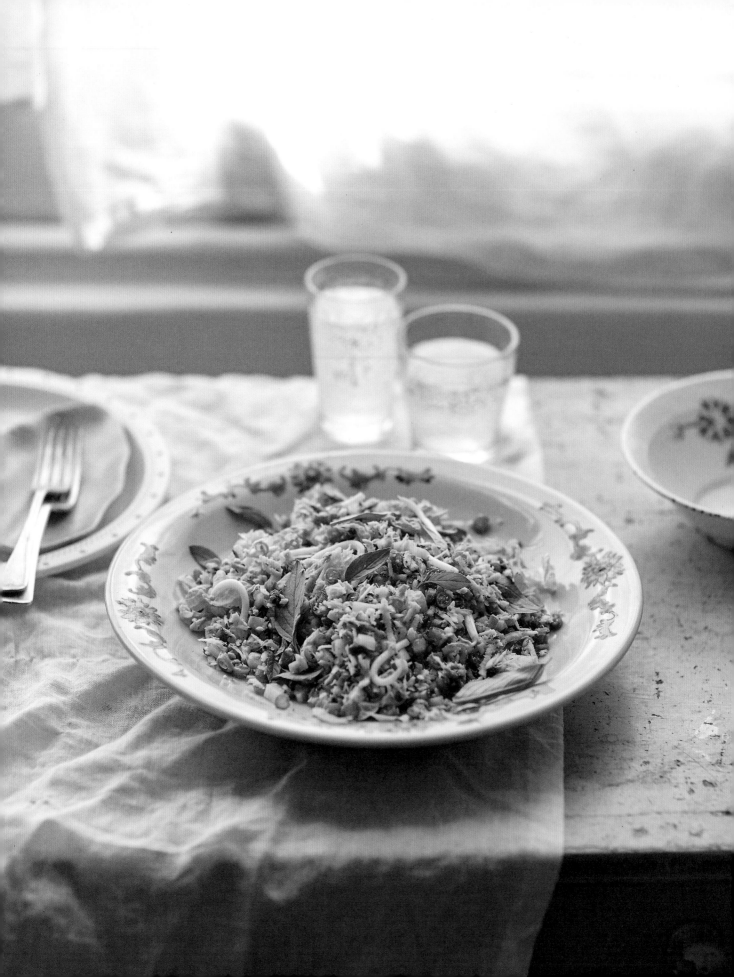

Sweet coconut & basil salad

Serves 4

2 red bird's eye chillies, sliced
3 cm (1¼ inches) kencur or 2 cm (¾ inch) galangal, peeled and chopped
2 lime leaves, deveined and finely sliced
½ teaspoon salt
3–4 tablespoons dark palm sugar (gula jawa), shaved
300 g (10½ oz) fresh coconut, finely grated
100 g (3½ oz) fine green beans, sliced to tiny rounds
100 g (3½ oz) Chinese napa cabbage, finely shredded
100 g (3½ oz) cucumber, peeled, seeded and finely diced
100 g (3½ oz) beansprouts
50 g (2 oz) Thai basil, leaves picked

A Central Javanese relative of urap, *trancam* is light and fragrant, sweet and spicy. I can't think of a table of food from this book that wouldn't be improved by having this amongst its members.

Using a mortar and pestle, pound together the chillies, kencur and lime leaves to make a rough paste. Add the salt and palm sugar and continue to grind to a smoother paste flecked with lime leaves. Add the coconut and mix well to make the dressing. Taste: both the sweetness and spice should be very pronounced at this stage as they will be muted by the vegetables.

When ready to serve, toss the dressing through the raw vegetables and herbs and heap onto a serving dish.

Gado gado

Serves 2

100 g (3½ oz) snake beans or
 green beans, cut into 3 cm
 (1¼ inch) lengths
2 bok choy, sliced
large handful water spinach
large handful spinach leaves
¼ Chinese cabbage, cut into 2 cm
 (¾ inch) slices
2 handfuls beansprouts
150 g (5½ oz) silken tofu, cut into
 small cubes
oil, for frying
2 eggs

Peanut dressing
75 g (½ cup) raw peanuts, skin-on,
 or unsweetened peanut butter
1 tablespoon oil (if using raw peanuts)
1 garlic clove, crushed
½ teaspoon salt
½ teaspoon dark palm sugar
 (gula jawa), shaved
1 tablespoon kecap manis
2 teaspoons crisp-fried shallots
juice of a kaffir lime or ½ lime

To serve
prawn crackers, rice crackers or emping
kecap manis

It is the peanut dressing that makes this salad. So compelling is the mix of umami with the zing of kaffir lime that folk songs have been penned to its name in Jakarta. I promise it is worth the effort of frying and grinding your own peanuts – it lifts the dressing to a new level – but no one will judge if you use peanut butter. Gado gado translates as a 'jumbled mix' so choose any vegetables you have. Bulk it out with tofu, boiled potatoes, ribbons of fried tempeh and prawn crackers if you want a more substantial meal. Or strip it back to just the blanched vegetables and dressing.

Start by preparing all your ingredients for the salad. Trim and slice the vegetables. Fry the tofu in a little oil for about 15 minutes, until golden. Soft-boil the eggs for 6 minutes and peel under cold water.

Bring a large pan of water to the boil. First add the beans. After 1½ minutes add the bok choy, water spinach and spinach. After half a minute more, add the cabbage and beansprouts and immediately turn off the heat. Drain and run cold water through the colander to stop the cooking. Set aside.

If you are using raw peanuts in the dressing, you'll need to fry them to bring out the toasty flavours. Heat the oil in a wok over a high heat until shimmering, add the nuts and stir-fry for a minute. Reduce the heat to medium and continue to fry, stirring often, for 5 minutes or until the nuts are deep golden brown. Remove with a slotted spoon and drain on paper towels.

Using a large pestle and mortar, food processor or high-speed blender, grind the peanuts (and their skins) with the garlic, salt and palm sugar. Keep going; the oils in the peanuts will eventually come out, turning the rubble into a smooth peanut butter. Thin with a little water, but the dressing should be thick and fragrant. Mix in the kecap manis, crisp-fried shallots and juice from the kaffir lime. Taste to make sure the flavours sing, and adjust if needed.

Traditionally the dressing will be ground in the wide bowl of a *ulek*, coating its base. The vegetables will be added on top and tossed together. I like to replicate this by spooning the dressing into serving bowls and spreading it up the sides. Arrange the vegetables and tofu on top, along with halved boiled eggs and a few crackers. Drizzle over a little kecap manis and let everyone toss together their own portion at the table.

Note
The Javanese dish of *karedok* is a raw salad with the same peanut dressing. Mix salad leaves, finely shredded cabbage, beansprouts, sliced Thai aubergine (eggplant), sliced cucumber and finely sliced green beans. Toss with the peanut dressing and serve at once.

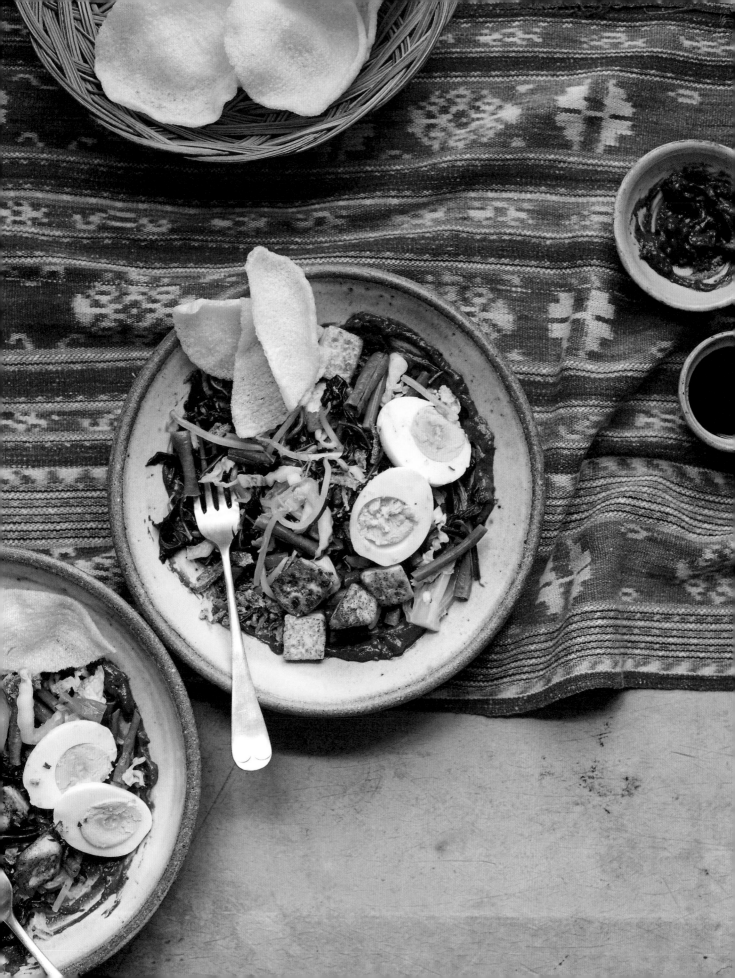

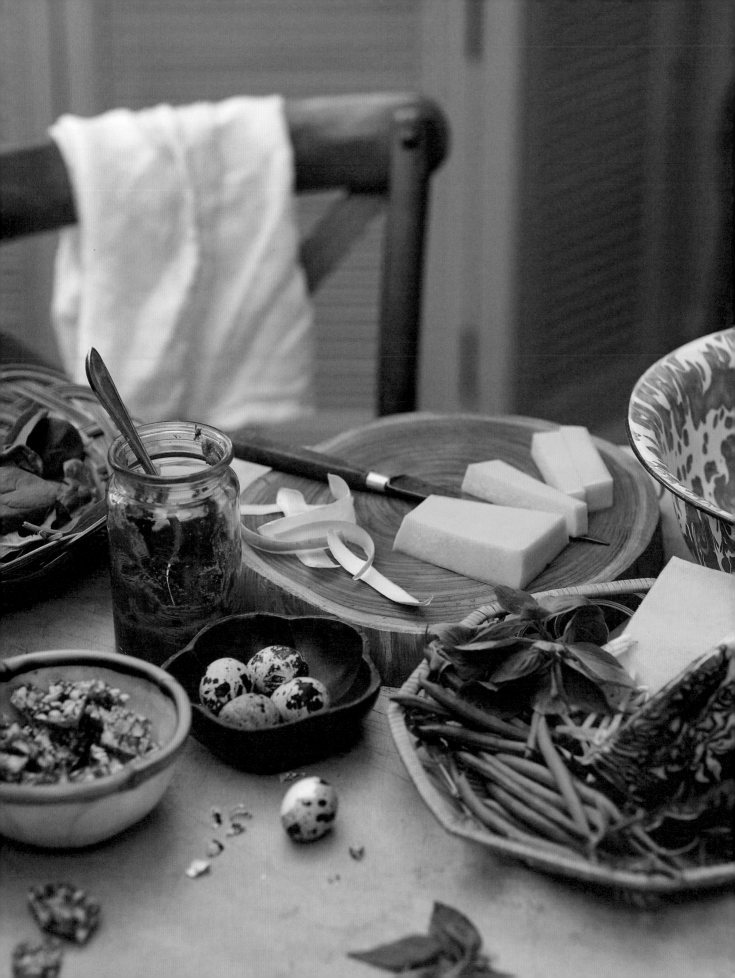

Pecel with peanut brittle

Serves 2

100 g (3½ oz) butternut squash
¼ purple cabbage
50 g (2 oz) green beans
large handful spinach leaves
handful beansprouts
Peanut dressing (page 136)
1–2 teaspoons tamarind paste
6 quail eggs
8 lemon basil leaves

Peanut brittle
oil, for greasing
70 g (⅓ cup) caster sugar
30 g (scant ¼ cup) dark palm sugar
 (gula jawa), shaved
100 g (⅔ cup) roasted peanuts,
 roughly chopped
1 tablespoon sesame seeds

A rainbow salad that uses the gado gado peanut dressing in another way. Amber nuggets of sweet-salty-smoky peanut brittle give a wonderful textural contrast.

Start by making the peanut brittle. Grease a flat surface or chopping board with a little oil. Without stirring, gently heat the sugar in a small pan with 2 tablespoons water and a generous pinch of salt until completely melted. Turn up the heat and let the mixture bubble furiously until it reaches 150°C (302°F) on a sugar thermometer. Quickly stir in the peanuts and sesame seeds and quickly tip onto the greased surface. Use a rolling pin or back of a spoon to press flat. Cut into small cubes and store any extra in an airtight tin.

Prepare the vegetables for the salad. Cut the butternut squash into fat chips. Separate the cabbage into leaves. Slice the green beans into 3 cm (1¼ inch) lengths.

Make the peanut dressing from the Gado gado recipe, then stir in the tamarind paste, which will give a sour edge. Taste and balance the flavours.

Steam the vegetables over boiling water. Add the squash first, cover with a lid and steam for 6 minutes. Add the cabbage leaves and green beans and steam for 4 minutes more, or until everything is tender to a fork. Add the spinach leaves and beansprouts and steam for just about 20 seconds longer, to soften them slightly. Remove from the heat and set aside.

Boil the quail eggs for 2 minutes, then transfer to cold water. Peel off the shells.

Assemble the salad in bowls. First the steamed vegetables, then dollops of the peanut dressing, halved quail eggs, a few pieces of peanut brittle and a final flourish of lemon basil leaves.

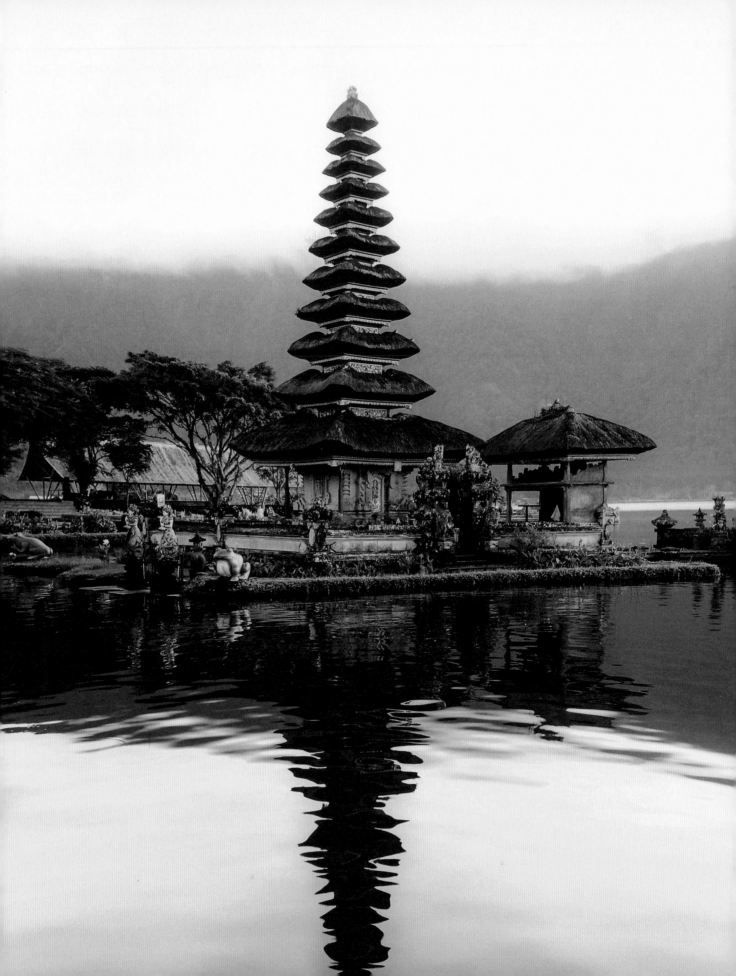

Bitter melon – *pare*

Bitterness is a taste appreciated in Indonesia and this knobbled green fruit, resembling a warty cucumber, is often served alongside sweeter food. It can be sliced into salads, braised in coconut milk or stir-fried.

Papaya flowers – *bunga pepaya*

An exotic ingredient that you are not likely to come across outside of the tropics, but I had to include them here as I have learnt to love these bitter little buds with their white petals curled inside. One of the best meals I have ever had was cured smoked pork from Timor, charred and sticky from the barbecue, served with a bitter green and papaya flower stir-fry.

Limes – *jeruk*

Limes are the major citrus fruit grown in the tropics and are an enlivener for many dishes. The small, yellowy-green key lime is the most common variety with its sour, fragrant juice. Greener Persian limes can be used interchangeably. Both have the remarkable ability to lift flavours in a complex curry or broth. Use the zest for extra fragrance, the juice for tartness and don't add when the food is too hot as this will kill much of the delightful sourness. Kalamansi limes with their extremely sour and citrussy orange pulp are also used in juices and cooking.

Kaffir limes – *jeruk purut*

Sometimes now called a makrut lime, this fruit and its scented leaves comes from a different tree to regular limes. The kaffir lime has similar colours to a lime but with a knobbled, bumpy skin and an amazing fragrance. Sadly, it is hard to buy in the West, but if you can grow or get it, use sparingly as the juice is sour and bitter (prized as such) and the zest intensely aromatic. (See page 69 for lime leaves.)

Tamarind

Poor tamarind is not a beauty, but is one of my very favourite ingredients. The fruit has knobbly, brittle, brown pods that hold a sticky, caramel-like pulp with a tantalising mix of sweet and sour. The fibrous pulp has to be mixed with warm water and the paste squeezed out from its strings and seeds. You can buy tamarind pressed into a block and make the paste yourself, but it is much easier to buy a jar of paste ready prepared. Do be aware though that the strength and sourness can vary a lot, from thin tamarind waters to thick and tangy pastes. Taste as you add until you have the right level of fruity tartness.

Other sour fruits

The marked taste for sour amongst Indonesians must have developed from the wealth of ingredients at hand. Here are some exotic local fruits I haven't included in my recipes: the sourness in Acehnese cooking comes from the sun-dried bilimbi fruit and gelegur gives tang to Batak cuisine (often used in clear broths as it doesn't have the brown colour of tamarind). Asam kandis is a lip-puckeringly sour fruit, whilst the fruit of the torch ginger is more refined with aromatic notes of lemongrass and ginger. It is used in fish dishes in South Sulawesi.

Sumba creamed corn

Serves 4

300 g (10½ oz) sweetcorn (2 large cobs)
40 g (1½ oz) butter
1 onion, finely chopped
4 garlic cloves, chopped
1 lemongrass stick, bruised and
 tied in a knot
3 lime leaves
200 ml (generous ¾ cup) full-fat
 coconut milk

In her open-air Sumbanese kitchen, Fransiska Lali shares with me her children's favourite dish, creamed corn with coconut milk. Rooster cries pierce the air as we cook. 'We call their sound *kukuruyuk-kukuruyuk*, and we use the same word for women who talk too much!' she laughs warmly. The browned butter is Fransiska's delightful addition to this Sumba comfort food.

Shave off the sweetcorn kernels into a bowl, then use the back of the knife to scrape against the cobs, pressing out any milky liquid.

Heat the butter in a pan, swirling occasionally as it first melts, then foams and darkens to a toasty golden. As soon as it smells nutty, tip in the onion and garlic. Season with a pinch of salt and soften in the browned butter.

Tip the sweetcorn into the pan along with the lemongrass, lime leaves and coconut milk. Warm through, then lower the heat to a whisper and cook for 10–15 minutes, stirring occasionally. The corn should be tender, sweet and creamy. Remove the lemongrass.

Menu ideas
Eat with Chilli-fried eggs (page 190) and perhaps some toast. Or serve as a side dish for grilled meat or fish.

Rica rodo

Serves 4

2 tablespoons oil
2 lemongrass sticks, tender
 middle finely chopped
thumb of ginger, peeled, finely chopped
2 small red Asian shallots, finely chopped
2–3 large red chillies, seeded and
 finely sliced
2 tomatoes, chopped
2–3 lime leaves, deveined and shredded
1 small aubergine (eggplant), diced
200 g (7 oz) sweetcorn, fresh or defrosted
100 g (3½ oz) green beans, sliced on
 the diagonal
1 teaspoon sugar
1 teaspoon salt
bunch of basil

A colourful tumble of spicy, aromatic vegetables from the volcano-ringed city of Manado in North Sulawesi. Unlike searing hot Chinese stir-frying, in Indonesia the heat is kept a little lower and the wok a little more crowded, meaning the food both fries and steams until tender and flavourful.

Heat the oil in a wok over a medium-high heat and add the lemongrass, ginger, shallots and chillies. Stir-fry until fragrant, then add the tomatoes, lime leaves and aubergine. Cook until the aubergine is almost soft. Add the sweetcorn, green beans, sugar and salt and continue to stir-fry until the vegetables are tender crisp. Leave to cool a little before scattering with basil leaves.

Shredded chicken salad with lemongrass & lime

Serves 4

Poached chicken

2 cm (¾ inch) ginger, smashed
3 chicken breasts, skin on

Dressing

4 lemongrass sticks, tender centres
 finely chopped
1 teaspoon shrimp paste, toasted
 (see page 189)
4 teaspoons dark palm sugar
 (gula jawa), shaved
1 teaspoon salt
160 ml (generous ½ cup) coconut milk
80 ml (⅓ cup) lime juice (about 3 limes)

Salad

100 g (3½ oz) fresh coconut, grated
150 g (5½ oz) beansprouts
½ Chinese napa cabbage, finely shredded
3 lime leaves, deveined and
 finely shredded
2 red bird's eye chillies, finely chopped
4 tablespoons crisp-fried shallots
2 tablespoons crisp-fried garlic

Light, bright and zingy, this is the perfect dish for a summer's day. Poached chicken is shredded then tossed with lots of crunchy bits and a zippy lime, lemongrass and coconut dressing. You can buy crisp-fried shallots and garlic in large plastic tubs in Asian supermarkets. They are a staple in Indonesian cooking and you'll soon work your way through them once you get in the habit of scattering them onto salads, curries, rice and noodles ...

In a large pan, bring to the boil 1 litre (4 cups) water with the slice of smashed ginger and a good pinch of salt. Add the chicken breasts and simmer over a medium heat for 5 minutes. Remove from the heat and leave to cool in the liquid for up to an hour.

Make the dressing by mixing the lemongrass, shrimp paste, sugar and salt. Whisk in the coconut milk and lime juice and taste for a balance of flavours.

Once the chicken is cool, discard the skin and shred the flesh into long strips. Toss with the salad ingredients and dressing,

Pickled salad with sour peanut dressing

Serves 4

250 g (9 oz) sauerkraut
½ Chinese napa cabbage,
 finely shredded
2–3 handfuls beansprouts
¼ cucumber, diced
2 tablespoons Wok-fried peanuts
 (page 180) or Disco nuts (page 33)
rice or prawn crackers, to serve

Pickled spring onions

100 ml (scant ½ cup) rice
 or cider vinegar
1 tablespoon sugar
1 tablespoon salt
bunch of spring onions (scallions)

Sour peanut dressing

2 large red chillies, seeded
1 red bird's eye chilli
50 g (⅓ cup) roasted peanuts or
 peanut butter
2 garlic cloves, peeled
½ teaspoon shrimp paste,
 toasted (see page 189) (optional)
2 tablespoons tamarind paste
75 g (½ cup) dark palm sugar (gula
 jawa) or dark brown sugar
½ teaspoon salt

The base of this pleasingly sour fermented cabbage salad has similarities to Korean kimchi, but *asinan* is lighter and fresher with the crackle of raw beansprouts and fried peanuts. It is usually eaten unaccompanied as a sensational comfort food snack, but I like to break the rules and serve it with Chicken sate (page 42). Jakarta resident and food expert Okty Rahardjo shared her recipe for the dressing with me. If she were from Bogor, a city an hour to the north, the dressing would be peanut free and the salad full of preserved tropical fruits from green mangoes to nutmeg fruit. Javanese traditional markets sell fermented cabbage ready for people to dress at home, so I have no compunction in using sweet-salty threads of sauerkraut as the base. Pickling spring onions (scallions) the day before adds an acerbic extra dimension, but omit these for speed.

Make the pickled spring onions by putting the vinegar, 100 ml (scant ½ cup) water, the sugar and salt in a pan and bring to the boil. Remove from the heat and cool completely. Trim the spring onions down to the white and very pale green parts. Add to the pickle juice and leave for at least 24 hours before eating. They will keep well in the fridge for a month or so.

To make the dressing, boil the chillies for 5 minutes to soften, then drain. Grind in a small food processor with the peanuts, garlic and shrimp paste until very smooth – push and scrape the sides if needed, it will get there in the end. Transfer the paste to a pan, add the remaining dressing ingredients and 200 ml (a generous ¾ cup) water and cook slowly over a low heat until the sauce starts to boil. Leave to cool. Taste and adjust the seasonings as needed – the dressing should be sweet, a bit salty, savoury and sour.

Mix the sauerkraut, fresh cabbage and beansprouts and toss with the loose, creamy dressing. Rain over the cucumber and peanuts and tuck the pickled spring onions around the edge. Serve with a crunch of puffed rice crackers.

Jakarta beansprouts

Serves 4

1 tablespoon oil
1 small red Asian shallot, sliced
1 garlic clove, sliced
½ large red chilli, seeds in or out, sliced
300 g (10½ oz) beansprouts
½ tablespoon soy sauce
15 g (½ oz) Chinese chives, chopped
15 g (½ oz) lemon basil, leaves picked
grinding of black pepper

Vendors walk the streets of Jakarta and Bogor selling spiky stir-fries of mung beansprouts, cooked to order on portable stoves. They might be topped with cubes of tofu or a slurry of fermented *oncom*, but the beansprouts are the star. Use the freshest you can buy and serve quickly whilst they still retain a crisp bite.

Heat the oil in a wok until shimmering. Add the shallot, garlic and chilli and stir-fry to soften but not colour. Add the beansprouts and soy sauce and stir-fry vigorously for a minute. Add the chives, lemon basil leaves and a good grind of black pepper and stir-fry for just a minute more, until barely wilted. Remove from the heat and serve at once.

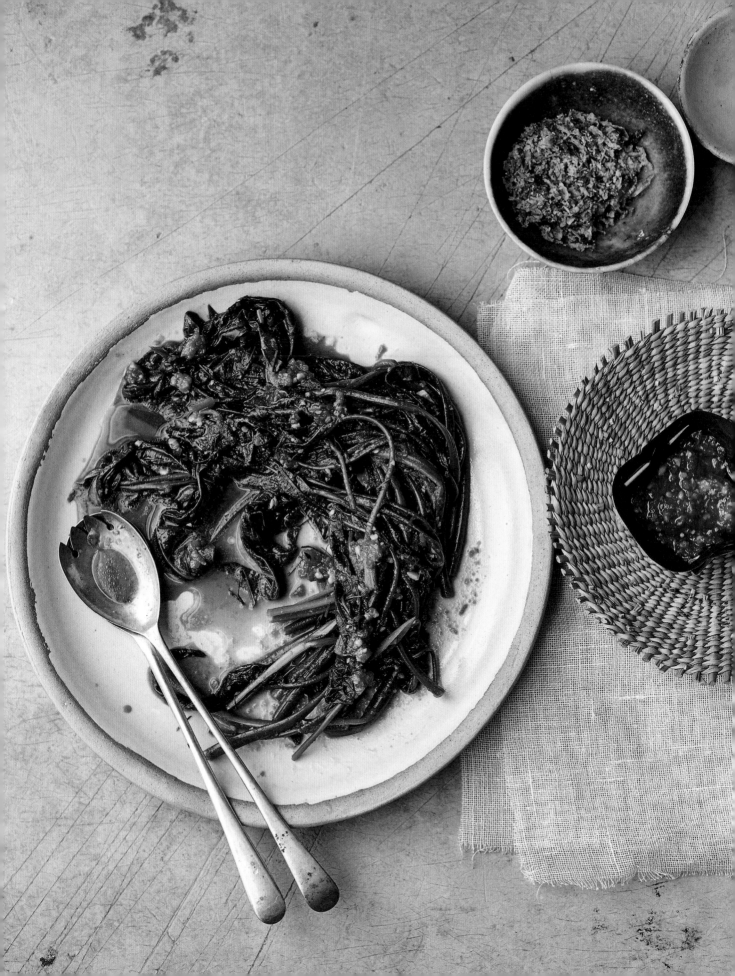

Water spinach with roasted tomato sambal

Serves 4

400 g (14 oz) bunch water spinach
 or garden spinach
3 lime leaves, deveined and
 finely shredded
1 tablespoon kecap manis
3 tablespoons crisp-fried shallots

Roasted tomato sambal
3 medium tomatoes
8 garlic cloves, peeled
2 large red chillies, seeded
1 red bird's eye chilli (optional, for heat)
4 tablespoons oil
1 teaspoon shrimp paste (optional)

Lombok means chilli in local Sasak language, so it's no wonder that people from the namesake island like their food fiery. Their favourite vegetable dish is usually laden with chillies, but I like to make mine a little milder so the sweet, smoky taste of pan-roasted tomatoes shines through. Water spinach (also known as morning glory) wilts to a tender tangle of hollow shoots and leaves, but substitute any seasonal greens.

Prepare the water spinach by running a knife down the length of the stem, then slice into pieces. Bring a pan of water to the boil and cook the water spinach for 2 minutes (or if using garden spinach just wilt in a hot pan with no more water than that clinging to it after washing). Drain and set aside.

To make the sambal, halve the tomatoes and roughly chop the garlic and chillies. Dry roast in a frying pan, turning occasionally, until the tomatoes begin to collapse and everything is slightly softened and charred. Pound to a paste with a pestle and mortar or food processor.

Heat the oil in the frying pan over a medium heat. Add the shrimp paste, if using, and break up with a spoon, letting it sizzle in the oil. Add the tomato mixture and cook for a few minutes, stirring often, until the sambal is a deep red and the smell is 'enak' (pleasing). The oil should have separated from the sauce and you can pour a little of it off if you would like – keep it for dressing salads. Season with salt.

Toss the water spinach with the tomato sambal, lime leaves, kecap manis and most of the shallots. Taste for seasoning; there should be sweet, salt and spice. Use the remaining shallots for a final crunchy topping.

Note
Use the same roasted tomato sambal to dress a mixture of water spinach, blanched beansprouts and green beans. Instead of the crisp-fried shallots, top with Spicy coconut flakes (page 182) and a scattering of fried peanuts.

Green bean lawar

Serves 4

750 g (1 lb 10 oz) green beans
8 small red Asian shallots, sliced
4 garlic cloves, sliced
oil, for frying
1 skinless chicken breast
100 g (1½ cups) grated coconut,
 or 80 g (1 cup) unsweetened
 desiccated coconut, steamed
 for 10 minutes
1 scant teaspoon green peppercorns,
 chopped (optional)
1 lime leaf, finely sliced
juice of a kaffir lime or juice
 and zest of ½ lime

Bumbu spice paste

6 garlic cloves, peeled
6 small red Asian shallots, peeled
2 red bird's eye chillies
2 cm (¾ inch) ginger, peeled
2 cm (¾ inch) galangal, skin scrubbed
2 cm (¾ inch) turmeric, peeled, or
 ½ teaspoon ground turmeric
2 cm (¾ inch) kencur, peeled (optional)
grinding of black pepper
grating of nutmeg (optional)
1 teaspoon coriander seeds (optional)
1 ground long pepper (optional)

Word spread in excited chatters around the Bali morning market that I, a foreigner, was planning to cook *lawar*. The lady selling bundles of verdant greens in palm leaf packaging, the vendor with plump ginger roots still damp with earth, the butcher chopping meat with her cleaver and the seller who wrapped individual spices to order, each laughed and clucked in delight to hear I was making the Balinese delicacy. Meaning 'finely chopped', the mere thought of this aromatic salad of minced meat, vegetables and grated coconut seems to make the eyes of any Balinese mist over with pleasure. I've tried many wonderful variations – lawar made with snake beans, jackfruit or ribbons of young coconut as the vegetable. The meat element can be chicken, pork, fish or smoked duck, and blood can be added to make crimson-stained lawar for temple ceremonies. There is even a roasted dragonfly version for ceremonies when a baby touches the ground for the first time at six months old. The bumbu genep spice mix is simplified in this recipe; at its most complex it contains up to 27 ingredients! One addition I do recommend, if you can source them, are the fresh green peppercorns and long pepper. These peppers, used in Central Bali alongside black and white peppercorns, bring a heat more complex and intriguing than chilli alone, harking back to the days before chilli was introduced to Indonesian cooking.

Boil the green beans for 2 minutes, drain and slice finely into little rounds. Fry the shallot and garlic in oil until crisp and golden. Drain on paper towels.

Poach the chicken breast in simmering water for about 15 minutes, until just cooked through. Chop as finely as you can, using your knife to mince it to a fine rubble.

Make the bumbu spice paste. Roughly chop all the ingredients and grind to a paste in a food processor, adding a little water if needed to help the blades do their work. Heat 2 tablespoons of oil and fry the paste, stirring often, for 5–10 minutes until fragrant and the oil begins to separate from the spices.

In a large bowl, mix the bumbu with the grated coconut and season with a large pinch of salt. Add the other elements: the green beans, fried garlic and shallot and the chicken. Stir through the green peppercorns, lime leaf and juice and massage everything together.

Menu ideas

For a Balinese feast serve lawar with Spice-stuffed smoked duck (page 85), Yellow coconut rice (page 159) and Acar pickles (page 191).

Stir-fried greens with garlic & chilli

Serves 4

300 g (10½ oz) Asian greens
1 tablespoon oil
3 small red Asian shallots, sliced
3 garlic cloves, sliced
1 large red chilli, seeded and sliced
½ tablespoon kecap manis
½ tablespoon soy sauce

Use any dark green leafy vegetables in this stir-fry. In Indonesia I might use water spinach, fronds of fiddlehead ferns, purple-veined kale or bitter young papaya leaves with their tiny white flowers. In my London kitchen I choose bok choy, pak choy, kai lan, tatsoi or chard.

Trim the bases from the vegetables and wash in cold water. Shake dry. Depending on the size, cut the greens into thick strips or leave whole. Slice any thicker stems.

Heat a wok over a medium-high heat. Add the oil and when shimmering hot, add the shallot, garlic and chilli. Stir-fry vigorously to soften and just slightly colour.

Add the greens, shortly followed by the kecap manis and soy sauce. Stir-fry briskly until the leaves have wilted, but still have texture and any stems are still crisp. The sauces should have provided enough salt, but taste for seasoning. Serve at once.

RICE & NOODLES

Chapter Six

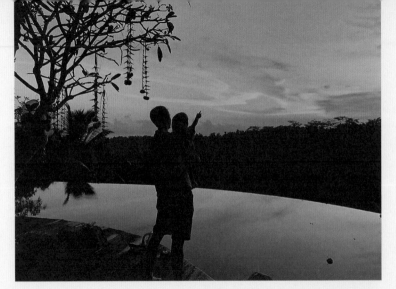

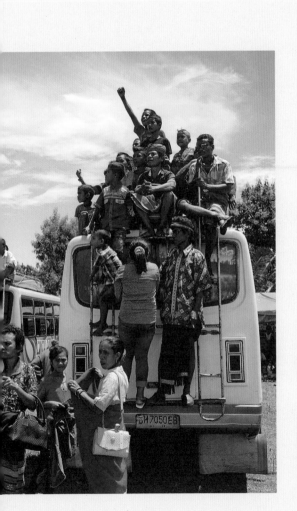

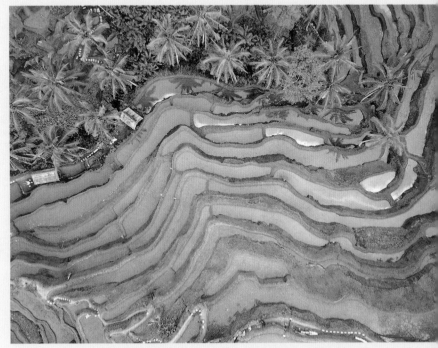

SHIMMERING
Rice Paddies

Terraces of brilliant green cascade down steep hillsides. Pools of water shimmer at the base of rice plants, making the whole vista iridescent. It would be hard to place this timeless scene in history as workers in straw-coned hats stoop in mud to tend the rice by hand, but this is modern Indonesia where growing rice is the work of millions.

Indonesia is the third largest producer in the world, yet still imports rice to keep up with the huge appetite. On average each person gets through 150 kg (330 lb) per year, and this doesn't account for the Eastern Islands where sago, cassava or corn are the staples. The word for cooked rice, *nasi*, is synonymous with food.

Not all rice fields are the dramatic floating terraces captured in countless photographs. Others are neat, flat rectangles joined by low mud walls that double as footpaths, lined with shady coconut trees. The complex networks of flooded fields are hard work to maintain, requiring knowledge, skill and labour. As such, community is the law of the rice paddy and people are bound by the need to share work and natural resources. With no distinct seasons, bar monsoonal rainfall, conditions for growing rice are excellent year round meaning as the rice in one family's paddy is ready for harvesting, the next will be taking root, allowing neighbours to share the load.

A bad harvest is disastrous so rice is treasured, never wasted or taken for granted. It is seen as a goddess, a woman who has to be honoured and coaxed. There are rituals to worship the grain throughout Indonesia, at their most complex in Bali where rice is seen as a representation of life. Cooking is said to awaken the spirit *amerta,* which is held in the grains and provides spiritual and physical nourishment. Chatter disturbs the amerta

so one of the first songs children learn is about eating without talking in homage to this food of life.

Three colours of rice are grown: black rice, which is a deep purple when hulled; red rice, which is hulled to a dusky pink; and brown rice, which becomes the ubiquitous white. The colourful varieties are eaten with less frequency, though are full of nutrients and worth seeking out. Brown rice is regarded as food for infants, invalids and tourists. This leaves white to form the basis of the diet, an aromatic long grain without the nutty flavour of the others. It becomes light and fluffy when cooked, perfect for sopping up sauces. Until the 1970s a plump shorter grained rice with a longer growing cycle was common. Older people reminisce about their youth when life was simpler and the rice more delicious.

It is rice that is the main part of meals, with other elements complementing its absorbing properties. Most often it is eaten plain, but it can also be steamed with coconut milk, stained yellow with turmeric or scented with fragrant leaves. Leftovers are used for nasi goreng, the fried rice so popular it is considered the national dish. Another favourite is rice compressed into dense cakes, either in banana leaf wrappings or woven coconut fronds, which are eaten cold, perhaps with a peanut sauce. Then there are the velvety bubur porridges, both savoury and sweet. Sticky rice is formed into sugary confections and rice flour made into pink and green cakes. Rice wine, a cloudy sweet alcohol, is coaxed from fermented grains.

For celebrations in Java a *tumpeng,* or conical mound of rice, is the centrepiece. It is a tumpeng you'll receive rather than a birthday cake. The tip of the cone is sliced off and given to the most honoured guest.

Perfect steamed rice

Serves 4–6

400 g (2 cups) jasmine rice
2 pandan leaves, knotted (optional)

Fluffy, fragrant, just steamed rice is the canvas onto which the flavours of almost every meal will be laid. Indonesian rice is hard to find outside of the country so Thai jasmine rice makes the best substitute. It should be cooked until *pulen*, that is soft with no bite but not soggy. Each grain should be separate, with just enough stickiness to eat with your fingers, should you so fancy. I have come across two cooking methods. The first is to parboil the rice, drain then transfer to a steamer to finish (in Java and Bali this is a woven conical basket that sits over the pan). The second method, and my preferred as it cuts down on washing up, is to boil the rice in just a little more water by volume, then cover and leave to steam in the pan. Salt is not added, but a pandan leaf gives beautiful fragrance if you have one. Indonesians tend to have a heartier appetite for rice than Westerners who are more unpredictable in their voracity! I usually cook 100 g (½ cup) rice per person, which swells to a very generous serving, as leftovers are a gift for making Nasi goreng (page 160) the next day.

Wash the rice thoroughly, swirling the grains in four changes of cold water until most of the cloudiness has gone. This breaks down the surface starch, which could otherwise make the rice come out sticky.

Drain well and put in a pan. Add 625 ml (2½ cups) water and shuffle the rice into an even layer. Set over a high heat and bring to a rolling boil. Bubble for 15 seconds, then turn down the heat to the lowest setting and cover tightly with a lid. Leave to steam for 15 minutes without disturbing.

Remove from the heat without peeking in and leave the rice to continue steaming under the lid for another 10 minutes. Gently fluff the grains with a fork before serving.

Note
For brown long-grain rice, add an extra 5 minutes steaming on the low heat (30 minutes in total).

Solo coconut rice

Serves 4–5

300 g (1½ cups) jasmine rice
2 lime leaves
2 salam leaves (optional)
pinch of sugar
280 ml (generous 1 cup) chicken stock
200 ml (generous ¾ cup) coconut milk

Rice is steamed with coconut milk and chicken broth until soft, unctuous and fragrant in this iconic dish from Solo, Java (formally known as Surakarta). I learnt this version of *nasi liwet* in the royal palace kitchens where the female chefs have been seasoning it this way for generations.

Wash the rice well, swirling it gently in four changes of water. By the end there should be little cloudiness left in the water. Drain.

Put all of the ingredients in a pan with a pinch of salt and bring to the boil, stirring to stop the coconut milk scorching. Boil hard for about 10 seconds, still stirring, then turn the heat to the lowest. Cover with a lid and simmer for 15 minutes.

Don't be tempted to lift the lid. After the 15 minutes, turn off the heat and leave covered for another 10 minutes for the rice to finish steaming. Gently fork through before serving.

Menu ideas
In a warung this rice would be topped with Coconut milk chicken (page 55), steamed pumpkin, Marbled eggs (page 193) and a spoonful of thick coconut cream.

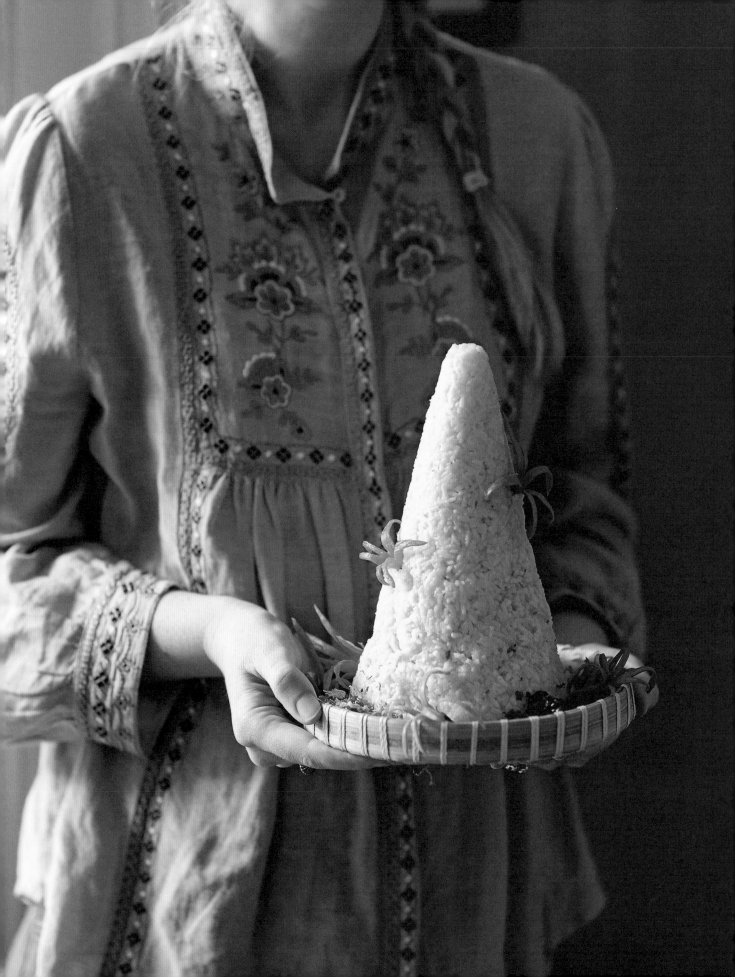

Yellow coconut rice

Serves 6–8

500 g (2½ cups) jasmine rice
6 cm (2½ inches) galangal, skin scrubbed
4 cm (1½ inches) turmeric, peeled, or
 1 rounded teaspoon ground turmeric
2 cm (¾ inch) ginger, peeled
5 small red Asian shallots, peeled
5 garlic cloves, peeled
400 ml (14 fl oz) tin coconut milk
5 lime leaves
3 lemongrass sticks, bruised and tied
 in a knot
2 tablespoons oil
1 heaped teaspoon salt

Resembling a heap of gold, *nasi kuning* symbolises good fortune and so is served at festivals and celebrations, often in a towering cone shape called a *tumpeng*. These can be small individual portions or tower several feet high like a splendid volcano. The rice is par-cooked, then bathed in amber-stained coconut milk, which it absorbs greedily, leaving the grains swollen with gentle flavour. There are notes of musky turmeric and balmy lemongrass, but this is a versatile dish to turn any meal into a celebration.

Wash the rice well, swirling it in four changes of water. By the end there should be little cloudiness left in the water. Steam for 10 minutes to par-cook.

Put the galangal, turmeric, ginger, shallots and garlic in a small food processor with a small glassful of water. Whizz, then strain and press through a sieve into a large pan to keep the brilliant orange liquid. Pass 400 ml (generous 1½ cups) water through the sieve and into the pan as well to extract extra flavour. Discard the solids.

Add all the remaining ingredients to the pan and bring to the boil. It should be a creamy primrose yellow – add more ground turmeric if not. Add the rice, stir and turn off the heat. Leave for 10 minutes or more to absorb the fragrant coconutty broth. It should be stained a beautiful yellow.

At this point you can keep the rice until you are ready to eat (in the fridge if longer than an hour). Transfer back to the steamer for a final 10 minutes. Remove the lemongrass and heap into a golden mound or shape into a cone.

Note
Indonesian kitchens have a metal cone for shaping rice. This is oiled, the rice packed in, then turned out to serve. A plastic cone will do the job, but line with plastic wrap before filling. Smaller tumpeng can be fashioned with a cone of banana leaf or paper.

Menu ideas
When yellow rice is served in a cone-shaped tumpeng it will be surrounded by, or even studded with, other celebratory foods. Fried chicken (page 34), glazed tempeh (page 185), Sweetcorn fritters (page 40) and Vegetable urap with fresh spiced coconut (page 132) provide substance whilst other frivolities provide drama: Marbled eggs (page 192), dried fish, crunchy peanuts (page 180), cucumber slices and chillies curled into fiery flowers. Make these by snipping red chillies in half lengthways, almost to the stem. Shake out the seeds and cut each side again into two to three strips. Soak in cold water for 15 minutes for the 'petals' to curl.

Nasi goreng

Serves 2

3 tablespoons oil
1 small onion, sliced
2 spring onions (scallions), sliced
1 small carrot, finely chopped
6 fine green beans, finely chopped
4 garlic cloves, chopped
1 large red chilli, seeded and sliced
handful Asian greens, finely sliced
handful shiitake mushrooms, sliced
handful beansprouts
2 eggs
300 g (1½ cups) cold cooked rice (about
 150 g/¾ cup rice), steamed and cooled
2 tablespoons kecap manis, plus
 more to serve
1 tablespoon tomato paste
 (concentrated purée)
1½ tablespoons soy sauce
1½ tablespoons sesame oil

Optional toppings
ribbons of omelette
crisp-fried shallots
prawn crackers or emping
Acar pickles (page 191)

There's not a tourist restaurant in Indonesia that doesn't serve *nasi goreng*, the umami-packed fried rice that will colour every traveller's memories. It takes a little care to make it well, but can be undeniably delicious with the sauces adding treacly depth and a smoky edge from the heat of the wok. What's more, it is the perfect way to use up odd vegetables (the below are just suggestions; any will do but keep them chopped small) and yesterday's rice. In fact, it demands rice that has been cooked and cooled, which helps keep the grains light rather than oily.

Heat a wok until almost smoking. Add the oil followed by the onion, spring onions and carrot. Stir-fry until softened, then add all the remaining vegetables and continue to stir-fry to a collapsed tangle of lightly caramelised vegetables.

Add the eggs and stir through, cooking until the egg is dry and crumbly. Turn off the heat.

Add the rice, sauces and sesame oil to the wok and very carefully mix with the back of a spoon – you don't want to break the grains. Taste and adjust the seasoning, splashing in more of the sauces if needed for salt, sweetness or more depth of flavour.

Reheat gently, turning the rice and avoiding the heat at the centre of the wok where it may catch.

Serve at once with any of the suggested toppings and spin over a fine stream of kecap manis.

Note
Crazy rice (*nasi gila*) is Jakarta's take on nasi goreng. It is souped-up with extras like meatballs, sausages, prawns and punchy spices stir-fried with the rice. One of the most famous versions is *Obama nasi gila*, so named as it comes from the street where the US president went to school.

Sweetcorn rice

Serves 6

300 g (1½ cups) jasmine rice
1 onion, sliced
1 tablespoon oil
½ teaspoon salt
300 g (10½ oz) sweetcorn, fresh
 or defrosted

In parts of Indonesia where rice isn't plentiful, it can be bulked out with corn. In Sumba I pounded dried corn for this, but fresh sweetcorn kernels can be added whole. This gives a pleasing textural contrast and is worth trying, perhaps alongside Rica rica clams (page 113) or Betawi spiced beef (page 125).

Wash the rice thoroughly, swirling the grains in three to four changes of cold water until most of the cloudiness has gone. Drain and set aside.

Soften the onion in the oil and, if you have the time, let it caramelise to a pale gold.

Add the rice and salt and stir. Pour over 550 ml (2¼ cups) water, bring to the boil and bubble enthusiastically for 15 seconds. Reduce the heat to low, cover with a lid and leave to simmer undisturbed for 15 minutes.

Add the sweetcorn and fork through the rice, then quickly clamp the lid back on. Leave to steam for a further 10 minutes over the low heat. Fluff gently with a fork before serving.

Spice rice

Serves 4–6

400 g (2 cups) jasmine rice
1 tablespoon coconut oil
1 onion, finely chopped
2 garlic cloves, crushed
2 cm (¾ inch) ginger, peeled and grated
2 cloves
4 cardamom, lightly cracked
½ teaspoon ground turmeric
½ teaspoon ground cinnamon

This rice is pale gold and very scented. Rice is more typically eaten plain, but in parts of Indonesia there are dishes resembling the pilafs and biryanis of the Middle East and South Asia. The spices – cloves, cardamom, cinnamon – of the old spice trading routes suffuse it with flavour.

Wash the rice thoroughly, swirling the grains in four changes of cold water until most of the cloudiness has gone.

Heat the coconut oil in a saucepan and fry the onion until softened. Add the garlic, ginger and spices and cook for a minute longer. Stir through the rice so it is lightly coated and glistening.

Add 625 ml (2½ cups) water and shuffle the rice into an even layer. Set over a high heat and bring to a rolling boil. Bubble for 15 seconds, then turn down the heat to the lowest setting and cover tightly with a lid. Leave to steam for 15 minutes without disturbing.

Remove from the heat without peeking in and leave the rice to continue steaming under the lid for another 10 minutes. Gently fluff the grains with a fork before serving.

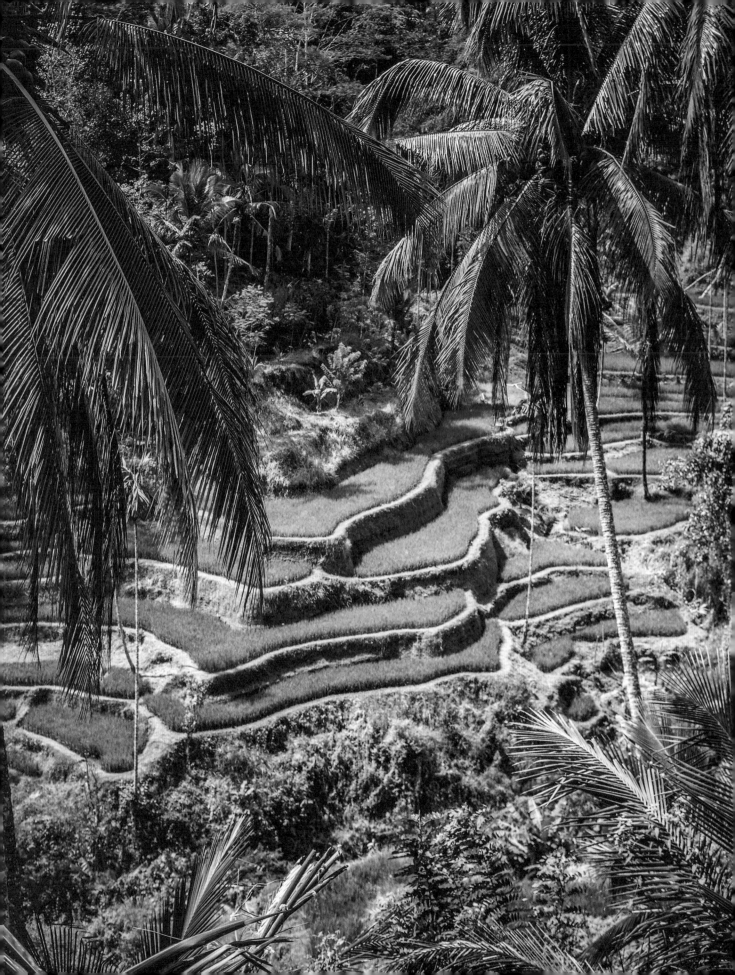

Red rice – *nasi merah* (cooked) or *beras merah* (raw)

High in fibre and nutrition, beautiful red rice is full of character. Usually sold unpolished but with the husk removed, it has a nutty flavour and slightly chewy texture. Serve it in place of white rice, but I suggest alongside something grilled with punchy flavours as it doesn't have the absorbent properties to match a delicate creamy sauce.

Black rice – *nasi hitam* (cooked) or *beras hitam* (raw)

Black rice is sometimes called purple rice as the dark grains turn to a gorgeous deep aubergine colour when cooked. The ancient grain has impressive health benefits due to its high antioxidant content (the same inky pigment present in blueberries and blackcurrants) as well as iron and fibre. There are both regular and sticky black rice grains. In the Majapahit Empire of the thirteenth century it was grown in limited quantities and reserved for the highest elite. Today everyone can enjoy it and a favourite dish is Black rice pudding with salted coconut cream (page 212).

White rice – *nasi putih* (cooked) or *beras putih* (raw)

The canvas around which almost every meal is built is white rice (brown is the same grain but with the bran layer intact). Choose a long grain variety such as the delicately perfumed Thai jasmine to get soft, individual grains with just a little stickiness. Read more on page 156.

Sticky rice – *ketan*

Also called glutinous rice, though it contains no gluten, this rice cooks to a sticky glue-like consistency that holds the individual grains together. It is used in many chewy Indonesian sweetmeats, as well as Sticky rice rolls (page 41).

Rice flour – *tepung beras*

Made from ground raw rice and used to make rice noodles, steamed cakes, pancakes and batters. On its own it can be gluey, just what you are after for sticky cakes; combined with wheat flour it makes a lighter, crisper batter.

Noodles – *mie*

This is the home of Indomie, the world's favourite instant noodle. So ubiquitous are these colourful packets of noodle blocks with seasoning powders that you don't even have to boil your own kettle – there are street stalls dedicated to preparing them, sometimes slipping in ribbons of fresh vegetables or an egg poached in the cooking water to cut the synthetic yet compelling flavour. Of course there are other noodles available too and the masters of using these are the street traders. They can either be stir-fried with dark and sticky sauces, or added into spicy noodle soups. For the former, thick Chinese egg noodles are most commonly used for their springy texture and ability to absorb flavours. Fresh noodles tend to be better than dried, but always follow packet instructions to see if cooking is needed before adding to the wok. For soups, rice noodles are wonderful for their slippery texture and delicacy. I tend to use vermicelli rice noodles.

Tempeh

Savoury, golden, pillowy cakes made from fermented soya beans. The beans are split, parboiled and a culture is added. They are then left to ferment for several days in leaf-wrapped parcels until a soft white skin, similar to brie, forms over the surface. An excellent source of protein, tempeh is a Javanese invention where they have endless inventive ways to make the most of its nutty flavour and nubbed, spongy texture. It might be cut into matchsticks and deep-fried with a spicy palm sugar glaze. It can be simmered in delicate coconut milk curries. Or maybe hefty chunks will be infused with spices, then cooked until golden brown and crisp. In Indonesia it is usually sold wrapped in glossy palm leaves; in the West look for a plastic-wrapped version in health food stores.

Tofu – *tahu*

The pressed bean curd protein can range from the custardy silken tofu to the denser, cheese-like firm tofu. The firmer varieties are used more in Indonesia as they can be diced and hold their shape to be fried. The crisp, golden cubes can then be used in silky sauced curries in the place of meat or fish.

Rubber noodles with chicken

Serves 4

1 tablespoon oil
1 red onion, finely chopped
2 lemongrass sticks, bruised
3 lime leaves
2 salam leaves (optional)
2 chicken breasts, cut to a very small
 dice, about 5 mm (¼ inch)
bunch of spring onions (scallions),
 chopped
1 tablespoon Chinese cooking wine
1 tablespoon soy sauce
1 tablespoon Worcestershire sauce
1 tablespoon kecap manis
1 teaspoon dark palm sugar
 (gula jawa), shaved
3 pak choy, sliced
400 g (14 oz) egg noodles
1 teaspoon sesame oil
800 ml (3¼ cups) fresh chicken stock,
 hot (optional)

Bumbu spice paste
6 garlic cloves, roughly chopped
6 small red Asian shallots,
 roughly chopped
2 cm (¾ inch) turmeric, peeled, or
 ½ teaspoon ground turmeric
2 cm (¾ inch) ginger, peeled
3 candlenuts or 6 blanched almonds
1 teaspoon ground coriander
½ teaspoon ground cumin
½ teaspoon ground black pepper
½ teaspoon salt

To serve
crisp-fried shallots or garlic
kecap manis
chilli sauce

One of the most popular street cart foods in Indonesia is Chinese-Indonesian *mie ayam* (chicken noodles), invariably served in a white bowl painted with red cockerels. I like that they are sometimes called rubber noodles for their springy, chewy texture. Buy medium thick, yellow egg noodles. Stir-fried chicken and fresh greens are spooned over with an optional ladle of chicken stock to transform a sticky glazed dish to a noodle soup. Bakmi meatballs or preserved vegetables can be added, but I keep mine more pared back – well, slightly more! The ingredient list is long, each element combining for an irresistible explosion of flavour, but the preparation is simple.

Start by making the bumbu. In a food processor, whizz all the bumbu spice paste ingredients together, adding a little water to help the blades bring everything together.

Prepare all the ingredients for stir-frying. Preheat a wok over a medium heat, add the oil and soften the onion. Add the bumbu, lemongrass, lime leaves and salam leaves and fry until very fragrant. Add the chicken and stir-fry for a couple of minutes.

Add the spring onions, all the sauces and palm sugar and stir-fry until the chicken is cooked through and glazed with the sauce. Remove from the heat, taste for seasoning and set aside.

Bring a pan of water to the boil and blanch the pak choy until the leaves are wilted and the stems tender crisp. Remove with a slotted spoon. Cook the noodles in the same water, making sure they keep some chewiness. Drain and toss with sesame oil to prevent sticking.

Divide the noodles into four bowls. Top with pak choy and the chicken. If using, ladle over the hot broth and bring to the table with crisp-fried shallots or garlic (or both), kecap manis and chilli sauce for everyone to tailor their bowls to their own taste.

Bubur Bali

Serves 4

200 g (1 cup) brown rice, washed
2 salam or lime leaves
125 g (4½ oz) finely grated fresh or
 rehydrated coconut
1 lemongrass stick, bruised and
 tied in a knot
2 small red Asian shallots, sliced
2 garlic cloves, sliced
1 large red chilli, seeded and sliced
1 tablespoon oil
50 g (2 oz) spinach or pak choy
juice of a lime
1 tablespoon crisp-fried shallots
4 tablespoons Wok-fried Peanuts
 (page 180)

Bumbu spice paste

2 small red Asian shallots, peeled
2 garlic cloves, peeled
1 large red chilli, seeded
1 red bird's eye chilli (optional)
4 cm (1½ inches) galangal, skin scrubbed
3 cm (1¼ inches) turmeric, peeled, or
 1 teaspoon ground turmeric
3 cm (1¼ inches) ginger, peeled
½ teaspoon coriander seeds
3 tablespoons oil

A favourite breakfast across much of Asia is rice cooked until collapsed and made creamy by its own starch. I have always found the name 'rice porridge' an unappealing way of describing this, the savoury flavours jarring with the description. A risotto is a far better culinary cousin to call to mind for its similar texture and depth of flavour. Bubur Bali is velvety, comforting, nourishing. This fantastic version with spinach urap comes from the Bambu Indah hotel kitchens. The toppings make every mouthful different, so play around with these, adding some crunch, some spice, perhaps something pickled. Without the bumbu spice paste it makes perfect baby food. Add a scarlet spoonful of sambal oelek for some extra fire and it will soothe away the fiercest hangover.

Put the rice in a pan with one of the salam leaves and top with 500 ml (2 cups) cold water and a good pinch of salt. Bring to the boil, then give the rice a good stir, scraping the bottom of the pan to stop sticking. Half cover with a lid and leave to cook on a gentle simmer for 1 hour. Stir occasionally, especially towards the end of cooking. The rice grains will burst open to make a thick and creamy mixture with the consistency of oatmeal. Add more water if needed during cooking. If you make it in advance (it lends itself well to this), then reheat with a splash of water.

Make the bumbu whilst the rice is cooking. Put all the ingredients for the spice paste into a food processor and blend to a purée. Season with salt and pepper. Cook in a shallow pan for 5–10 minutes, stirring often, until the mixture darkens and the oil begins to separate from the paste. Tip in most of the grated coconut (keeping some back for later), the whole knotted lemongrass and the remaining salam leaf. Add 150 ml (generous ½ cup) water and a pinch of salt and cook over a medium heat for about 15 minutes. The mixture should be a fragrant, loose sauce.

In a small pan, fry the shallot, garlic and chilli slices in the oil until golden and crisp.

Remove three-quarters of the spiced coconut sauce from the pan and set aside. Add the spinach to the remaining mixture and wilt over the heat. Turn off the heat and stir in the reserved grated coconut, the lime juice and the fried shallot/garlic/chilli mix. Taste for seasoning.

To serve, spoon the bubur into bowls. Divide the spiced coconut sauce over the top and then the spinach. Finish with a scattering of crispy shallots and fried peanuts.

Mie goreng

Serves 2

150 g (5½ oz) dried egg noodles
50 g (2 oz) chicken (optional)
2 small red Asian shallots, sliced
2 garlic cloves, sliced
2 spring onions (scallions), sliced
1 large red chilli, seeded and sliced
1 small carrot
60 g (2 oz) Asian greens
60 g (2 oz) cabbage
2 tablespoons oil
1½ tablespooons kecap manis
2 teaspoons soy sauce
1 teaspoon tomato paste
 (concentrated purée)
crisp-fried shallots, to serve

Sometimes all you want is that delicious, filthy, umami-packed flavour that only a good takeaway usually provides. These fried noodles have it and are the ideal speedy one-dish supper for when the fridge is near bare. You only need a few odds and ends of vegetables, cut into ribbons, and store cupboard sauces and sprinkles for a mild salty-sweetness. Bolster with a protein of your choice: chicken, prawns, tofu or leftover meat, or add thin strips of omelette at the end instead.

Get all the ingredients ready and laid out next to you before you begin to stir-fry.

Boil the noodles as instructed on the packet, keeping them chewy.

Slice the chicken into thin strips, then into tiny pieces. Slice the vegetables into separate piles on another chopping board. Cut the carrot into long slices, and then julienne them (i.e. cut into matchstick-like strips). Slice the greens and cabbage into similarly thin strips.

Set a wok or frying pan over a medium-high heat. Heat the oil, then add the chicken. Stir-fry for 1–2 minutes until cooked through. Push to the side of the wok (or remove if using a frying pan). Add the shallot and garlic and cook briefly to soften, then stir through the spring onions and chilli and cook for about 20 seconds or so longer. Shuffle the chicken back down and stir everything together. Add a splash of water to moisten the meat.

Add the vegetables and stir-fry to soften. Add the noodles and sauces and use tongs to mix everything together well. Toss through for a minute or two until heated through.

Check the seasonings – you can add salt or more soy sauce for saltiness and a generous grind of black pepper is good. Serve scattered liberally with the crisp-fried shallots.

AWAKENING
THE SENSES

Chapter Seven

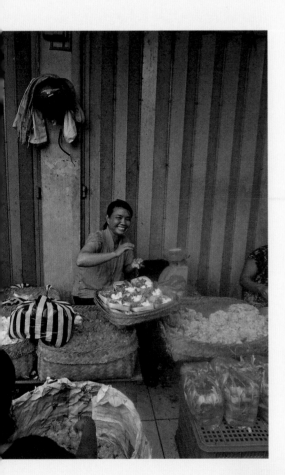

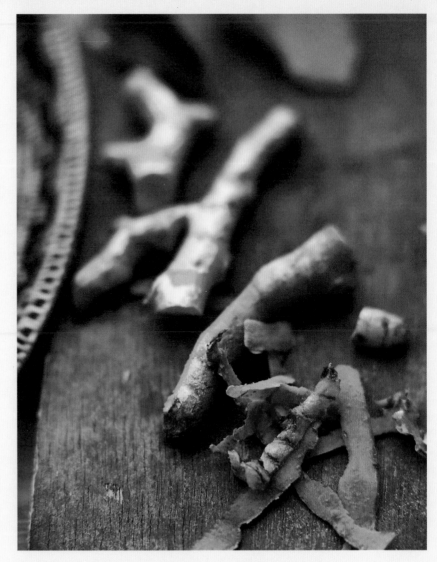

The
WARUNG

Clustered along every roadside in Indonesia are small family-owned food stalls and shacks, sometimes no more than a lone table under a tarpaulin. The humble warung draws diners from all walks of life; bus drivers huddle next to businesswomen on plastic chairs or floor seating. Everyone is drawn by the one dish they make better than anyone else.

It might be sate, the smoky grill set at the front to lure passing trade. Or perhaps rice with an assortment of spicy pre-cooked accompaniments each dotted around the plate in tiny portions. Nasi goreng, the umami-packed fried rice, is ubiquitous and warungs serving up soto are unrivalled for their intense broths shimmering with bone marrow fat.

Food is brought quickly on mismatched floral plates. There will be small glass soda bottles, plastic dispensers of waxy tissue paper and perhaps a television flickering in the corner.

Local delicacies fill a glass cabinet. Maybe home-grown pumpkins, single clove heads of garlic, assorted deep-fried offal, bitter herbal drinks in unlabelled water bottles or eggs boiled in tea. There will be jars of individually wrapped sweets and mysterious spongy cakes in a cacophony of colours.

Then there are the crucial components to enliven your plate and awaken your palate. The warung will have their house sambal, a flavour-boosting chilli paste no meal can be without. There might also be pickles to add a bright sharpness. Certainly there will be a basket of crunchy foods in sealed plastic bags.

Indonesians love to add an element of crunch to food with baked or fried krupuk crackers. Made from different seasoned flours, sometimes with a dried fish base, there are puffy prawn crackers, crisp emping, lacy swirled nests of rice flour, red sago crackers and deep-fried cassava chips. Maybe you'll choose a scattering of caramelised coconut flakes, crackled chicken skins, crisp sticks of spiced tempeh or sugar-glazed banana slices. The crackling sound as you eat is said to stimulate the appetite.

Chilli sambals

Whilst bumbu spice pastes provide the bass note for almost every Indonesian meal, sambal sauces bring the final spicy crescendo. The bumbu is cooked into the dish, its warm flavours developing and melding with the meat or vegetables. Sambal is served like a relish alongside, although it can also be the main event in itself. The simplest meal, and a fantastic one it is too, is fluffy steamed rice, salt, a slick of virgin coconut oil and a fiery red sambal to ignite the palate. Here are a few versions with different degrees of heat, colour, texture and complexity. Choose whichever appeals and I guarantee it will lift your meal to a new height.

Sambal oelek

This is the most basic sambal, fiercely hot and quick to make. Jars of sambal oelek can be bought in many Asian shops and can be used in place of fresh chillies in cooking.

250 g (9 oz) large red chillies, stalks removed
1 teaspoon dark palm sugar (gula jawa)
1 teaspoon salt

Heat a heavy frying pan until smoking hot. Tip in the whole chillies and dry roast for a few minutes. Blitz to a paste in a food processor with the palm sugar and salt. Store in a jar in the fridge for a week or so.

Red chilli sambal

Red chilli sings out in this sweet but complex coral red paste. It is more exciting than sambal oelek and incredibly versatile – if any dish is missing a certain something, stir in a spoonful of this to bring it back on track.

6 tablespoons oil
4 small red Asian shallots, roughly chopped
6 garlic cloves, peeled but whole
2 large tomatoes, roughly chopped
2 large red chillies, roughly chopped
½ or 1 red bird's eye chilli
½ teaspoon shrimp paste (optional)
1 tablespoon dark palm sugar (gula jawa)
juice of a kaffir lime or zest and juice of ½ a lime

Heat the oil in the frying pan – be generous as it's crucial for depth of flavour: you can pour the excess off later. Soften the shallots and garlic in the oil for a few minutes, then add the tomatoes, chillies with their seeds and shrimp paste. Fry over a medium heat until everything is collapsed and softened.

Transfer to a high-speed blender and whizz to a purée. Return to the pan with the palm sugar and a pinch of salt. Fry, stirring often, until the sambal darkens and the oil starts to rise to the surface. Leave to cool.

Brighten the flavours of the sambal with a final spritz of kaffir lime.

Padang green chilli sambal

Not blitzed to smoothness, rather the green chillies slump down to a silky, army green relish. Despite the scary quantity of chilli seeds it is the flavour, not the heat, from the chillies that shines through. Sometimes teeny salted fish are added too.

5 large green chillies
1–2 green bird's eye chillies (optional for extra heat)
3 small red Asian shallots, peeled
2 garlic cloves, peeled
1 large green tomato
3 tablespoons oil
3 lime leaves
½ teaspoon sugar
½ teaspoon salt

Chop the chillies, shallots, garlic and tomato. Simmer in a pan with a large glass of water to soften the vegetables.

Drain and transfer to a mortar. Use a pestle to smash and grind the vegetables, just to encourage their flavours out, not to create a smooth paste.

Heat the oil in a frying pan over a medium heat and scrape in the pounded chillies. Add the lime leaves and season with sugar and salt. Fry for a few minutes until the sauce is collapsed and fragrant. Leave to cool.

Sweet tomato sambal

The chilli fire is dialled back here by palm sugar sweetness. *Sambal bajak* would win hands down in any tomato chilli jam wars.

200 g (7 oz) tomatoes
2 large red chillies
3 small red Asian shallots, peeled
7 tablespoons oil
1 tablespoon dark palm sugar (gula jawa)
1 teaspoon sea salt
2 tablespoons tamarind paste

Roughly chop the tomatoes, chilli (with the seeds) and shallot. Heat half the oil in a frying pan and cook the vegetables until soft and wilted.

Pound to a paste with a large pestle and mortar, adding the sugar, salt and tamarind paste. (You could use a food processor, but try not to lose the texture.) Return to the pan with the remaining oil and cook to reduce the liquid and turn the sambal a darker red. Spoon off the excess oil, if you like, and save it for cooking. Leave the sambal to cool.

Fermented sambal

Locavore has been named Indonesia's top restaurant for its creativity with local produce. One simple yet sensational morsel is their fermented chilli sambal, which they serve on a cassava crisp with a lemon basil leaf. Head chef Eelke Plasmeijer generously shared the recipe with me.

250 g (9 oz) red chillies, seeded and finely chopped
85 g (3 oz) red Asian shallots, finely chopped
2 garlic cloves, grated
1 lemongrass stick, white centre only, finely chopped
2 lime leaves, finely chopped
1 teaspoon sea salt
1 tablespoon lime juice

Mix everything together and transfer to a sterilised jar. Close with a lid. Let sit at room temperature for 4–5 days, depending on how funky you'd like it to be. Store in the fridge.

Strawberry sambal

Fruity sambals are a popular pairing for fish, whether made with tart green mango, sweet pineapple or pungent fermented durian. The cool highlands of Bandung are home to many strawberry farms and this enchanting combination – a thin red slurry that makes a good dipping sauce.

100 g (3½ oz) strawberries, roughly chopped
1 large red chilli, seeded and roughly chopped
1 teaspoon sugar
grinding of black pepper
juice of ½ lime

Blend all the ingredients together in a blender with a pinch of salt and taste to balance the flavours. Depending on the sweetness of the fruit it may need more sugar or an extra zing of lime juice.

Balinese lemongrass sambal

A vibrant raw sambal perfumed with citrussy lemongrass. Or if you find pointy pink buds of torch ginger flowers, finely slice and use these instead for their exotic, floral piquancy. This sambal makes a good counterpoint to rich food or a natural pairing for grilled fish.

3 lemongrass sticks or
 ½ torch ginger flower
8 small red Asian shallots, peeled
2–3 red bird's eye chillies
1 lime leaf, finely shredded
juice of ½ a kaffir lime or spritz
 of lime juice
2 tablespoons virgin coconut
 oil, melted

Trim the woody green parts from the lemongrass, then bruise the stalk with the heel of the knife to release the fragrance before chopping finely. Finely chop the shallots and chillies and mix the three together.

Add the lime leaf, juice and a pinch of salt and massage the ingredients together well. Given the chilli seeds, I recommend sparing your hands and using the back of a spoon or plastic gloves. Stir through the coconut oil and taste for balance of flavours – you are after bright fragrance and spice.

Peanut sauce

100 g (⅔ cup) raw peanuts, skin on
1 tablespoon oil, for frying peanuts
1 garlic clove, crushed
½ teaspoon shrimp paste,
 toasted (see page 189) (optional)
½ teaspoon dark palm sugar
 (gula jawa), grated
3 tablespoons kecap manis
juice of ½ a lime

Peanut sauce is a big deal in Indonesia, and in our house. For a lighter, fragrant version see the Gado gado peanut dressing (page 136), but it's this, its dark and intense cousin, that I turn to for Chicken sate (page 42). The peanuts are cooked twice, first to brown and secondly to caramelise to stickiness in the sauce. Simple but loud flavours.

Fry the peanuts to bring out their toasty flavour. Heat the oil in a wok or frying pan over a high heat. When shimmering, add the nuts and stir-fry for a minute. Reduce the heat to medium and continue to fry, stirring often, for about 5 minutes, until the nuts are deep golden brown. Remove with a slotted spoon and drain on paper towel.

Tip the nuts into a food processor (keep the skins on) with the garlic, shrimp paste, palm sugar and a good pinch of salt. Blitz to a sandy rubble, then scrape the sides and process for another minute. Continue scraping and blitzing for a few minutes at a time until you have a smooth purée (it should get there, with some perseverance).

Transfer the peanut butter to a saucepan, add the kecap manis and a small glassful of water. Cook over a medium-high heat, stirring often, until you have a sauce that is dark and slightly sticky. Thin with more water if it gets too thick – you want it to thickly coat the sate but be just pourable. Leave to cool and taste for seasoning, adjusting the saltiness and sweetness if you like. A final spritz of lime juice will brighten the flavours.

Wok-fried peanuts

3 tablespoons oil
400 g (3 cups) raw peanuts, skin on
5 garlic cloves (optional)
5 small red Asian shallots (optional)

Learn from Indonesian wisdom: fried peanuts trump roasted peanuts. Using a wok and a little oil – you drain it off later – brings out the amazing toasty aromas locked inside a raw peanut. Do try and seek out nuts with their red skins on: a lot of the nutrients and flavour lies in here. You'll find them in Asian supermarkets. Make more than you need as not only are these an addictive snack, they will keep for weeks in an airtight container. Eat alongside any dish in this book for crunch, scatter into salads, toss into the Tempeh with red chilli & palm sugar (page 185) or grind to the ultimate Peanut sauce (page 179).

Heat the oil in a wok over a medium-high heat until shimmering, add the nuts and stir-fry for a minute. Reduce the heat to low and continue to fry, stirring often, for 5–10 minutes until the nuts are a deep golden brown (a smaller quantity will cook much quicker at both stages, so turn the heat down quickly and watch they don't burn). Remove with a slotted spoon and drain on paper towels.

An optional step is to add crisp-fried garlic and shallots. Slice them to a similar thickness, add to the hot oil left in the wok and fry until golden. Drain on paper towels, then mix with the nuts.

Season with salt, which will keep the peanuts dry and crisp.

Caramelised chicken floss

Serves 4–8 as a side dish

1 chicken breast
2 garlic cloves, sliced
1 small red Asian shallot, sliced
1 red bird's eye chilli, seeds in or out, sliced
1 cm (½ inch) turmeric or ½ teaspoon
 ground turmeric
1 cm (½ inch) kencur (optional)
1 tablespoon coriander seeds
½ teaspoon black peppercorns
¼ teaspoon salt
1 tablespoon dark palm sugar
 (gula jawa), shaved
oil, for frying

Delivering a serious umami punch, a little of this meat cooked to a texture of coarse cotton transforms a simple bowl of rice or makes a great side dish to an otherwise vegetarian meal. In Muslim majority Indonesia, beef floss is the most popular, though it can also be made from pork, chicken or tuna. Most people don't make it at home nowadays, but my friend Dayu Putu still makes her mother's recipe for her daughter, who proclaims it much better than any you can buy. She was kind enough to share it with me.

Poach the chicken breast in simmering water for 15 minutes, or until cooked through – don't worry about overcooking as that will be happening anyway soon enough. Leave to cool a little, then shred very finely to get a tangle of fibres.

Make a spice paste in a food processor or pestle and mortar, grinding together all the remaining ingredients. Mix the chicken with the spice paste to coat well.

Coat the bottom of a frying pan generously with a layer of oil and stir-fry the chicken mixture until everything is fragrant, dried out and well browned. Remove from the pan, leaving behind the excess oil, and lay out on paper towels to drain away any residual oiliness. Allow to cool, then tease into shreds once more.

Spicy coconut flakes

175 g (6 oz) fresh grated coconut
or 150 g (5½ oz) desiccated coconut
1 tablespoon dark palm sugar
(gula jawa), shaved
½ teaspoon salt
1 salam or lime leaf, deveined
1 tablespoon oil

Bumbu spice paste
2 garlic cloves, peeled
1 small red Asian shallot, peeled
1 red bird's eye chilli
1 cm (½ inch) turmeric, peeled, or
½ teaspoon ground turmeric
1 cm (½ inch) kencur, peeled (optional)
1 candlenut or 2 blanched almonds
1 teaspoon coriander seeds

Add a powerful flavour boost to any meal with pan-roasted spiced coconut. Scatter generously over vegetables, eat with yellow rice or serve as a side dish like a dry relish.

Start by making the bumbu spice paste. Roughly chop the fresh ingredients, then blend to a paste in a food processor. Add a little water to help everything come together.

Use your hand to massage together the coconut, bumbu, palm sugar and salt. If you are using desiccated coconut, add 200 ml (generous ¾ cup) of water, which will help the flavours infuse into the coconut. Add the salam leaf.

Heat the oil in a small frying pan over a medium heat. Stir-fry the spicy coconut mix, stirring often, until the coconut starts to colour. This may take 15–30 minutes. If you intend to use all the coconut the day you make it, you can leave it at a light golden. If you want to store longer, cook until completely dry and well browned. It will then keep in an airtight jar for a month or more.

Note
Make a fantastic Javanese salad by tossing generous amounts of spicy coconut flakes with blanched vegetables: a mixture of beansprouts, spinach leaves, cabbage, green beans and carrots cut into matchsticks.

Chilli-fried potato crunch

1 tablespoon dark palm sugar
(gula jawa), shaved
150 g (5½ oz) matchstick potato crisps
75 g (2½ oz) Wok-fried Peanuts (page 180)
juice of ½ a lime

Bumbu spice paste
2 large red chillies, seeds in or out,
roughly chopped
4 small red Asian shallots,
roughly chopped
2 garlic cloves, roughly chopped
1 cm (½ inch) galangal (optional)
1 teaspoon oil

An addictive sweet-spicy mix is the secret ingredient of many rickety roadside warungs (family restaurants). A generous sprinkle adds heat and crunch to any meal and is especially good with vegetables. They also make a great snack. You can vary the base as you like; I've used roasted peanuts and the potato matchsticks you can buy in packets, but tiny dried fish are often included.

Grind the ingredients for the bumbu together using a pestle and mortar or food processor.

Stir-fry the bumbu in a frying pan for 3–5 minutes, until fragrant and the raw garlic taste has gone. Add the palm sugar (and some salt if your potatoes and peanuts are not already seasoned). Tip in the potatoes and peanuts, squeeze over the lime juice and stir-fry for a minute to coat everything in the spice. Taste for seasoning, adding more sugar, salt or lime until it has just the flavour punch you are after.

Tip into a bowl to cool to a sticky crunch.

Tempeh with red chilli & palm sugar

Serves 4 as a side dish

60 g (2 oz) dark palm sugar (gula jawa)
300 g (10½ oz) tempeh
oil, for frying
5 small red Asian shallots, sliced
5 garlic cloves, sliced
1–2 red chillies, sliced
1 lime leaf, deveined and finely
 shredded (optional)

This is a great snack with drinks or a side dish to add a kick to any meal. Prepared in this elegant Javanese style it is packed with crunch and flavour. The palm sugar forms a sticky glaze, whilst generous lashings of chillies leave a long, lingering burn on the palate. Add some red-skinned peanuts into the mix if you like, frying them to a crisp golden in the same oil as the tempeh.

Shave the palm sugar into a small pan and add 70 ml (⅓ cup) water. Cook until the sugar has melted and the mixture has bubbled to a dark syrup. Season with a good pinch of salt and set aside.

Slice the tempeh into skinny batons, like nubbly matchsticks. Heat 5 cm (2 inches) of oil in a wok until the oil bubbles around the handle of a wooden spoon. Add the tempeh in batches and fry until nut brown and very crisp. Remove with a slotted spoon and drain on paper towels.

Pour away all but a tablespoon of the oil from the wok. Add the shallots and garlic and soften over a medium-high heat. Stir in the chillies and lime leaf, if using, and fry until the garlic is pale gold. Add the tempeh and palm sugar syrup and stir-fry until the glaze clings to it. Leave to cool before tasting for seasoning.

Sour & spicy pineapple relish

1 small ripe pineapple
2 large red chillies, seeded and chopped
1 tablespoon sugar
½ teaspoon salt
1 tablespoon vinegar

A chunky fresh relish, with the sour-spice balanced by sweet fruit. It is sensational with anything, especially seafood.

Peel and core the pineapple, then chop into small chunks.

Crush the chillies to a rough paste with the sugar and salt in a pestle and mortar. Loosen the mixture with vinegar and stir through the pineapple. Taste – depending on how sweet or sour your pineapple is you may want to add more vinegar to balance the flavours.

Leave to sit for at least 15 minutes before serving so the flavours meld.

Lombok chopped salad

Serves 2–4

2 Thai aubergines (eggplants),
 chopped to a small dice
100 g (3½ oz) fine green beans,
 sliced into little rounds
50 g (2 oz) small red Asian shallots, sliced
1 large red chilli, seeded and sliced
1 red bird's eye chilli, finely
 sliced (optional)
¼ teaspoon shrimp paste,
 toasted (see page 189) (optional)
pinch of sugar
zest and juice of a kaffir lime or lime
1 tablespoon virgin coconut oil, melted

This has perfectly balanced oomph: the sweet crunch of raw vegetables matched with the citrus tang of kaffir lime, the brakishness of shrimp paste and a spark of chilli heat. An accompaniment rather than a meal in itself, this is a great side for grilled meat or fish.

Combine the raw vegetables with the chillies, shrimp paste, a pinch of salt and the sugar. Cooks in Lombok will use their hands to massage everything together well, which helps the texture and flavour develop, but you may prefer a spoon (or glove) as the heat of the chilli seeds can burn.

If you have a kaffir lime, add all the juice and just a little of the zest. With a regular lime, the zest is less bitter so the salad can take more alongside the juice. Taste for seasoning, then dress with the coconut oil.

Menu ideas
Pair this salad with Ayam taliwang (page 86). For a full Lombok meal, add Water spinach with roasted tomato sambal (page 149), steamed rice and extra sliced chillies.

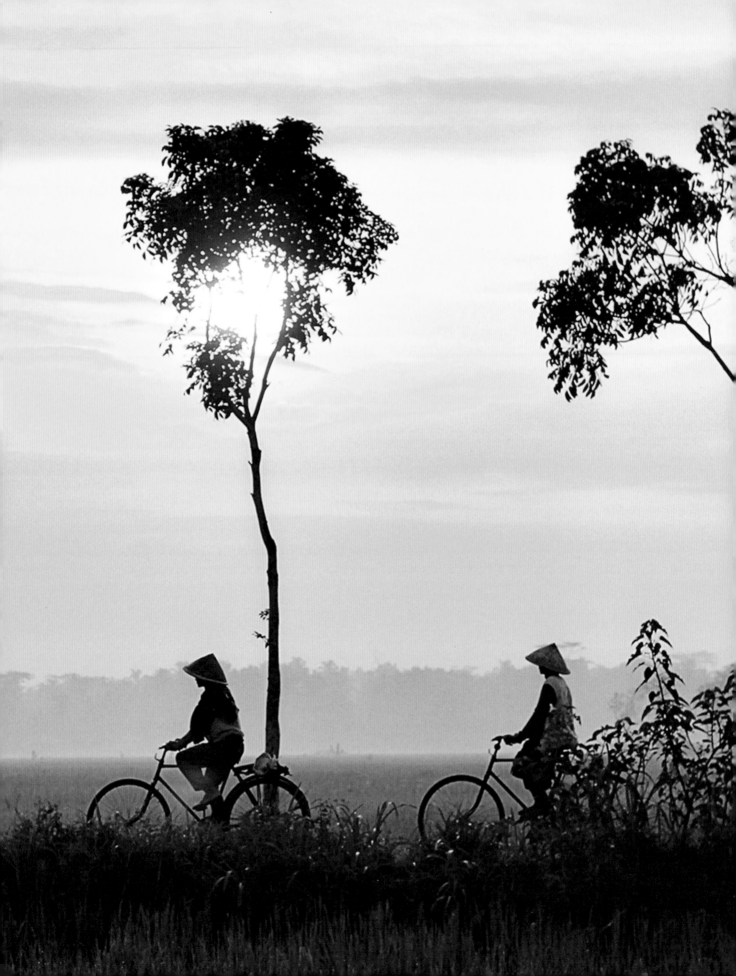

Shrimp paste – *terasi*

Made from brined and fermented krill, this salty pink or brown paste is a signature ingredient of Indonesian cooking. The smell is intense and unappealing to many – even some Indonesian cooks choose to leave it out –but once cooked it recedes quietly to become a back note of umami and richness rather than fishiness. Use very sparingly in a similar way to Thai fish sauce. Sold either wet or dry, it needs to be toasted before use. If it is not being fried in a bumbu, I toast terasi in a dry frying pan until it releases its pungent odour leaving the paste brown and crumbly. It keeps almost forever in an airtight container, which will also keep the smell confined.

Dried shrimps – *udang kering*

Small peeled or unpeeled shrimp from the South China Sea are sundried and sold in small plastic packages. Soak in warm water to soften, then use as a garnish or to give a briny undertone to dishes. Look for shrimps that are small in size without a lurid pink colour (too much preservative).

Salted fish – *ikan asin*

Fish of a myriad varieties are preserved by curing in salt, then drying in the sun (the microbacteria in the air add extra flavour that a dehydrator cannot). The simplest country meal is fluffy steamed rice, salted fish and a chilli sambal.

Soy sauce – *kecap asin*

One of the oldest condiments in the world, China's wonder ingredient made from fermented soya beans and roasted wheat has been used in Indonesia for centuries. A splash of the dark liquid adds salt and umami and depth. See kecap manis too (page 203) for Indonesia's signature sweet soy sauce. Here we are concerning ourselves with the salty variety and it is best to choose quite a dark soy sauce with a robust flavour for Indonesian cooking.

Worcestershire sauce – *kecap Inggris*

Would you believe that the classic English fermented sauce has found a home in Indonesia too, where it is known as kecap Inggris – English soy sauce. It is often a secret ingredient for *kakilima* vendors, adding that certain something to their noodles or fried rice.

Tomatoes – *tomat*

A natural source of MSG. Indonesians exploit the flavour-enhancing properties of tomatoes in sambals, stir-fries and soto broths. Tomato paste and soy sauce are used together in Nasi goreng (page 160) for the ultimate umami.

Cheese – *keju*

Not part of traditional Indonesian cuisine, it was Dutch colonial rule that brought a taste for mild and melty cheeses. You might find it used at kaki lima stalls with favourites like bakso meatballs given an oozing cheese centre. It is also found in desserts, where cheese has really been embraced for those after a sweet-salty fix. A night market treat is bananas fried in butter and topped with chocolate sprinkles, a grating of cheese and a slick of condensed milk (see also Bright Moon page 206). Choose something like a very mild cheddar or grated mozzarella as you are after salt and goo rather than a pronounced cheese taste.

Salt – *garam*

With thousands of miles of coastline, sea salt is of course the most common in Indonesia, though I have also tried Javanese volcanic salt with its sulphurous edge. It is the unspoken foundation that lifts every dish, both savoury and sweet. Buy a good-quality salt and don't just add at the end of cooking. Adding judiciously at each stage allows the seasoning to penetrate and the layers of flavour to develop, rather than just giving a salty top note.

Ingredients — for umami & salt

Chilli-fried eggs

Serves 1–2

3 tablespoons oil
2 eggs
2 small red Asian shallots, sliced
2 garlic cloves, sliced
1 large red chilli, seeded and sliced
1 tablespoon kecap manis

Fried eggs are known as *mata sapi* or 'cow's eyes' for their staring appearance. I learnt in Indonesia the joy of a truly crisp egg. They are cracked into fiercely hot oil, which almost makes them explode in the pan as the white bubbles up around the yolk and the bottoms brown to deep golden. They then get elevated further with fried aromatics and the resiny depth of kecap manis. A great accompaniment to any rice-based meal.

Fry the eggs in blazing hot oil until well bubbled and browned underneath – watch out, they will hiss and splutter. Remove with a slotted spoon, letting any oil drip back in to the pan.

Lower the heat a little and add the shallots and garlic to the hot oil. Stir-fry until golden. Add the chilli and cook for about 30 seconds longer. Remove with a slotted spoon.

Season the eggs with salt, a tangle of caramelised aromatics and spin a fine stream of kecap manis over the top.

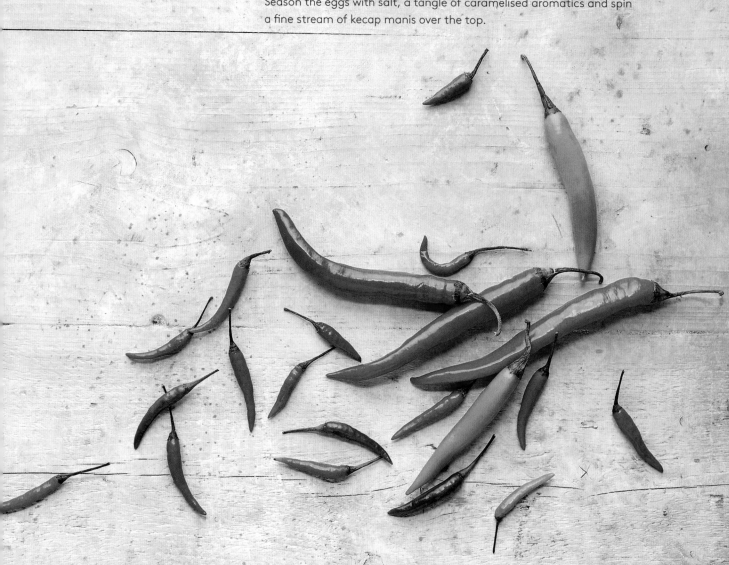

Acar pickles

Serves 4–6

400 g (14 oz) carrot, cucumber
 or a mixture of both
3 small red Asian shallots, finely sliced
1 red bird's eye chilli, halved and seeded
2–3 tablespoons sugar
1 teaspoon salt
4 tablespoons rice or cider vinegar

The perfect sweet, tangy, fresh, crunchy contrast to add to any meal. These speedy pickles are ready in half an hour and will keep in the fridge for a week. I can happily drink the sweet sour juices that puddle at the bottom.

Peel the carrots and peel and seed the cucumbers. Cut both into thin julienne sticks.

Put into a lidded plastic container with the shallots, chilli, sugar and salt. Shake very well to muddle the vegetables and release the flavours. Add the vinegar and mix again. Leave to sit for half an hour or chill in the fridge for longer, where they will lose some crunch but intensify in flavour.

Marbled eggs

Makes 6

6 eggs
large handful shallot or onion skins
3 tablespoons kecap manis
2 lemongrass sticks, bruised and
 tied in a knot
1 teaspoon coriander seeds

A delicate savoury flavour infuses these slow-cooked eggs, but it is their looks that really impress. The natural dye in onion skins seeps through the cracked eggshells, leaving the whites gleaming and veined like marble.

Wash the eggs well and choose a pan that will hold them in a fairly snug single layer. Put the shallot skins at the bottom and sit the eggs and other ingredients on top with a pinch of salt. Cover with water.

Bring to the boil, cover and lower the heat to simmer for 10 minutes. Remove the eggs with a slotted spoon, cool under running water and bash them lightly all over on a hard surface. You want to craze the shells with cracks whilst keeping them intact. Return to the cooking liquor, cover and continue to simmer for another hour. Top up the water as needed.

Leave the eggs to cool in their cooking water. Remove the shells before serving, revealing the beautiful crackle surface within.

Menu ideas
Serve alongside rice, sambal and one or two other main dishes to turn this simple meal into a celebration.

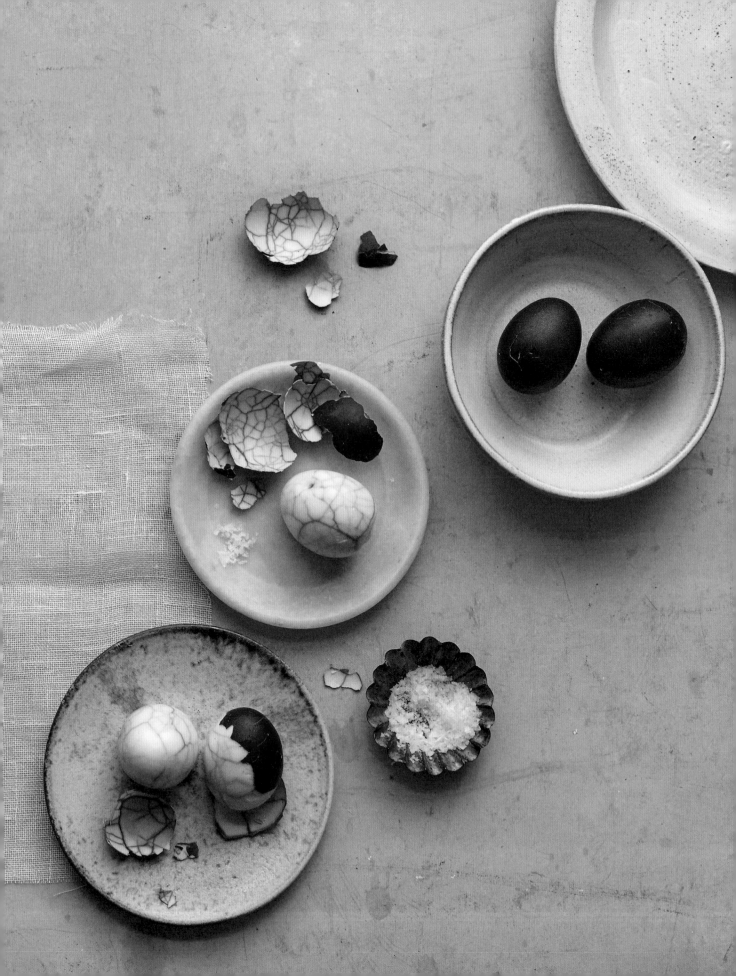

SWEET & STICKY

Chapter Eight

DRAGON FRUIT
& Collision Coffee

The exotic, sweet confections that Indonesians so love don't usually follow a meal; there isn't a dessert culture. Instead, if a sweet ending is needed there is a bounty of tropical fruits to choose from. Honey-sweet mangoes, electric pink dragon fruit, pearly-centred mangosteen and snakeskin salak. Spiky durians are prized for their custardy flesh, if not their pungent smell. Baby pineapples have a tropical acidic zing. And no one could fail to be enchanted by rambutan with their translucent white fruit encased in wild curly red hair.

It is between meals that flaky pastries, steamed sponges and sugared doughnuts have their moment. Creamy puddings enriched with coconut milk are eaten as pick-me-ups in the heat of the day or to break the fast during Ramadan. Sweets for many people, especially in Java and Bali, represent the riches of the world and are offered in temples and given to welcome guests. There are countless variants of sweetmeats made from rice flour, glutinous rice or tapioca. Chewy, gooey or sticky, most have palm sugar sweetness and a flurry of grated coconut scattered over them. They are bought from street vendors along with bubbled pancakes, fermented rice puddings and crisp fried bananas.

Stars of the night markets are stalls selling *es cincau* and *es campor*. The first is a delightful drink made with a local grass jelly, iced coconut milk and treacly palm sugar syrup. The latter is a shaved ice dessert in an artist's palette of colourful fruits and jellies.

Coffee is taken seriously and some of the best in the world is grown in Indonesia. The beans of Java, Flores, Sulawesi and Sumatra are revered for their rich and complex characteristics. Collision coffee is the term used for the traditional brewing method where the ground beans are boiled in the water then left to settle. A slice of fresh ginger is sometimes added for an extra kick.

Lying in the magic band of 0-20 degrees from the equator, the lush Indonesian rainforests are ideal for growing cocoa pods, which hang directly from tree trunks in an otherworldly fashion – furrowed, auburn and swollen with precious beans. After fermenting to develop the chocolatey flavour, the beans are sundried before processing. Given the humid climate, this is helped with wood kilns giving irresistible smoky tobacco notes to the chocolate.

A beguiling tradition is that of *oleh oleh* or edible souvenirs. Every port and airport sells local delicacies as no one would dream of travelling to another island without taking something back home to share with friends. Perhaps curls of sesame brittle, sugared balls of tamarind or pleasingly gluey, hot ginger sweets. One of my favourite gifts was the dried fruit of the nutmeg tree, suffused with the scent of spice. On the Banda Islands, where they grow, they use the fruit more than the nut, making fresh nutmeg jam for breakfast.

Chocolate & lemongrass ice cream

Serves 6

4 lemongrass sticks
500 ml (2 cups) full-fat milk
100 g (3½ oz) dark chocolate
 (min. 70% cocoa solids)
4 egg yolks
130 g (generous ½ cup) caster sugar
40 g (⅓ cup) best-quality cocoa
 powder, sifted

Indonesia is the world's third-largest producer of cocoa beans, most of which are exported. The national taste for chocolate is expanding though, and artisan chocolate houses are joining multinationals in producing bars locally. They are clearly having fun, infusing flavours from cloves and ginger to tangy fruit rujak. It was at a chocolate factory in Bali where we tasted a rich, fragrant chocolate and lemongrass ice cream and were entranced by the combination.

Trim the woody green parts from the lemongrass, then smash the stems to release the flavours. Cut each into three or four pieces and add to the milk in a pan. Bring to a simmer without scorching, then leave to infuse at room temperature for an hour.

Once the milk has infused, melt the chocolate in a bowl above (not touching) simmering water in a pan. Set aside.

Sit a large bowl on a wet tea towel to keep it stable. Add the egg yolks and sugar and beat until thick and creamy and pale ribbons form when you lift the whisk.

Reheat the milk, bringing it just to the boil. Strain through a sieve into the egg yolk mixture, beating as you pour. Next whisk in the chocolate and finally the cocoa powder and a pinch of salt.

Transfer the chocolate mixture to a saucepan set over a low-medium heat. Stir with a silicone spatula, scraping the bottom well as you go. Cook until the mixture thickens to a thin, smooth custard – if you run a clean finger along the spatula it should leave a distinct line. Leave to cool, cover closely with plastic wrap, then chill in the fridge until really cold.

Churn in your ice-cream machine following its instructions.

Note
For coconut & lemongrass ice cream, pour a 400 ml (14 fl oz) tin full-fat coconut milk into a pan. Add 75 g (⅓ cup) caster sugar and 2 lemongrass sticks (trimmed, smashed and sliced), ½ teaspoon vanilla extract and a pinch of salt. Bring very slowly to a simmer, stirring often, to infuse the milk and melt the sugar. Cool, then transfer to a fridge overnight. The next day, whisk to bring the coconut milk back together and strain through a colander. Churn in an ice-cream machine to soft and billowing whiteness.

Kaffir lime sorbet

Serves 6

250 g (generous 1 cup) caster sugar
8–10 limes
12 fresh lime leaves, sliced

Though not traditionally Indonesian, this sorbet is a good full stop to a meal that has been rich, spiced and filling. The combination of lime juice, zest and fragrant kaffir lime leaves (use fresh or frozen; dried won't cut it here) mean it is at once nippy and floral. Very refreshing. Serve alongside fresh tropical fruits, or just as it is.

Put the sugar in a saucepan with the zest of one of the limes and the sliced lime leaves. Add 250 ml (1 cup) water and heat very gently until the sugar has dissolved. Simmer for 5 minutes or until slightly thickened and syrupy. Set aside to cool and infuse for at least an hour or overnight in the fridge – it should be pale lime green and very scented.

Squeeze the limes to get 250 ml (1 cup) juice and add this to the sugar syrup. Strain through a nylon sieve. Taste for tartness and sweetness, remembering that freezing will mute the flavour so it should be extra punchy now.

If you have an ice-cream machine, churn and freeze according to instructions. Alternatively, transfer the syrup to a shallow container and freeze for about an hour, until the edges are frozen. Tip into a food processor, whizz to a slush and return to the freezer. Repeat a couple more times until you have a smooth sorbet. Return to the freezer for at least another hour.

Hotcakes with coconut cream caramel

Makes 12

Coconut cream caramel
160 ml (generous ½ cup) coconut cream
50 g (⅓ cup) dark palm sugar
 (gula jawa), shaved
¼ teaspoon salt
2 pandan leaves, bruised and tied
 in a knot (optional)

Hotcakes
125 g (scant 1 cup) plain flour
2 teaspoons baking powder
1 teaspoon sugar
1 egg
150 ml (generous ½ cup) coconut milk
oil, for greasing the pan

The southern Indian pancakes *appam* (light, bubbled and bowl-shaped, made from rice flour and coconut milk) have derivatives along Asian trading routes. In Sri Lanka there are *hoppers*, in Java there are *serabi*. Roadside sellers in Bandung cook these sweet treats to order in lidded terracotta bowls. Without the requisite kit at home, I use a thicker batter and a frying pan to get a fat and fluffy hotcake. Drenched with golden coconut cream caramel, it is an irresistible combination.

To make the caramel, put all of the ingredients in a saucepan and gently heat, stirring often. You want everything to melt to a butterscotch-coloured sauce, without bubbling up. It will thicken slightly as it cools. Remove the pandan leaves.

For the hotcakes, mix together the flour, baking powder, sugar and a pinch of salt. Make a well in the centre, break in the egg and gradually add the coconut milk and 90 ml (⅓ cup) water, whisking to a smooth batter.

Use a trickle of oil to grease a non-stick frying pan and set over a medium-high heat. When hot, drop in large spoonfuls of batter. When the upper side is blistered and bubbling, flip and cook the other side. It will only need a minute, if that.

Serve warm with the coconut cream caramel.

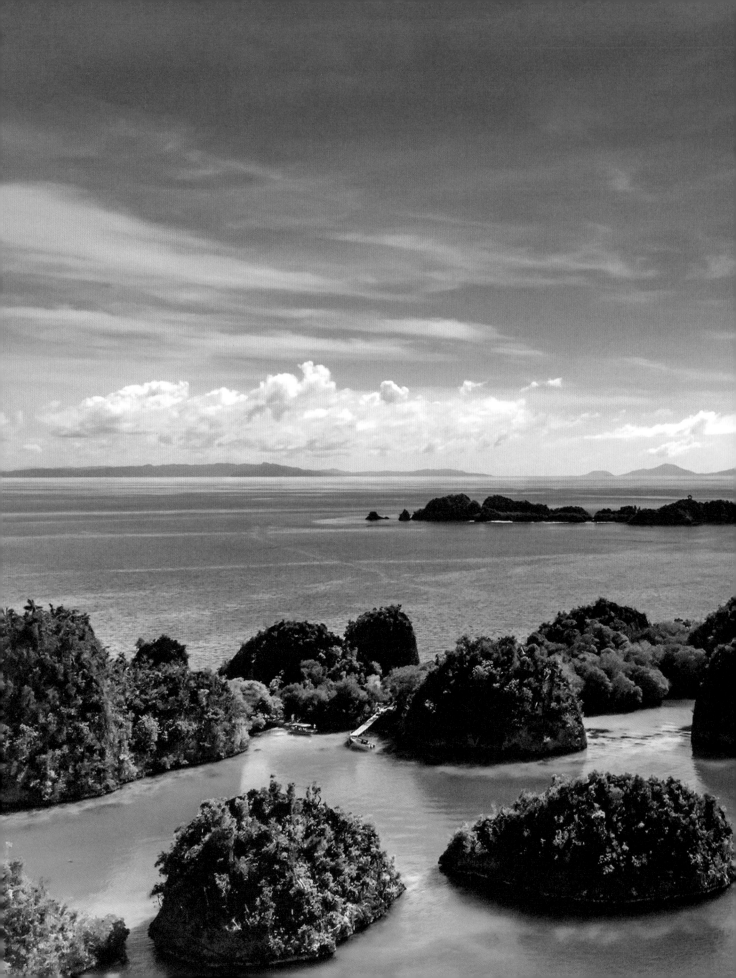

Palm sugar – *gula jawa & gula merah*

Indonesian palm sugar is surely set to be the next 'it' product once the West cottons on to this remarkable ingredient. Unlike the paler, toffeed palm sugar of Thailand, gula jawa is deep reddish brown. The sugary notes are matched by a complex, smoky, almost savoury quality that means it brings so much more than just sweetness. It rounds out and deepens the flavours of a curry or marinade, and has a compelling taste on its own, which is highlighted in some of the desserts. I can't resist cutting off a nugget to eat like fudge whenever I use it. It is made from the boiled sap of the sugar palm and is usually sold in cylinders (when it has been set in bamboo poles) or half spheres (when a coconut shell has been used). It is solid, but soft and fudgy, so can be easily shaved with a knife before using. You can substitute milder flavoured Thai palm sugar, Indian jaggery or soft, dark brown sugar.

Kecap manis

The Chinese introduced Indonesians to soy sauce and they made it their own by adding molasses, star anise and galangal. The resultant dark and sticky sauce adds resinous depth and sweetness to cooking. Incidentally, the English word for ketchup is derived from the Indonesian/Chinese name for soy sauce, kecap. I do recommend sourcing this soy – it is a fantastic ingredient and supermarkets have caught on. To make your own, dissolve 50 g (¼ cup) dark brown sugar in 150 ml (generous ½ cup) dark soy sauce, but it will lack a little nuance. Keep a bottle on the table as well to douse over food such as Nasi goreng (page 161).

Condensed milk – *susu kental*

You won't find much dairy in most Indonesian kitchens save for a tin of much-loved condensed milk. The milk has been evaporated and sweetened, so provides a concentrated creaminess as well as a rich, milky, almost toasted caramel flavour. It is stirred into cake batters and drizzled over fruits, pancakes, basil seed jellies and technicoloured shaved ices.

Crisp-fried shallots – *bawang goreng*

Food should make sound and crunch, which is a key element to an Indonesian meal. Stock your cupboards up with crackers, peanuts and these crisp-fried shallots. If you have an Asian supermarket accessible, you should be able to buy large plastic jars of fried and crunchy shallots. These are just as good as homemade (make them by frying sliced shallots in oil to a deep brown tangle then cool until crisp) and my cupboard is never without them. Scatter them liberally over rice, curries, salads and noodles. Their partner, crisp-fried garlic, is great too.

Emping

These crackers are bought raw and need to be fried in hot oil before eating, rewarding you with a puffed-up snack with a nutty, slightly bitter note. They are made from melinjo nuts, which are hammered flat and sun-dried. Serve alongside Nasi goreng (page 160) or Gado gado (page 136) or simply with a green chilli sambal.

Prawn crackers – *krupuk*

Krupuk means crackers and there are huge varieties in Indonesian supermarkets, flavoured with chillies, onions, dried fish or seafood. Prawn crackers, *krupuk udang*, are the best known. The easiest to find are Chinese, but these are smaller than their Indonesian cousins. Krupuk are usually bought as pale oblongs and must be fried in very hot oil upon which they whoosh out to two or three times their original size.

Banana fritters

Serves 4

100 g (⅔ cup) plain flour
50 g (⅓ cup) rice flour
1½ teaspoons baking powder
220 ml (scant 1 cup) ice-cold water
4–6 pisang raja bananas (see note)
oil, for shallow frying
icing (confectioners') sugar, to serve

It is dusk at the night market and people are gathering to eat and relax. The air hums with chatter and the whirr of generators. Stalls are piled with shocking-pink dragon fruit and salak in their snakeskin casings. Sticky rice is unwrapped from palm leaf parcels. A man deftly folds an oversized pancake as it sizzles in hot oil, cooking as street theatre. One thing you don't want to miss are the fried bananas in their crisp batter jackets. Eat hot from the pan, as you would in the market.

Sift the flours into a large bowl with the baking powder and a pinch of salt. Whisk in the water and mix well to get out all the lumps. You should have a thick, smooth batter that generously coats the back of a spoon.

Cut each banana lengthways into slices about 1 cm (½ inch) thick.

Pour oil to the depth of 4 cm (1½ inches) into a wok or deep-sided frying pan. Set over a medium-high heat until hot but not smoking – add a drop of batter, which should sink then rise immediately if the oil is ready.

Fry the bananas in small batches. Dip each piece into the batter, turning to get a good even coating, then carefully lower into the oil. Fry, turning them two or three times, until uniformly golden and crisp. Keep the heat high so they don't get soggy, but if they are scorching then turn it down. Drain off excess oil on paper towels.

Serve immediately with a good dusting of icing sugar. Some ice cream alongside is always a winner as hot and crisp meets the cool smoothness.

Note
Indonesia has a dizzying array of banana varieties. For frying you are after something ripe but firm to keep the batter crisp. The ultimate is the *pisang raja* or 'king banana' with its honey sweetness or ask for a cooking banana in an Asian supermarket. A very ripe plantain, with gold and black-streaked skin, works too. The West's standard Cavendish banana isn't the best here.

Coconut custard pie

Serves 8

Pie crust

150 g (5½ oz) coconut biscuits
50 g (2 oz) fresh coconut,
 coarsely grated
80 g (⅓ cup) butter, melted

Filling

2 large egg yolks
60 g (½ cup) icing
 (confectioners') sugar
30 g (¼ cup) plain flour
1 teaspoon cornflour
¼ teaspoon salt
250 ml (1 cup) milk
125 ml (½ cup) coconut milk
15 g (1 tablespoon) butter,
 at room temperature
1 teaspoon vanilla extract
50 g (2 oz) fresh coconut,
 coarsely grated

Meringue

150 g (⅔ cup) caster sugar
2 large egg whites

In the colonial period, North Sulawesi was referred to as the thirteenth province of the Netherlands due to the popularity of all things Dutch there. This continues today and one favourite is the custard tart, Klappertaart, studded with the gelatinous flesh of young coconuts. Just as delightful, and easier to source ingredients for outside the tropics, is this coconut pie. The influence is more American with a squidgy cookie base, oozing custard middle and billowing meringue top. I was given the recipe by the idyllic d'Omah hotel in Java. Their secret is coarsely grating fresh coconut for an extra textural contrast.

Preheat the oven to 180°C (350°F).

Put the biscuits in a bag and smash to crumbs. Add the coconut and butter to the bag and squish everything until well blended. Press into a 20 cm (8 inch) pie tin or dish. Bake for 10 minutes, then leave to cool.

To make the filling, whisk the egg yolks together in a large bowl and set aside. In a saucepan, mix together the icing sugar, flour, cornflour and salt. Add the milk and coconut milk and set over a medium-high heat. Stir constantly as it comes to the boil and starts to thicken. Once boiling, cook for a further 2 minutes.

Slowly stream a third of the hot custard into the egg yolks, whisking constantly. Return the contents of the bowl to the saucepan. Cook, stirring often, until the mixture reaches a boil. Remove from the heat and strain through a fine mesh sieve.

Leave to cool for a few minutes before stirring in the butter, vanilla and coconut. Spread into the prepared pie dish and cover closely with plastic wrap. Refrigerate for 4 hours, or until firm.

To make the meringue, put the sugar into a pan with 50 ml (¼ cup) water. Heat gently to dissolve the sugar, then bring to the boil. Cook until the syrup reaches 120°C (250°F).

Meanwhile, put the egg whites into a freestanding mixer with a balloon whisk. When the syrup reaches 110°C (230°F), start whisking until stiff peaks form. Once the sugar reaches 120°C (250°F), pour slowly into the whites with the whisk running. Whisk until the meringue is cool, stiff and shiny.

Spread the meringue over the cooled custard, taking it right to the pie shell edge. Swirl with a spoon. Use a blowtorch or hot grill to gently caramelise the meringue. Store in the fridge until ready to serve.

Bright moon

Serves 4

120 g (generous ¾ cup) plain flour
2 tablespoons plus 1 teaspoon
 caster sugar
¼ teaspoon salt
2 large eggs
½ teaspoon bicarbonate
 of soda (baking soda)
20 g (1½ tablespoons) butter
filling of choice (see recipe introduction)

Spongy and honeycombed, this street food favourite is rather like a giant crumpet. Its entrancing name (*terang bulan* in Indonesian) comes from the resemblance to a cratered full moon once the batter has puffed and bubbled in the pan. Pick a filling of your fancy before sandwiching into a half moon. A rubble of roasted peanuts and sesame seeds frosted with lots of sugar and a little salt is good. I also like salted butter and a glossy slick of tropical honey. The combination found at most street stalls is a thick spread of yellow margarine (at home I use butter) followed by a generous scattering of dark chocolate sprinkles, grated mild cheese and a final drizzle of condensed milk. Suspend your disbelief at the chocolate cheese combo; as they melt together in the residual heat the resultant salty-sweet ooze is riotously vulgar and totally glorious.

Tip the flour, 2 tablespoons of sugar and salt into a large mixing bowl and whisk together. Add 100 ml (scant ½ cup) water and one of the eggs and beat until smooth. Set aside for half an hour.

Set a heavy-based frying pan over a medium-low heat – I use one 20 cm (8 inches) across.

At the last moment, when the pan is hot, whisk the second egg into the mixture to make a loose, custard-coloured batter. Stir together the bicarbonate of soda and 1 tablespoon water and whisk this in too.

Grease the sides and base of the pan with a small knob of the butter, then pour in the batter. Swirl to thinly coat a little way up the sides of the pan. Leave undisturbed to cook until three quarters of the surface is pricked with large bubbles.

Turn the heat down to low. Sprinkle over the remaining teaspoon of sugar and cover with a lid. Cook for 5–10 minutes longer. It is ready when the wobble has gone and the bubbled surface feels springy to the touch. The bottom should be well browned and crisp.

Remove from the pan and slather the top with butter whilst still hot. Add your chosen fillings in generous quantities and slice the moon in half. Sandwich together and cut into manageable pieces. Eat without delay.

FIRE ISLANDS

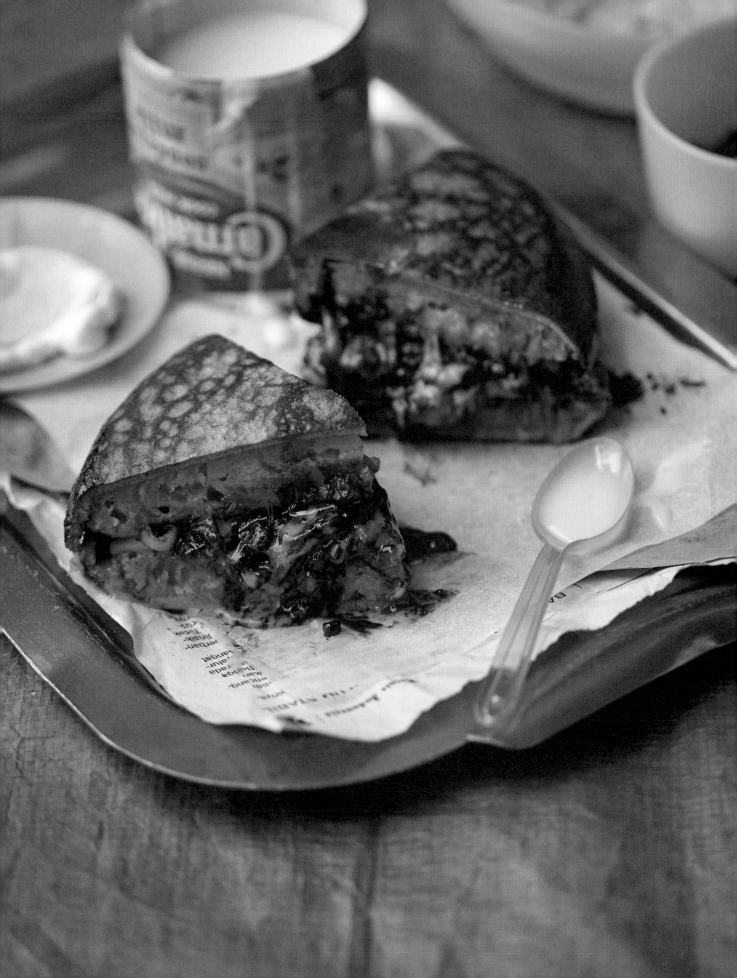

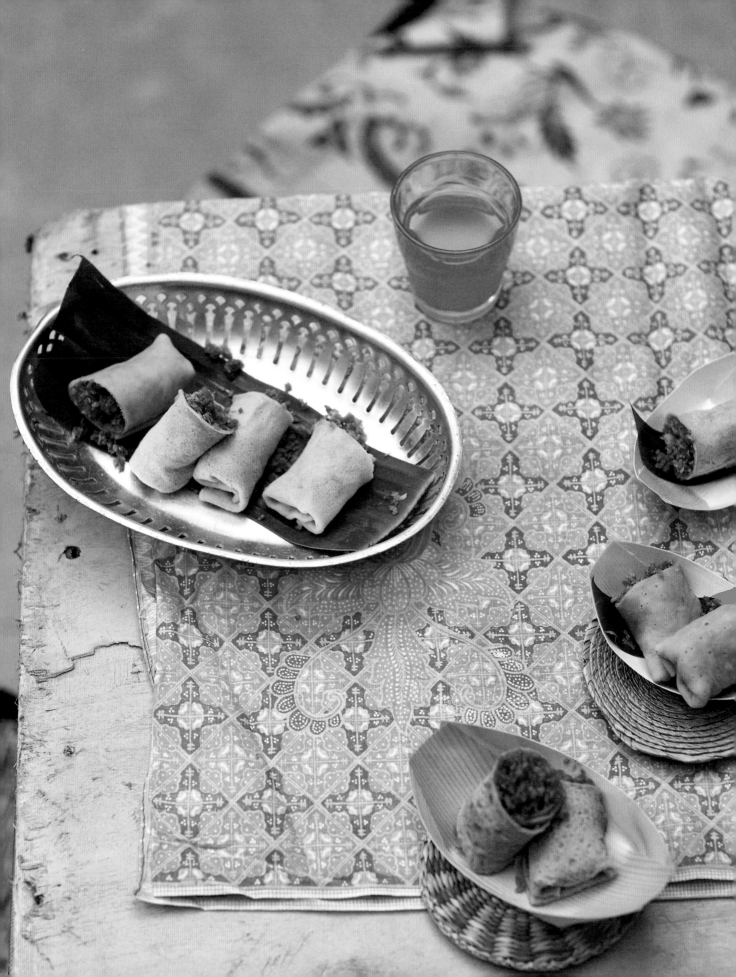

Green coconut pancakes

Makes 12 pancakes

10 pandan leaves
150 g (1 cup) plain flour
2 eggs
2 tablespoons oil

Coconut filling

150 g (scant 1 cup) dark palm sugar
 (gula jawa), shaved
150 g (5½ oz) fresh grated coconut or
 120 g (4¼ oz) desiccated coconut
1 teaspoon ground cinnamon (optional)
2 pandan leaves, bruised and tied
 in a knot

Jade-coloured pancakes make you assume food colouring is at work (and indeed it often is in Indonesian sweets, dyeing cakes luminous pinks and greens). However, here it is the delicately scented pandan leaves that give these crepes both their colour and bosky sweetness. If you can't find fresh leaves, you should be able to get pandan paste or extract in an Asian supermarket. Add a teaspoonful to the batter – it may or may not stain it green, depending on the brand. The treacly coconut filling made these my very favourite childhood treat.

Prepare the filling first by heating the sugar with 200 ml (generous ¾ cup) water. Bring to the boil, then reduce the heat and simmer uncovered for about 10 minutes, until syrupy. Add the coconut (with a good splash of water if using desiccated), cinnamon, pandan leaves and a pinch of salt. Cook, stirring often, until the mixture is dry and sticky. Set aside to cool.

To make the pancakes, blitz the pandan leaves with 500 ml (2 cups) water in a blender. Pass through a fine sieve, keeping the vibrant green liquid.

Tip the flour into a bowl, break in the eggs and slowly whisk in the green water to make a thin, smooth batter. Leave to rest for 15 minutes.

Lightly grease a small 15 cm (6 inch) frying pan and heat over a medium heat. Ladle in a little of the batter, swirl around the pan and cook until it sets and curls at the edges. Flip and cook for about 20 seconds on the other side. Slide onto a plate and repeat with the remaining batter. There is a certain lore with pancakes that the first will never be a success and they will improve as you go.

Fill the pancakes and roll them up to serve.

Rice dumplings with palm sugar

Makes 20 dumplings (serves 4-6)

200 g (7 oz) glutinous rice flour
¼ teaspoon pandan paste (optional)
80 g (½ cup) dark palm sugar (gula jawa)
100 g (3½ oz) fresh coconut, finely grated
½ teaspoon salt

Pandan paste, a natural extract from the leaves, stains these chewy little dumplings an unlikely shade of green and gives a soft fragrance to the rice flour. There is a surprise waiting inside – as you bite in, a pool of molten palm sugar is released.

Tip the rice flour into a large bowl. Make a well in the middle and pour in 180 ml (¾ cup) water and the pandan paste. Use a spoon to bring everything together, then knead to a smooth, pliable and beautifully green dough. If it is too sticky, add more rice flour.

You'll need to shape and cook the dumplings in two or three batches before the dough softens the sugar and makes it melt and leak, so get everything ready. Cut the palm sugar into a rubble of small nuggets and shavings. Line a tray with plastic wrap. Cover another plate with a mixture of the coconut and salt.

Take a piece of dough and roll into a ball about 2.5 cm (1 inch) across (they will swell as they cook). Press in your finger to make a cavity and fill with about ½ teaspoon of the palm sugar. Shape into a ball around the filling and sit on the lined tray while you make some more.

Bring a pan half filled with water to the boil and cook the dumplings. Boil until they float to the surface, then leave for about 30 seconds longer and remove with a slotted spoon. Drain well.

Roll the sticky dumplings in the salted coconut to get a good coating. Serve at room temperature.

Sulawesi sweet potato fritters

Makes 20 small fritters (serves 4)

250 g (9 oz) sweet potato, peeled
½ teaspoon ground cinnamon
pinch of grated nutmeg
50 g (⅓ cup) dark palm sugar (gula jawa)
30 g (scant ¼ cup) rice flour
50 g (⅓ cup) plain flour
½ teaspoon baking powder
100 ml (scant ½ cup) ice-cold water
oil, for frying

In Sulawesi these are known as *tai kuda*, literally 'horse shit'. I assure you this doesn't do justice to the crisp battered coating, silky sweet potato filling and the treacly heart of molten palm sugar. Sweet potatoes in Indonesia come with orange, white or purple flesh, so you can choose the colour to suit your mood. I like to add cinnamon and nutmeg for a warm spiciness, but I have been told in no uncertain terms this is not authentic (with the concession it is a rather tasty addition). Leave out the spices if you'd prefer.

Boil the sweet potato until tender and mash. Add the spices and a pinch of salt. Set aside.

If you have palm sugar in a block, cut into small chunks to fill the fritters. Otherwise you can fill with small spoonfuls of ground sugar.

Take portions of the sweet potato mash in the palm of your hand, set a chunk of palm sugar on top and wrap the mash around to form a neat ball. Repeat, using up all the ingredients.

Mix the two flours together with the baking powder and a pinch of salt. Just before you start frying, whisk in the ice-cold water to make a batter. It should have a gluey consistency, running easily off the spoon but leaving a good coating behind. Adjust with more flour or water if necessary.

Heat 2 cm (¾ inch) oil in a small frying pan until it is hot enough to bubble around the handle of a wooden spoon. Working quickly, dunk half the balls into the batter to coat, then transfer to the hot oil. I like to use my hands to dip and drop them in the pan one by one, but do be extra careful if you are doing it this way.

Fry until golden brown, then remove to paper towels to drain off the excess oil. Repeat with the second batch. The fritters will crisp as they cool.

Black rice pudding with salted coconut cream

Serves 4

200 g (1 cup) black glutinous rice
2 pandan leaves, bruised and knotted,
 or 1 cinnamon/cassia stick
40 g (¼ cup) dark palm sugar
 (gula jawa), shaved
100 ml (scant ½ cup) best-quality
 coconut cream
pinch of salt

Glossy black grains of rice stuck to our daughter's baby cheeks has become a familiar sight as she so loves this inky pudding. Any Asian supermarket should sell black rice from either Indonesia or Thailand. It is packed with nutrients and has a great nuttiness, but needs long soaking to soften the fibre-packed hulls before cooking. I like the rice not too sweet (do add more palm sugar if you'd prefer) and a luscious topping of salty coconut cream provides the perfect unctuous contrast.

Wash the rice well in several changes of water, picking out any grit or husks. Leave to soak in cold water overnight.

Drain the water and wash the rice again. Put in a pan with 800 ml (3¼ cups) water and the pandan leaves. Bubble uncovered over a medium heat for about 40 minutes, stirring occasionally, until you have a soft, porridge-like rice pudding. Depending on your rice, it may need more water and longer cooking for the grains to yield.

Discard the pandan leaves and stir in the palm sugar. Reduce the heat and simmer, stirring, for a final 5 minutes. Leave to cool to room temperature.

Mix a pinch of salt into the coconut cream and serve in a jug to drizzle cool white over inky black.

Note
Make homemade toasted coconut cream for a nutty, complex, slightly smoky flavour. Start with pieces of mature coconut flesh removed from the shell. Set the brown skin of the coconut over a naked flame until it toasts and nearly blackens (scrape off any very black bits). Grate the coconut and skin very finely and mix with an equal quantity of water and a pinch of salt. Sit for a few minutes, then massage and squeeze to extract as much oil and flavour as possible from the coconut. Strain into a jug.

Striped steam cakes

Makes 8 cakes

3 eggs
250 g (generous 1 cup) caster sugar
¼ teaspoon salt
250 g (1⅔ cups) plain flour, sifted
2 teaspoons baking powder
125 ml (½ cup) sparkling water
1 teaspoon grated nutmeg
1 teaspoon vanilla extract
2 tablespoons cocoa powder, sifted

As ovens are not common in Indonesian kitchens, these steamed cupcakes are the answer and they are really fun to make. You'll find them in most markets, piled up in an often lurid array of multicolours to tempt children on their way home from school. I prefer a subtler, two-tone approach of chocolate with a whisper of nutmeg and vanilla. Hot steam causes the cakes to whoosh up, unfurling like blooming flowers, creating wonderful stripes and striations as they do so. The texture inside is soft and pillowy, with only a gentle sweetness.

For this recipe you'll need eight large baking cups, the sturdy paper kind that don't need a supporting tin. Line them with tulip paper liners if you like. You'll also need a large pan with a steamer that will fit the baking cups in a single layer with some space around each (cook in batches if need be).

Bring water to the boil in the base of the steam pan so it is hot when you are ready to cook.

Using a stand mixer or whisk, beat the eggs, sugar and salt until very pale and thick and the mixture leaves a ribbon-like trail if you lift the whisk. Fold in one third of the flour and the baking powder, then half the sparkling water. Add another third of the flour followed by the remaining sparkling water. Finish with the remaining flour. The batter should be a soft dropping consistency. Remove half to another bowl, folding nutmeg and vanilla into one and cocoa powder into the other.

Dollop the batter into the baking cups, layering brown upon white in six to eight haphazard layers. They should be filled to the top.

Bring the water back to the boil. Wrap the lid with a clean tea towel – this will stop water dripping onto the cakes and create a tight seal. Put the baking cups into the top of the steamer, lower over the water and clamp on the lid. Keep the water boiling and don't open the lid to peek. Steam for 15 minutes, or until the cakes are risen and 'bloomed'. They should feel springy to the touch of a finger. Set on a rack to cool.

Spice & butter cake

70 g (½ cup) plain flour
2 teaspoons ground cinnamon
½ teaspoon ground ginger
½ teaspoon grated nutmeg
¼ teaspoon freshly ground cardamom
¼ teaspoon ground cloves
140 g (generous ½ cup) butter,
 at room temperature
120 g (½ cup) caster sugar
6 eggs, separated

A colonial Dutch contrivance, still enormously popular in Netherlands restaurants, is the *rijsttafel* or 'rice table'. The rice in question is served with a parade of dozens of small plates of Indonesian food, a take on a *nasi padang* feast. It is typically rounded off by slices of richly spiced *spekuk*. This Indo-Dutch cake is made by layering and grilling twenty or more alternating dark and light layers. Beautiful as it looks, I don't have the patience for such matters. Here is my speedy version, which has all the intoxicating spice flavour and almost custardy texture, but none of the hours of sitting in front of a hot oven.

Grease and line a 20 cm (8 inch) cake tin. Preheat the oven to 170°C (325°F).

Whisk together the flour, a pinch of salt and the spices and set aside.

In a large bowl, cream the butter and sugar until very light and fluffy – this will take about 3 minutes with an electric whisk. Whisk in the egg yolks one at a time, adding a spoonful of the spiced flour if it starts to split. Beat in the remaining spiced flour until just combined.

With a clean whisk, beat the egg whites to form stiff peaks. Stir about a third briskly into the batter to loosen it, then gently fold in the rest. Scrape into the cake tin and shake to level.

Bake for 30 minutes until the top is golden and springs back to the touch. Cool for 5 minutes in the tin before turning out onto a rack to finish cooling.

Black rice steam cake

Serves 8

200 g (7 oz) butter
250 g (9 oz) black glutinous rice flour
6 large eggs
250 g (generous 1 cup) caster sugar
½ teaspoon salt
1 teaspoon baking powder
2 tablespoons sweetened condensed milk
½ teaspoon vanilla extract

The best recipes, ones that are really loved, used and shared, invariably have history. This cake's tale started with a Dutch colonial past that brought a taste for cake to Indonesia. Using a base of black rice flour with its bold, nutty flavour is a local addition. Aisah Wolfard learnt the recipe from her mother, and in turn shared it with my friend Julia Winterflood. They would sit together as students on the balcony of Aisah's home in the northern hills of Badung and eat it with black coffee. The cake is decadent yet delicate, smooth yet springy, and has a fabulous inky colour. It keeps well for days in a tin, the texture changing from slightly moussey when freshly steamed to damp and squidgy as it matures.

You'll need a cake tin and a steaming pan or basket large enough to hold it. I use a 22 cm (8½ inch) bundt tin, which fits neatly into my steamer.

Melt the butter and use a little to grease the inside of the cake tin well. Dust with just a little of black flour to help stop the cake sticking. Start the water boiling underneath the steamer so it is ready for the cake.

In a large bowl, whisk together the eggs, sugar and salt to get a frothy mixture with the sugar dissolved. Stir in the black glutinous rice flour and baking powder.

Stirring as you go, gradually add the condensed milk, the vanilla extract and finally the melted butter. Keep stirring until the mixture is smooth and velvety.

Pour into the cake tin and sit in the steaming basket. Wrap the lid with a clean tea towel – this will stop water dripping onto the cake and create a tight seal. Steam over a medium-low heat (making sure there is always water in the pan). How long it will take depends on the size and shape of your pan – Aisah's takes 25 minutes, mine closer to 40. Check every 5 minutes or so towards the end of the cooking time. The top should be gently springy with not too much wobble below, then poke in a skewer to check the middle has a delicate crumb rather than raw batter.

Remove from the steamer and leave to cool for 10 minutes in the tin before turning out onto a rack to cool. Serve with strawberries perhaps, or for a real Indonesian touch, grated mild cheddar cheese.

Toasted coconut brittle

350 g (1½ cups) caster sugar
1 tablespoon golden syrup
125 g (½ cup) butter
⅓ teaspoon salt
200 g (4 cups) toasted coconut flakes
1 teaspoon vanilla extract
½ teaspoon bicarbonate of soda
 (baking soda)

This gorgeous amber rubble is my secret ingredient. Sprinkled over shop-bought coconut ice cream it makes an instant fuss-free dessert, lifting an already sumptuous treat to new heights.

Line a baking tray with parchment.

Put 60 ml (¼ cup) water, the sugar, golden syrup, butter and salt into a large pan and cook gently without stirring until the sugar melts. Turn the heat to high. Cook as the sugar first bubbles, then caramelises and eventually reaches the hard-crack stage or 154°C (309°F) on a sugar thermometer.

Immediately remove from the heat and mix in the coconut flakes. Quickly add the vanilla and the bicarbonate of soda and stir to incorporate them without overmixing.

Quickly tip the mixture onto the baking tray and use the back of a spoon to smooth it out thinly, not worrying about being neat or even. Leave to cool and harden.

Snap into pieces or smash to a rubble in a mortar. Store the brittle in an airtight container. It will keep for a couple of months.

DRINKS

Chapter Nine

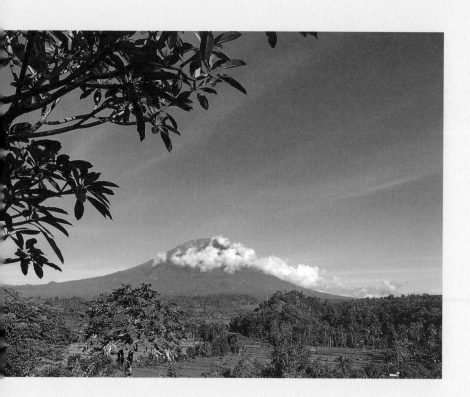

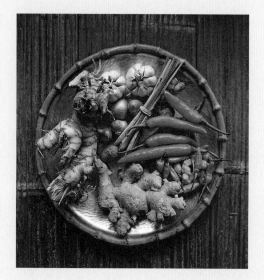

JAMU
Elixir of Life

There is a folk tale that Indonesian princesses would drink *jamu* to sustain eternal youth and beauty to serve their kings. Certainly these herbal tonics seem to have originated in the royal courts of Java more than a thousand years ago and are still drunk widely today. Sometimes they are taken as powerful natural medicines, other times for health-giving properties. Jamu falls into eight taste groups, each representing a different stage of life, and ideally you should drink one after another, working your way from a *sweet-sour* childhood, through the *spicy* teenage years and eventually culminating in a *sweet* end of life. Many are delightful, including an inky green betel leaf extract with a spicy fragrance, and vivid yellow turmeric and lime elixir that you can feel doing you good. Others are a real test, such as *sambiloto jamu*, which can cure or frighten away ailments with its excruciating bitterness.

Herbal medicines and tonics are relied on heavily alongside modern medicine in Indonesia and every Indonesian I know has their own natural cures for minor conditions. Below are a few that have been shared with me:

— **Ginger tea** eases nausea and morning sickness, whilst gingery sugar syrup helps coughs and boosts stamina.
— **Bitter herbs** are taken by the elderly to reduce inflammation and ease arthritis.
— **Clove extract** is an analgesic that helps toothache (a flavour of my childhood as every gap from a lost tooth was rubbed with the powerful spice).
— **Galangal** boosts circulation and soothes sore stomachs.
— **Turmeric** is taken for menstruation and constipation.
— **Kencur** eases stiffness.
— **Nutmeg** treats insomnia.
— Make a tonic for common colds with coriander seeds, ginger and garlic sweetened with honey.

In this chapter I will be sharing some jamu and other drinks that are as enjoyable as they are healthy.

Being predominantly Islamic, warungs and restaurants in Indonesia are often dry and restrictions on alcohol are increasing. Despite this, beer, wine and traditional spirits are commonplace, although the big brand glass vodka bottles you see on roadside stalls are more likely to contain petrol for motorbikes than spirits. Palm sap and rice wines, including *tuak, arak* and *brem*, range from the mildly fermented homebrews I have drunk from coconut shells in villages to the noxious moonshine that can blind with its strength. Iconic Bintang beer, a clean and slightly sweet lager, is a safe choice to serve alongside your Indonesian meal.

As Indonesian food is full of complex flavours, full-bodied reds clash. Instead go for aromatic grape varieties such as Riesling, Gewurztraminer or Pinot Grigio. These will calm the spiciness in the mouth and ready it for the next mouthful. Rafaela Pons, a top sommelier in Indonesia, advises choosing a perfumed white wine like an Astrolabe Wairau Valley Riesling (New Zealand) or Isola, a Moscato from Bali. For red wine, choose something ranging from light to medium bodied such as Pinot Noir Babydoll (New Zealand) or a Malbec from Bodegas Zuccardi (Argentina).

Sweet tamarind jamu

This delicious drink reminds me of a homemade cola and is particularly good over ice.

2 tablespoons tamarind paste
thumb of turmeric, skin scrubbed, chopped
3 lime leaves
1 pandan leaf, bruised and tied in a knot
50 g (¼ cup) dark palm sugar (gula jawa)

Put all the ingredients in a pan with 750 ml (3 cups) water and a pinch of salt (adjust the tamarind amount depending on how sour your variety is and how sour you'd like your drink). Cover, bring to the boil slowly over a low heat and simmer for 10 minutes. Strain the infused liquid and serve either hot or ice cold.

Turmeric jamu

Jamu sellers have been championing turmeric's health-giving properties for generations, long before the West caught on. This tonic is light, refreshing and my favourite start to a day.

100 g (3½ oz) turmeric
thumb of ginger
juice of a lime
2 tablespoons honey

Scrub the turmeric and ginger clean (no need to peel) and roughly chop. Blitz to a purée in a high-speed blender with a little water. Scrape into a pan with 750 ml (3 cups) water, bring slowly to the boil and simmer for 10 minutes.

Remove from the heat and add the lime juice. Strain through a fine sieve, pressing the pulp to extract all the juice. Sweeten with honey and chill before serving.

Frozen mint juice

Not traditionally Indonesian, but for years I have been served it at different private houses in Bali so the secret is out. A perfect hot weather cooler that everyone loves.

large handful mint leaves
100 ml (scant ½ cup) lime juice (4–5 limes)
2 tablespoons sugar, or to taste
ice

Put the mint, lime and sugar in a high-speed blender and top up with ice. Blitz to a green slush – the mint leaves should break down to small flecks. Tip into a jug, top up with water and taste. Add more sugar or lime juice to taste. Serve at once.

Cucumber limeade

As a foil for the spicy food of Banda Aceh they have the ultimate refreshing combination: filling glasses with grated cucumber and ice, then topping up with fresh limeade. It's even better when everything is blitzed together.

200 g (7 oz) cucumber, peeled, seeded and roughly chopped
100 ml (scant ½ cup) lime juice (4–5 limes)
70 g (⅓ cup) caster sugar
ice
sparkling water

Put the cucumber in a high-speed blender with the lime juice, sugar and a handful of ice. Blend to a slush and taste for sweetness (remembering it will be diluted). Transfer to a jug with more ice and top up with a little sparkling water. Serve at once.

Bir pletok

Betawi people chill this spiced drink by shaking inside a bamboo stick filled with ice cubes, making a 'pletok pletok' sound that gives it its name.

75 g (2½ oz) ginger, skin scrubbed, sliced
3 lemongrass sticks, trimmed, bruised and tied in a knot
3 lime leaves
2 pandan leaves, bruised and tied in a knot
½ cinnamon/cassia stick
2 cardamom, lightly crushed
2 cloves
grating of nutmeg
50 g (½ cup) dark palm sugar (gula jawa)

Put all the ingredients in a pan with 750 ml (3 cups) water, cover and bring to the boil. Simmer for 10 minutes, then remove from the heat and leave to cool before straining. Serve chilled.

STMJ

A bad wind entering the body is blamed for coughs and colds in Indonesia. The cure? This warming milky drink known affectionately by the acronym for *susu telor madu jahe* – milk, egg, honey, ginger. Here, enough to comfort one invalid.

250 ml (1 cup) full-fat milk
2 slices ginger, skin scrubbed, bruised
1 egg yolk
1 tablespoon honey

Heat the milk and ginger slowly until it just comes to the boil. Turn off the heat.

In a bowl, whisk together the egg yolk and honey until pale and bubbly. Gradually whisk in the hot gingery milk. Pour into a mug and serve at once.

Bandrek spice tea

A warming tea from the cool highlands of West Java. It is usually drunk very sweet and milky. Minangkabau street food sellers skilfully blend the tea with sweetened egg yolk and condensed milk to create a rich, two-layered drink topped with ground cinnamon. I prefer it black.

1 cinnamon/cassia stick, broken
1 lemongrass stick, trimmed, bruised and tied in a knot
1 slice ginger, skin scrubbed, bruised
5 star anise
6 cardamom
10 cloves
¼ teaspoon coriander seeds

Put all the ingredients in a pan with 750 ml (3 cups) water. Cover, bring to the boil slowly over a low heat and simmer for 10 minutes to brew. Strain the infused liquid. Serve as it is or with milk and sugar to taste.

Banda cinnamon tea

A trick from the Spice Islands, where spice finds its way into everything, is to use cinnamon-scented water to brew black tea.

1 cinnamon/cassia stick
2 black teabags

Bring 750 ml (3 cups) water to the boil with the cinnamon stick, cover and simmer for 10 minutes. Use this spice-infused water to brew the tea.

Fiery ginger tea

100 g (3½ oz) ginger

Scrub the ginger clean (no need to peel) and chop into small pieces. Put in a lidded pan with 750 ml (3 cups) water and bring slowly to the boil. Simmer for 10 minutes and taste for spiciness. Simmer longer for more oomph, or dilute with water if it has gone too far. Strain and drink hot.

Candlenut – *kemiri*

The kernel of this nut is waxy, hence its name. Candlenuts are ground to a paste and used for thickening pastes and sauces, lending body and richness. They can be substituted for their distant relative, the macadamia nut, which they resemble closely, though the candlenut is slightly larger. I tend to use a couple of blanched almonds instead as they fulfil a similar function – use whichever creamy nut is easy for you to source. If buying candlenuts in an Asian supermarket look for shiny, dust-free nuts. Like any nut they turn rancid with time, so use within 6 months, or 12 months if stored in the freezer. They are mildly toxic until heated so don't take them up as a snack.

Coconut – *kelapa*

It is hard to imagine an Indonesian meal without coconut: their grated meat adds mellow sweetness to spiced salads, their pressed milk adds creaminess to curries, and their flesh is used for body and richness in soft and sticky puddings.

For grated coconut, I really recommend buying it fresh either as a whole coconut or pieces of flesh. This tastes so much better than dried, gives you control of the texture you want, and allows the opportunity to toast it first for extra flavour. (Do this by holding a piece of coconut in an open flame, with the brown inner skin facing down. Once very toasty, scrape off the blackened bottom and grate the remaining flesh.) Grate coarsely or finely and I usually include the thin brown skin as it adds a subtle nuttiness. If you can only get desiccated coconut, buy a good quality unsweetened variety. Rehydrate by just covering with boiling water and leaving to sit for 10 minutes. Drain and gently turn in the sieve to remove extra liquid, leaving the grated coconut moist and fluffy.

Coconut milk (*santan*) is the creamy liquid made from the flesh, not the pale coconut water that fills the shell. Buy it in tins or cartons and look for a good-quality variety as it can make a real difference. Shake or stir well to bring the richer top and thinner bottom together (unless you want to scoop off the coconut cream). I don't bother buying lighter coconut milk, which has been diluted – if you want it thinner then add water yourself, but usually it is the luscious richness you are after. Coconut cream is richer and thicker. Store leftovers of either in a covered container in the fridge for up to 3 days or 3 months in the freezer.

See page 233 for more on cooking with coconuts.

Oils – *minyak*

Coconut oil, made from the coconut flesh, is the traditional cooking oil of Indonesia. This can be refined to be flavourless with a high smoking point (better for cooking) or extracted for virgin coconut oil with a nutty flavour. Where I have specified simply oil in a recipe, you can choose whichever neutral cooking oil is available. Groundnut/peanut oil is a good choice, but you could also go for vegetable oil, rapeseed oil or sunflower oil. Olive oil has the wrong taste for Asian food.

Peanuts – *kacang tanah*

Peanuts have two important functions in Indonesian cuisine. The first is being ground into creamy sauces and dressings such as for Chicken sate (page 42) or Gado gado (page 136). The other exploits their crunchy texture when fried. A scattering alongside rice and a saucy curry or a thin vegetable stew varies the texture of the meal.

Two different types are used depending on the recipe: larger roasted peanuts without their skins, and the smaller raw, red-skinned peanuts that you can buy in Asian supermarkets. The latter have great flavour when fried and make a superior coloured and flavoured peanut sauce.

Some
KITCHEN
tricks

Indonesian cooks don't follow recipes or use weights or measures. Kitchen knowledge is passed through the generations and ingredients are added by eye and by taste. They are piled in mounds next to each other – twice as much ginger as turmeric, shallots and garlic in equal volumes etc. It certainly makes no sense to follow recipes slavishly as in different islands and different seasons – even from different plants – there is huge variation in size, flavour intensity and spice. The same is true of different varieties of bottled sauces. Learn to trust your instincts and taste as you go, adjusting seasoning in little bits.

The secret of Asian cooking is a careful balance of sweet, salt, sour and chilli heat. If a dish doesn't seem quite right, then adjust each of these elements in turn, tasting as you go until you hit on the perfect equilibrium.

Remember flavours should be intense and chilli a little on the side of too hot – everything will be muted by the accompanying rice, which is cooked unseasoned.

Too spicy? Calm with acidity and palm sugar. Too flat? Add salt and acid. Too salty? Add coconut. Too sweet? Add acid, not more salt which will intensify the sweetness. Too bitter? Salt rather than sugar will help even the flavour.

An Indonesian 'pinch of salt' usually involves all four fingers! Don't underestimate the power of seasoning a dish well at each stage of cooking to enhance every ingredient and make the flavours sing.

When a dish has no liquid for salt to dissolve in, such as fried rice or noodles, add soy sauce for extra saltiness. Similarly, kecap manis can add liquid sweetness instead of sugar. Heat zaps the acid kick of citrus, so add lime juice at the end of cooking once the food has cooled a little. For tang in hot food, use tamarind or vinegar instead, which doesn't lose its acerbity.

Fresh spices freeze well. Chop rhizomes, lemongrass and chillies and store separately in the freezer for future use. I always keep a tub of fresh lime leaves frozen too; they don't need defrosting. Spice pastes are great to have on hand, frozen in ice-cube trays. If I have extra limes I make lime juice ice cubes, ready for popping straight into cooking or drinks.

Preparing food in advance

Being served warm or at room temperature rather than piping hot, Indonesian food lends itself to cooking in advance. If you are planning a big dinner, spread the load. Sambals and crunchies can be made a few days ahead, meat and vegetable curries the day before to let their flavours mature, leaving just fish dishes, stir-fries and rice for making on the day.

Indonesian stir-fries are not the smoking heat, fast-action affairs of their Chinese equivalents. Cooking at a medium heat, the food both fries and steams, so a little pan overcrowding is fine. Nonetheless, it is still a good idea to have all the ingredients prepared before you start.

Making a stockpot

For an Asian vegetarian stock, put the following in a large pan: 1 chopped onion, 2 chopped garlic cloves, 3 cm (1¼ inches) bruised galangal, 2 bruised lemongrass sticks and 3 lime leaves. Top up with 2 litres (8 cups) of water. Bring to the boil and simmer for about 6 minutes. You want to just release the flavours for a fresh taste. For a chicken stock, see the Soto ayam recipe on page 123.

At the renowned cooking school Bumbu Bali, they have a stockpot bubbling in the kitchen all day. Into it they put scraps and peelings – shallot skins, lemongrass trimmings, carrot ends etc. This impromptu stock is used instead of water for an extra layer of flavour in dishes.

If you are draining rice cooking water (rather than using the absorption method) or you are making compressed rice cakes, a spoonful or two of the starchy liquid can be used to thicken broths or vegetable stews.

Cooking with coconut

In a land with an abundance of coconuts, cooks take great care to select one at exactly the right stage of maturity for a recipe:

— **very young:** fresh green skin and inside plenty of sweet, clear coconut water. There can be no more refreshing drink and, if you are lucky, just a little jelly-like flesh inside to scoop out with a spoon.
— **young:** when a little more mature the water is used as a tenderiser for meats, as in the recipe for I.F.C. (page 35). The flesh is still soft, but has more body and can be chopped to use in cakes and ice cream.

— **mature:** the water is still usable and the flesh soft and it can be grated with or without its rind. Use in Fish sate (page 45) or Vegetable urap (page 133).
— **old:** with its scrubby hair and brown shell, this is what we buy in the West. The water is not much good to drink, but can be used in cooking. The firm flesh is used to make coconut milk, oil and desiccated coconut.

If you can't get hold of fresh coconut to grate, soak unsweetened desiccated coconut in a little hot water for 10 minutes to plump it up. Remember it will increase in weight so weigh again once rehydrated.

Coconut milk is made by grating flesh, soaking in hot water and squeezing out the oily milk. A second squeezing makes thinner, lighter coconut milk. When using from a tin, give it a shake to redistribute the fats.

Coconut oil is the oil of choice for cooking in Indonesia. You can make your own by boiling coconut milk for several hours until it separates. The sediment left in the pan is called *blondo*. While still white it can be used as a topping for Coconut rice (page 157). Further through the stage of making oil the blondo will turn brown. It can then be mixed with crushed garlic, chilli or Sambal oelek (page 175) and lime juice and served as a relish.

Usually when cooking with coconut milk you don't want the oil to separate out. Prevent this by stirring often as it comes to a simmer and don't cover the pan. Never let it boil aggressively for more than a few seconds.

Using banana leaves

Banana leaves are nature's tinfoil. Snipped fresh from the tree, they have a waxy surface that makes them strong and waterproof. Food can be steamed inside banana leaf parcels and the leaves themselves will impart a subtly herby flavour. Outside of the tropics, you can buy frozen banana leaves in Asian supermarkets, which defrost quickly.

Clean the leaves carefully. They are brittle and crack easily when folding, so soften over heat. To do this, hold above a gas flame or hotplate until it slightly wilts and changes colour. It should be pliable and easy to work with.

Wrap your food as if you were wrapping a present in paper. Tear off some long strips of leaf to tie the parcel up. Alternatively, use splinter-thin toothpicks to pin the leaves in place. It is fine if it seems overwrapped, the steam will still penetrate. The parcels can now be steamed, cooked in the oven or on an oiled rack over hot coals.

WHAT *to do* *with* LEFTOVERS

Food should never be wasted and in Indonesia everything is carefully saved and used. Spiced coconut flakes or meat floss are served moist the first outing, then crisped and dried to store in jars for future meals. Excess oil is spooned off sambals, stained with chilli colour and heat, to be used in stir-fries. Soft vegetables are given new life in Mie goreng (page 169).

Using up ...

coconut milk – leftover coconut milk is a great treat to have in the fridge. Stir into soups or curries to add richness or slick a little into stir-fried greens for a silky sweetness. It is also great in smoothies, or season with sugar and salt and drizzle over cold tropical fruits – an Indonesian night market favourite. I like to use it as an excuse to make the dreamy Coconut custard pie (page 205).

There are two recipes in this book for spiced coconut rice, but a quick alternative is to replace some of the water for coconut milk in the Perfect steamed rice (page 156). All of the following recipes use less than a tin of coconut milk so

with a little planning you'll be able to make two: Sumatran lamb korma (page 59), Lamb shank red curry (page 71), Coconut milk chicken (page 55), Ayam taliwang (page 86), Sea bass & spinach curry (page 120), Snake beans with coconut milk (page 121), Sumba creamed corn (page 142).

coconut – grated coconut, whether fresh or desiccated, is the base for urap salads. Try the Vegetable urap with fresh spiced coconut (page 133) or Sweet coconut & basil salad (page 135). It also goes into Beef & coconut patties (page 36), Green bean lawar (page 150), Lemongrass fish sate (page 45) and Coconut & lime leaf omelette (page 32). A way to store coconut longer, and one of the best store cupboard standbys to have around, is Spicy coconut flakes (page 182) or go for broke with the Coconut brittle (page 219).

sambal – chilli sambals will keep for a week or more in the fridge and I think they make excellent additions to any meal, Indonesian or not (try a sweet tomato sambal in a bacon sandwich!). They are also great to stir into dishes that seem a bit flat, bringing heat but also other flavour-boosting properties.

rhizomes (ginger, turmeric, galangal) – almost every dish begins with a bumbu spice paste, usually with ginger, turmeric and sometimes their piney cousin galangal at their base. Clean and slice excess and freeze in bags for future bumbus, or make up a large batch of Master bumbu (page 23). You must also try some of the drinks recipes, which make good use of these fresh spices.

lemongrass – outside of Asia, lemongrass tends to be sold in small amounts so you'll be more likely to be buying more than seeking uses for leftovers. Half the recipes in this book use lemongrass, either pounded into the spice paste or, more usually, bruised then knotted and thrown into the pot. Throw in with abandon as most savoury dishes will happily marry with the fragrant lemony scent, and lots of sweet ones too. You can also add a stick to the rice pot ... and cocktails ... oh, and be sure to try the Balinese lemongrass sambal (page 178).

lime leaves – you can store lime leaves in the freezer for months, but I'll warrant you'll get a taste for them and want to find other dishes where their verdant citrussy flavour comes through. You won't have to look far in this book, but they really shine in the Tofu fritters (page 37), Peanut & lime leaf crackers (page 31), Disco nuts (page 33), Coconut & lime leaf omelette (page 32) and, of course, the Kaffir lime sorbet (page 200).

pandan leaves – mainly used in sweet dishes in the way vanilla is in the West, you can infuse any milk with an exotic kiss of pandan. The leaves are used in the Black rice pudding (page 213) and in several of the spiced drinks, and they stain the Green coconut pancakes (page 209). You could also try adding a leaf to custards, creams or ice creams. Or do as they do in Bali and add a leaf to your Perfect steamed rice (page 156).

tamarind paste – one of my favourite kitchen ingredients. I use it often to give a sour note to balance sweetness. If you've run out of citrus, tamarind can step in. In the rujak dipping sauce (page 29), tamarind is the star. Use in a glaze for grilled fish, as in the Spice Islands tuna (page 93), or meats (adding salt, pepper and a slick of honey). Stir as a brightener into coconut-based curries such as Padang-style eggs (page 75). Maybe you'll like my cola-like Sweet tamarind jamu (page 224).

chillies – if you have chillies in the fridge threatening to soften, extend their life by whizzing them into a sambal (pages 175–8).

peanut sauce – not only a natural partner to sate, this is excellent with all grilled meats and a welcome addition at barbecues. You can also use leftovers to dress a salad as in the Gado gado (page 136) or Pecel (page 139).

rice – rice is the one component of an Indonesian meal that is invariably served freshly cooked and warm. You can steam cold rice to reheat, but it isn't really as good so your answer ... Nasi goreng (page 161).

INDEX

ACKNOWLEDGEMENTS

It takes many teams to create a book and I am so grateful to every one of them.

An amazing publishing and design team have made *Fire Islands* a beautiful reality with their creativity, vision and belief: Lou Johnson, Corinne Roberts, Jane Price, Vivien Valk, Madeleine Kane, Clive Kintoff, Jemma Crocker, Kristin Perers, Tabitha Hawkins, Becks Wilkinson, Cissy Difford, Kay Halsey, Lucy Sykes-Thompson, Neil Gower. Thank you also to Heather Holden-Brown and Cara Armstrong for supporting and encouraging my work.

Friends, acquaintances and strangers across Indonesia have been endlessly welcoming and generous with their time as I wrote my ode to their cuisine. My huge thanks and gratitude to Karim Rabik, Arief Rabik, Joanna Boville, Rasmini Gardiner, Dayu Padmi, Dayu Anom, Dayu Putu, Ida Dayurai, Nattalia Sinclaire, Nengeh, Amir Rabik, John Hardy, Lorna Buchanan Jardine, Penelope Williams, Chef Putu, Andre Dananjaya, Julia Winterflood, Sam and Isabella Branson, Nyoman Jasmin, Made Candra, Eelke Plasmeijer, Diah Kencana, Heinz von Holzen, Rafaela Pons, Fransiska Lali, Veronica and Kelvin Rapp, Chef Didik, Chef Nurry, Aisah Wolfard, Warwick Purser, Gusti Moertiyah, Nyai Gondoroso, Bimo, Sri Sutarti, Astrid Maharani Prajogo, Okty Rahardjo.

My home team: friends, family and other supporters who have helped me with their expert knowledge, advice, testing and tasting. Thank you, Kirsty Smallwood, Christopher Smallwood, Elizabeth Ford, Augustine Ford, Niloufer King, Amanda Nicolas, Camilla Brown, Caroline Eden, Spencer Hyman, Carolyn Lum, Harriet Jenkins, Camilla Purdon, Gloria Ford, Clifton Chilli Club, Catharine Carew Hunt, Caroline Morton, Olivia Chapman, Lynda Aitken, Cameron Stauch.

Most of all, thank you to Sebastian, Otto and Sylvia Ford for their patience, love and voracious appetites for both food and adventure.

There is one person who has been in my mind at every stage of this journey: Ibu Linda Garland. We first plotted the idea of this book nine years before I wrote it, eight years before she left this world. Pioneering, creative, outrageously funny, Linda has been an inspiration in my life and a magnet that brought my family back to Indonesia so often when I was growing up. It is the help and support from her amazing tribe of people that made this book possible.

ISBN: 978-1-948062-80-0

For Murdoch Books:
Publisher: Corinne Roberts
Design manager: Vivien Valk
Editorial manager: Jane Price
Designer: Studio Polka
Editor: Kay Halsey

Food photography: Kristin Perers
Food preparation and styling for photography: Rebecca Wilkinson
Stylist: Tabitha Hawkins
Map illustration: Neil Gower
Production director: Lou Playfair

Location photography pages: 8 Omer Rana; 16 bottom Joshua Newton; 38 Sebastian Staines; 50 The Minang House at Bambu Indah Hotel, Ubud by Djuna Ivereigh: 68 Bambu Indah, Ubud; 90 Sander Wehkamp; 118 istock mrezafaisa; 130 Daily morning harvest in the organic permaculture gardens at Bambu Indah Hotel by Vasily; 140 Aron; 154 bottom Joel Vadell; 164 Bernard Hermant; 188 Dikaseva; 202 Sutirta Budiman; 230 Thomas Ciszewski All other photographs, author's own.

Color reproduction by Splitting Image Colour Studio Pty Ltd, Clayton, Victoria.

Printed by C&C Offset Printing Co Ltd, China.